Johann Willsberger

THE HISTORY OF
PHOTOGRAPHY

Cameras
Pictures
Photographers
Translated by Helga Halaki

Doubleday & Company, Inc.
Garden City, New York
1977

LIBRARY OF CONGRESS CATALOG CARD NUMBER:
76-024894

Conception and Design: Johann Willsberger
1977 Johann Willsberger
Consultant: Charles E. Fraser
Printed in West Germany
ISBN: 0-385-12664-6

This book was produced in collaboration with
Klaus op ten Höfel/Agfa-Gevaert Foto-Historama

Preface: Helmut Gernsheim
Taxonomy: Dr. Laurent Roosens (Classification),
Klaus op ten Höfel (Final Arrangement)

The photographs were taken in the following museums and collections:
Agfa-Gevaert Foto-Historama (including the Stenger and Wendel
Collections), Leverkusen
Deutsches Museum, Munich
George Eastman House, Rochester
Kodak Museum, Harrow
Leif Preus, Horten (Norway)
Provinziaal Museum Het Sterckshof, Antwerp
Royal Photographic Society, London
Rudolf Skopec, Prague
Museum of Technology, Prague
Hans J. Wendel, Düsseldorf

Grateful acknowledgment is made to Dr. Rolf-Hasso Ley of Agfa-Gevaert
Foto-Historama for his assistance.

Three inventions have advanced the progress of mankind most dramatically: script, printing, and photography.

The photograph is an invention of the industrial revolution. It fulfilled the desire of the burgeoning middle class for realistic portraits at reasonable prices which could not be satisfied by either silhouette or physionotrace representations. It also provided inexpensive wall decoration offering views that were faithful to reality and made accessible still-life and genre paintings which had enjoyed great popularity during the period of the Dutch masters of the seventeenth century. In fact, it is difficult to understand why, under the ideal circumstances of that time, Dutch scientists had not yet produced mirror images of nature. The necessary optical and chemical knowledge was at their fingertips; it was merely a question of combining the two.

The camera obscura had been used by painters for landscape drawing since the Renaissance. Small-size instruments with convex/concave lenses—direct forerunners of the photographic travel camera—had been mentioned in treatises on optical science since the middle of the seventeenth century as frequently as the blackening process of silver nitrate under the action of sunlight. Angelo Sala wrote in 1614: "When silver nitrate is exposed to the sun, it turns the color of ink." A German professor of anatomy named Johann Heinrich Schulze went one step further in 1725: he placed letter stencils around a bottle containing a mixture of chalk, silver and nitric acid and found that the spots protected from light remained white, while the parts exposed to it blackened. Since Schulze was searching for phosphorus, however, this observation remained incidental.
Thomas Wedgwood was the first to have the idea of fixing the light images received in the camera obscura by using paper soaked in a solution of silver nitrate. Being a chemistry student, he pondered the laborious procedure of copying the designs for his father's pottery plant. The year was 1799. While his photographic experiments with the camera failed, because the images would fade after a certain time, his production of contact prints of leaves, wings of insects and pictures behind glass succeeded within two to three minutes at sunlight. However, Wedgwood found no solvent for the unexposed silver chloride in order to make the light image permanent. Thomas Wedgwood, as well as his friend Sir Humphry Davy, professor of chemistry at the Royal Institution of London, overlooked the fact that, in 1777, Carl Wilhelm Scheele had given an account of the properties of ammonia. These first photographic experiments came to a standstill just before their fruition.

Despite this apparent breakdown, we are indebted to Davy for publishing Wedgwood's incomplete findings in the *Journal of the Royal Institution* in 1802. As a result of this publication, William Henry Fox Talbot became inspired three decades later to search for, and find, a fixing agent. Talbot wanted to record the impressions of his travels in greater detail than the camera lucida and the drawing pencil allowed. He began his experiments in 1834. Initially he, too, succeeded only with contact prints of pressed plants and lace, which he fixed in a solution of ordinary table salt (sodium chloride). Only during the summer of the following year did his photographs bring the desired results. They were taken in his 2¼" × 2¼" "mouse-traps," as his wife was wont to call these miniature cameras, and exposed to light for a half hour. Content to have solved the problem, and in the belief that his castle was "the first building to have drawn an image of itself," Talbot turned his attention their independent discoveries proves that the time was ripe for "facsimile to other scientific matters, neglecting, however, to publicize his discovery.

Independently of these English experiments, a French amateur scientist had considered the solution of the same problem since 1816. Like Talbot, Joseph Nicéphore Niepce had no talent for drawing, and his efforts to find instead a way to project and fix a design led to the photomechanical reproduction of nature. Unable to pursue the lithographic process, then coming into fashion, Niepce decided to make the stone itself light-sensitive and to fix on it the image of nature received in the camera obscura. Subsequently, the image on stone was to be etched and impressions made on paper. The excessive duration of exposure, lasting one full day, on a slowly working layer of bitumen (which hardens under the influence of light, while unexposed portions dissolve in lavender oil), did, in 1824, produce satisfactory results of the oft-repeated view from his study, but the image proved to be too weak for the second step of subjecting it to etching.

When Niepce experimented with surfaces such as glass, zinc, copper or pewter, he applied the simpler contact method to engravings, which he had made transparent with oil. After two to three hours of exposure, they showed a sharper definition than the pictures made in the camera which, even after eight hours under the action of light, were still underexposed and therefore unsuitable for etching. In January 1826, Niepce acquired from the Parisian optician Charles Chevalier his first professionally produced camera obscura, equipped with a meniscus lens to correct the lateral displacement of the image. In May, he ordered pewter plates which, because of their smooth surface, he

considered more suitable than any previously used base. With the help of this material, he successfully completed, during the course of the summer, the first photograph in the camera and obtained the best print of an engraving. The engraving, portraying Cardinal d'Amboise, was the only heliograph he had treated with acid and of which he had two prints made on paper in February 1827. It was the world's first example of photogravure. The photograph which Niepce repeated for Louis Jacques Mandé Daguerre in 1829 as proof of his innovation is the only one which has been preserved for posterity.

In 1827, Niepce took the photograph, along with several heliographic contact prints, to England in order to have his invention registered at the Royal Society. In Niepce's own words, it was his "first successful effort at reproducing nature." This photograph, as well as his announcement addressed to the Royal Society and a copy of the picture of the cardinal, were rediscovered in 1952 after a six-year search.* It took three weeks of continuous experimentation in the Kodak Research Laboratory to reproduce the photograph for the first time since its original production.* It shows the view from Niepce's study onto a court and garden of his Maison Gras in the village of St. Loup-de-Varennes, approximately five miles south of Chalon.

Unfortunately the reproduction gives a rather distorted impression of the original, for the glass-covered, extremely thin layer of bitumen, on the 6.5" × 8" pewter plate in its gold frame, is actually white and smooth as a mirror. The graininess of the picture is caused by the only possible way of reproducing it, at an angle of 45 degrees, using sidelighting and a high-contrast film. This magnified unduly the unevenness of the pewter plate and a layer of dust accumulated over 125 years, which

normally do not show. The perspective distortion of the reproduction had to be corrected. Despite great efforts to remove the most severe rough spots by retouching, it was impossible to do justice to the original.

The camera obscura, in which this photograph was made, no longer exists, but other "photographic" cameras of large dimensions, which Niepce used in later experiments, survive. The exposure time was approximately eight hours, as can be seen from the angle of incidence of the sunlight on the right as well as on the left tower. At noontime, Niepce undoubtedly had to interrupt his work because of the direct light incidence.

Much as the desire to discover India caused Columbus to chance upon America, so Niepce's plan to produce lithographs by optical and chemical means led to something entirely new—the invention of the photograph, which he called "heliograph" or "sun drawing." Niepce made his picture nine years before Talbot introduced the paper negative, and 11 years before the first Daguerreotype. The rediscovery of this first photograph made it possible to antedate the invention of photography to the year 1826, from the year 1839 chosen somewhat arbitrarily, and to attribute it, without a doubt, to Niepce, its originator, rather than to its developer Daguerre.* A still life showing a set table, which still appears in articles giving 1822 as its date of origin, is attributable not to Niepce but most likely to Daguerre and, at the earliest, was produced under the partnership contract signed by the two men in 1829. It was made by use of a glass plate and today survives in a poor half-tone reproduction from the year 1891.

In December 1829, Niepce and Daguerre, along with Charles Marie

Bouton, the inventor of the brilliantly successful optical Diorama spectacles, signed a contract defining the conditions for joint work. The intention was to improve the heliograph by accelerating exposure time. Daguerre, as yet having produced no results, was urged by Niepce to experiment with silvered copper plates that had been exposed to iodine fumes. He made a first step forward in 1835 by accidentally discovering that the latent image could be developed by means of mercury vapors, which reduced exposure time to 20–30 minutes. Two years later, he also found sodium chloride to be a fixing agent. That year, 1837, he made his first photograph, a still life in his studio. The way was now clear to publicly launch the heliograph, which Daguerre renamed after himself; but the discovery was not made public until more than two years later since Daguerre first wanted to ensure the commercial exploitation of the invention. When his efforts failed, he gained the favor of François Arago, an influential scientist and politician. Arago used his authority to induce the French government to bestow upon Daguerre and Niepce's son (Niepce having died in 1833) a lifetime pension in return for the promulgation of the two photographic processes. It turned out later, however, that this generous gesture on the part of the French government was restricted by the fact that the patenting of the Daguerreotype had been kept secret in England. The eagerly awaited disclosure of the photographic invention was made by Arago on August 19, 1839, during a joint session of the Academies of Sciences and of Fine Arts at the Institut de France.

No other invention has conquered the world as triumphantly as the Daguerreotype. Daguerre's *Handbook* was translated into eight languages in 1839/40 and appeared in a total of 32 editions. The great number of inventors who, upon the mere an-

nouncement of the Daguerreotype on January 7, 1839, laid claim to prints of nature" and that an invention of this kind was in the air. Suffice it here to mention but four of the most important men who furnished convincing evidence of their claim as contributors to the history of photography.

In 1819, the English astronomer and physicist Sir John Herschel had already discovered and reported on a weak solution of sodium sulphide as a solvent for silver salts. It would have been easy for him to develop a photographic process much before he actually did, within one week in January 1839, if he had suspected that it would facilitate his scientific pursuits, or if he had been concerned with a practical application of it, as Wedgwood, Niepce, Daguerre, Talbot and Gerber were. On January 30, 1839, Herschel managed to produce a photograph in the camera on paper coated with silver carbonate, which he showed to Talbot. As he did not want to detract from the impact of Talbot's earlier invention, however, he refrained from publishing his own discovery.

Friedrich Gerber, professor of anatomy at the University of Berne, had been conducting experiments since 1837 and had worked out a negative-positive as well as a direct-positive method, on paper, which enabled him to make microphotographs. He asserted his claim in a Berne newspaper on February 2, 1839, and, in the preface of his *Handbook of Anatomy*, dated January 1839, wrote that practical considerations had forced him to abandon his plan to illustrate the book with photographs.

Hippolyte Bayard, a treasury official in Paris, had also begun experiments in 1837 and had developed a method of making direct-positive photographs in the camera, on paper coated with silver chloride. In May,

he showed his prints to Biot and Arago; however, tempted by a substantial amount of money for a better camera and further research, he allowed himself to be dissuaded from publishing his findings before the proclamation of the Daguerreotype—which would have thwarted Arago's plans. In June of 1839, Bayard exhibited 30 of his pictures at a public benefit sale in Paris—largely genuine photographs of still life, scenic views, and sculptures.

As mentioned earlier, Talbot had taken several pictures of his castle during the summer of 1835, but did not consider his perfection of the Wedgwood method significant enough to seek publication. In his understandable fear that the Daguerreotype might too closely resemble his own finding, he disclosed his claim to priority and announced his "photogenic drawing" process to the Royal Society on January 31. His apprehensions were unfounded since Niepce had preceded both Talbot and Daguerre with his invention. It was also evident that Talbot's pictures—primarily contact prints of pressed plants—were in no way competing with Daguerre's camera pictures and were far surpassed by Daguerre's results in clarity, definition, and exposure time.

Talbot now began feverishly to perfect his photogenic drawings. Word reached him of various improvements of the process by others, such as the polishing of the negative, which diminished the visibility of the paper texture, or the reports on gallic acid that the clergyman J. P. Reade recommended as a chemical accelerator. With the aid of new instruments, Talbot concentrated on the production of prints as large as those made by Daguerre (approximately 6" × 10"). A breakthrough finally occurred in September of 1840, when he discovered a way to develop the latent image with gallic

acid. It reduced exposure time in the camera from more than an hour to 3–5 minutes. Talbot patented the new process under the name of "Calotype" (for its beauty) in February 1841. The public announcement, however, only followed in June of that year. The Calotype, later renamed "Talbotype," was technically equivalent to the Daguerreotype, which had been improved upon in the meantime by chemical and optical acceleration by other scientists. Indeed, due to its greater variety of application, the negative-positive principle proved more viable. While the metal plate could not be duplicated, Talbot's procedure permitted any number of positive prints to be made from the paper negative. This not only reduced the price of the print, but it could also be used for the purpose of illustration, as Talbot demonstrated in his work *The Pencil of Nature* (published from 1844 through 1846). It was the first publication enhanced by glued-in original photographs, and was soon succeeded by many more of its kind, as well as by illustrated newspaper and magazine articles. Unfortunately, this elaborate presentation is rare today. During the 1850's, both procedures were supplanted by the "wet-collodion" method, employing a glass plate. It was invented by Frederick Scott Archer, and published in 1851. This method continued in use until the commercially produced gelatin-coated dry plates were introduced around 1880. Each new application of this gelatin emulsion increased the light sensitivity twentyfold. Although, until 1875, the substance was oversensitive for the blue color and undersensitive for greens and reds, this flaw was gradually eliminated by adding various aniline dyes to the emulsion—until ultimately the first panchromatic plates and films were put on the market (1906).

While, during the period of the Daguerreotype and the Talbotype, one was content with pictures of small

to medium size (rarely larger than $6^{1}/_{2}'' \times 8^{1}/_{4}''$), the collodion method soon led to an increase in the size of the equipment as well as of the necessary accessories. The rush for exhibitions, which proliferated with the foundation of photographic societies in the 1850's, provided the impetus. A large-format photograph would, of necessity, stand out impressively, while a smaller-size one could easily go unnoticed. Contact prints of $9^{1}/_{2}'' \times 11^{3}/_{4}''$ and $11^{3}/_{4}'' \times 15^{3}/_{4}''$ plates were customary; even the $15^{3}/_{4}'' \times 19^{3}/_{4}''$ format was not unusual. In time, however, the lengthy process of enlargement on albumen-coated copy paper, yielding but slow results, proved to be too tedious to be successful. A photographer going into the field had to carry his darkroom with him, usually in the form of a tent weighing more than 200 pounds—approximately twice the load the Daguerreotype had required. While well-to-do photographers traveled by carriage, which served as a darkroom at the same time, others were their own coachmen. There were also cameras offering the possibility to conduct the various phases of producing a photograph on their inside, from sensitizing the plate to fixing the final print. A "serious" photographer, however, would consider these contraptions as little as the tempting small-size cameras recommending subsequent enlargement. Whatever the preference, the cameras of the collodion period were no longer solid wooden boxes but foldable models, equipped with bellows.

Not until the introduction of paper coated with silver bromide and the advent of electric light around 1880 did the process of photographic enlargement evolve full-scale. Before 1910, however, only leading photographers could afford their own dynamo or the installation of electric lines. The ones who were not so fortunate had to send their negatives to a commercial processing labor-

atory, much as it is done with color films today.

When, due to the growing popularity of amateur photography, gelatin-coated silver bromide plates and roll film began to be mass-produced, and possibilities of commercial development and enlargement became a reality, the picture size could be reduced significantly. Inspired by the considerable simplification of the operation, manufacturers saw the need for uncomplicated and manageable cameras and, adapting to new demands, the photographic industry soon mass-produced small-size box cameras and folding cameras. They were portable and vest-pocket-type models in the new formats of $3^{1}/_{2}'' \times 4^{1}/_{2}''$ and $2^{1}/_{2}'' \times 3^{1}/_{2}''$.

The one camera that gave the greatest stimulus to amateur photography and influenced its further development most dramatically was the Kodak, introduced by George Eastman in 1888. It was the first camera to have a built-in roll film, and was later succeeded by other, even smaller models. The Kodak was small, light, inexpensive and extremely simple to operate. All one had to do was press the shutter release and advance the film, and 100 circular photographs, $2^{1}/_{2}''$ in diameter, could be made. Another model offered 250 pictures at $ 25, including a leather case. Small wonder that 90,000 cameras were sold during the first four years, particularly since Eastman practically had the monopoly on the production of celluloid film.

With the advent of the Kodak camera, the era of modern photography was ushered in, and Eastman's assessment of mass psychology proved to come true in its fullest sense: "The Kodak camera makes possible a collection of photographs which record the life of its owner and which increase in value each day that passes."

The Leica, produced by Ernst Leitz since 1924, offering 36 photographs on 35 mm motion picture film, and the Polaroid, introduced by Edwin M. Land in 1947, had a similarly phenomenal impact. But even the Leica, in its novel construction, had a forerunner in the 35 mm film camera built by George P. Smith in Missouri in 1912. The twin-lens reflex camera, which was successfully marketed by Franke & Heidecke in 1929 under the name of "Rolleiflex", can be traced back to the camera called "Divided," introduced by Ross & Co. in England in 1891. The single-lens reflex, so popular today, derived from the "Cambier Bolton," featuring a shutter speed of up to $^{1}/_{1000}$ second, which was designed by F. W. Mills and produced by W.Watson & Sons in 1898. Finally, the "Minox," marketed since 1937, had its ancestor in the "Minigraph," built by Levy-Roth, Berlin, in 1914, which could make 50 pictures ($7'' \times 9^{1}/_{2}''$) on 35 mm motion picture film.

As in all other art forms, the creative element in photography is in no way dependent upon the technical knowledge or technique applied. The photos of the past as well as those of the present are documents of humanity. Most likely, everything worth expressing through the medium of photography has been stated within the first 150 years of its existence. We know where we come from; but the mystery of where we will go remains. We will continue to experiment. The photojournalist has a most precious task in reconnoitering today's reality, thus becoming an historian of our times. The year 1976 marks the 150th anniversary of this magic art. In the knowledge of past and present achievements, it seems appropriate to celebrate this anniversary and to honor the man who made it all possible: Joseph Nicéphore Niepce.

Helmut Gernsheim
Castagnola, Switzerland Sept 1975

For thousands of years, artists used their hands to create images on rock, glass, and canvas. During the nineteenth century, the light began to ''draw images.'' Photography was born. Cameras were built to make portraits, pictures of panoramic vistas, and underwater photos. Photographs were taken everywhere—from walking sticks, in the human womb, on the moon. Whatever the later improvements and new possibilities offered by advancing technology—faster lenses, precision shutters, superior film material—the ''optical era'' was ushered in by the three men below:

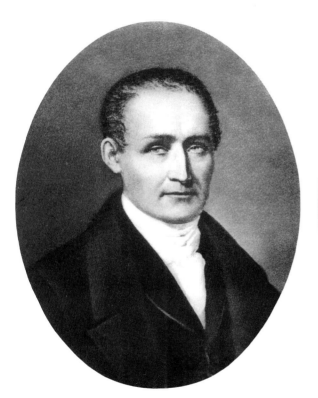

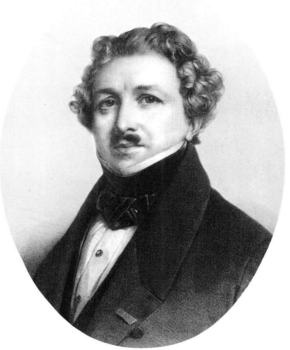

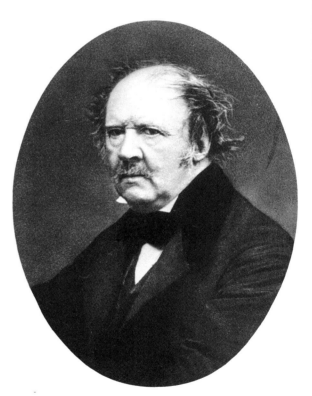

Nicéphore Niepce
A Frenchman
1765–1833

He made the world's first photograph.

Louis Jacques Mandé Daguerre
A Frenchman
1787–1851

He invented the first successful photographic process: the Daguerreotype, named after him.

William Henry Fox Talbot
An Englishman
1800–1877

He conducted photographic experiments with paper and discovered the negative-positive process.

The World's First Photograph. View from the study of the French scholar Niepce. The picture appropriately introduces this history of photography although its creator was not concerned with the "invention of photography." Having no talent for drawing, Niepce tried to find a way to obtain "images of nature" for the lithographic process, that is, a printing foundation from which to produce printed impressions, and thus became the first photographer.

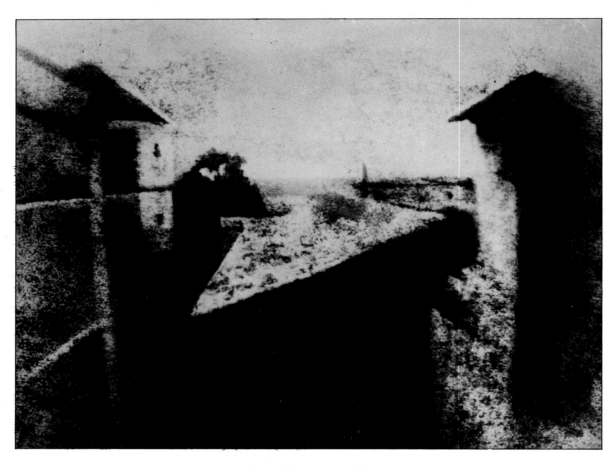

Date of photograph: 1826
Location: Maison Gras, near Chalon-sur Saône, France
Exposure time: Approx. eight hours
Medium of photographic impression: Pewter plate, coated with layer of asphalt
Method: The areas of the asphalt exposed to light hardened. The unexposed parts were washed out with lavender oil and turpentine.
Camera: Probably own construction
Format: 21 × 16.5 cm (8¹/₄'' × 6¹/₂'')
Photographer: Nicéphore Niepce
The photograph was discovered in England in 1952 by Helmut Gernsheim.
(Gernsheim Collection, University of Texas)

Box Camera
The type of camera used by Niepce for his photographic experiments from 1822 to 1826. These presumably oldest cameras already possessed an array of technical refinements, which were reclaimed only decades later (Example: the iris diaphragm belonging to the camera shown at right).
(Denon Museum, Chalon-sur-Saône)

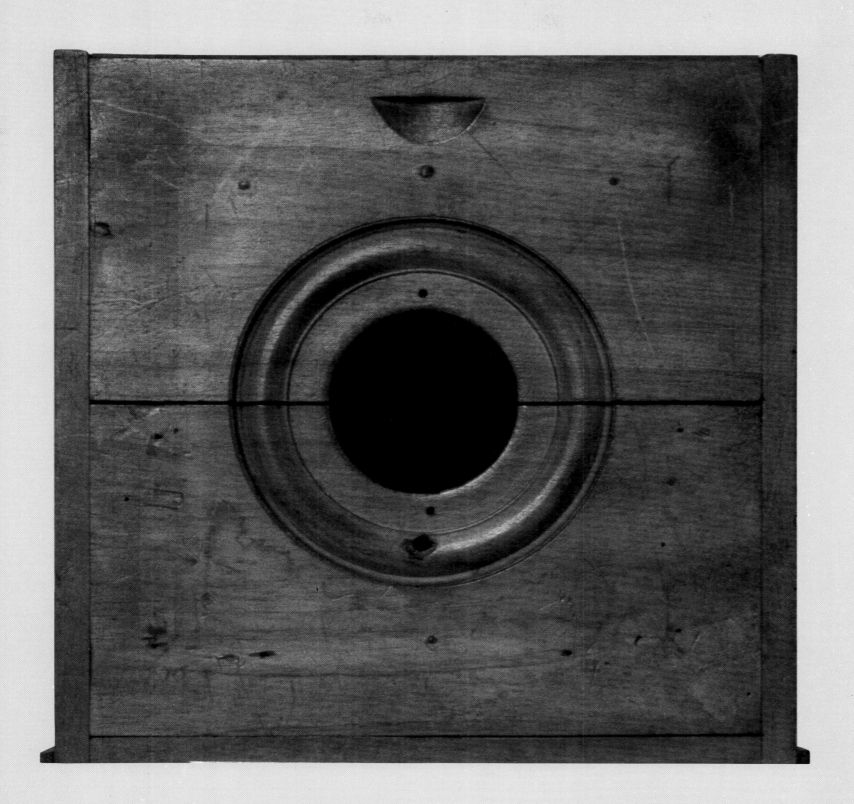

August 19, 1839. The official "birthday" of photography. French physicist François Arago reports to the Academy of Sciences and Fine Arts in Paris on the invention of photography by Louis Jacques Mandé Daguerre. He had already announced the discovery on January 7 of that year. The French government officially purchased the invention for an annual pension of 10,000 francs (6,000 for Daguerre, 4,000 for Niepce's son) and placed it at the disposal of the public.

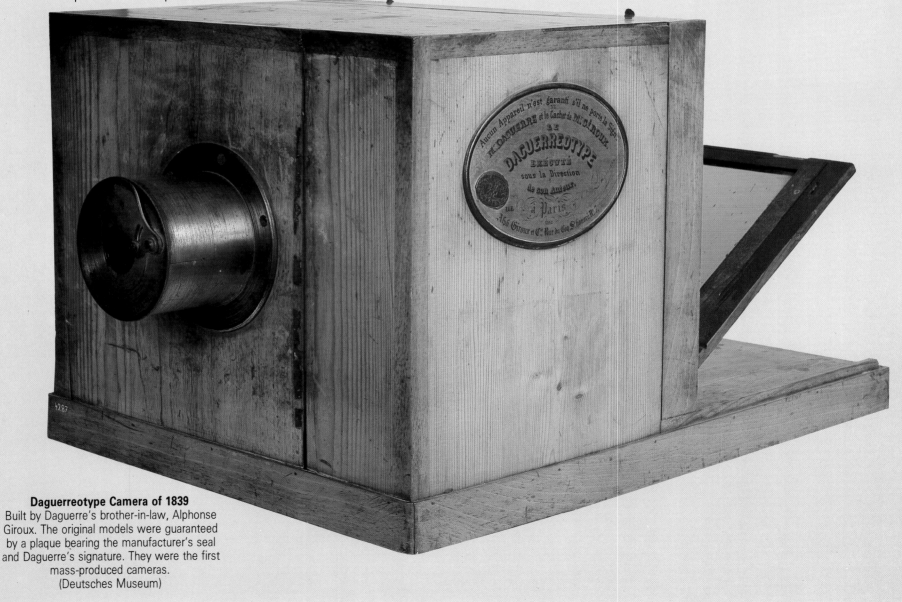

Daguerreotype Camera of 1839
Built by Daguerre's brother-in-law, Alphonse Giroux. The original models were guaranteed by a plaque bearing the manufacturer's seal and Daguerre's signature. They were the first mass-produced cameras.
(Deutsches Museum)

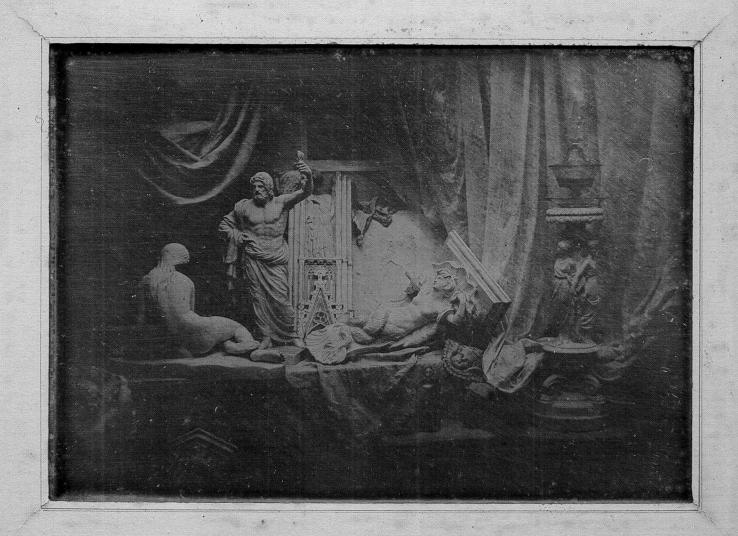

*Epreuve ayant servi à constater la découverte du Daguerréotypie, offerte à Monseigneur le Prince de Metternich
par son très-humble & très-obéissant serviteur,
Daguerre*

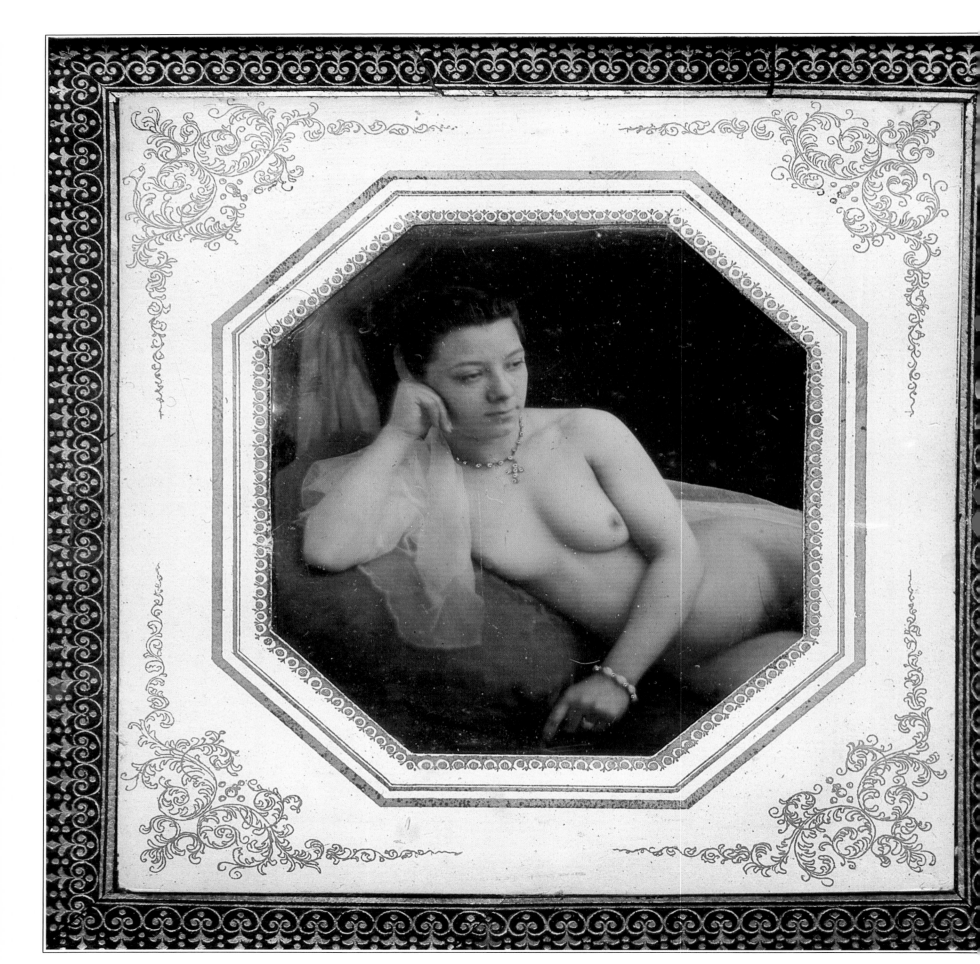

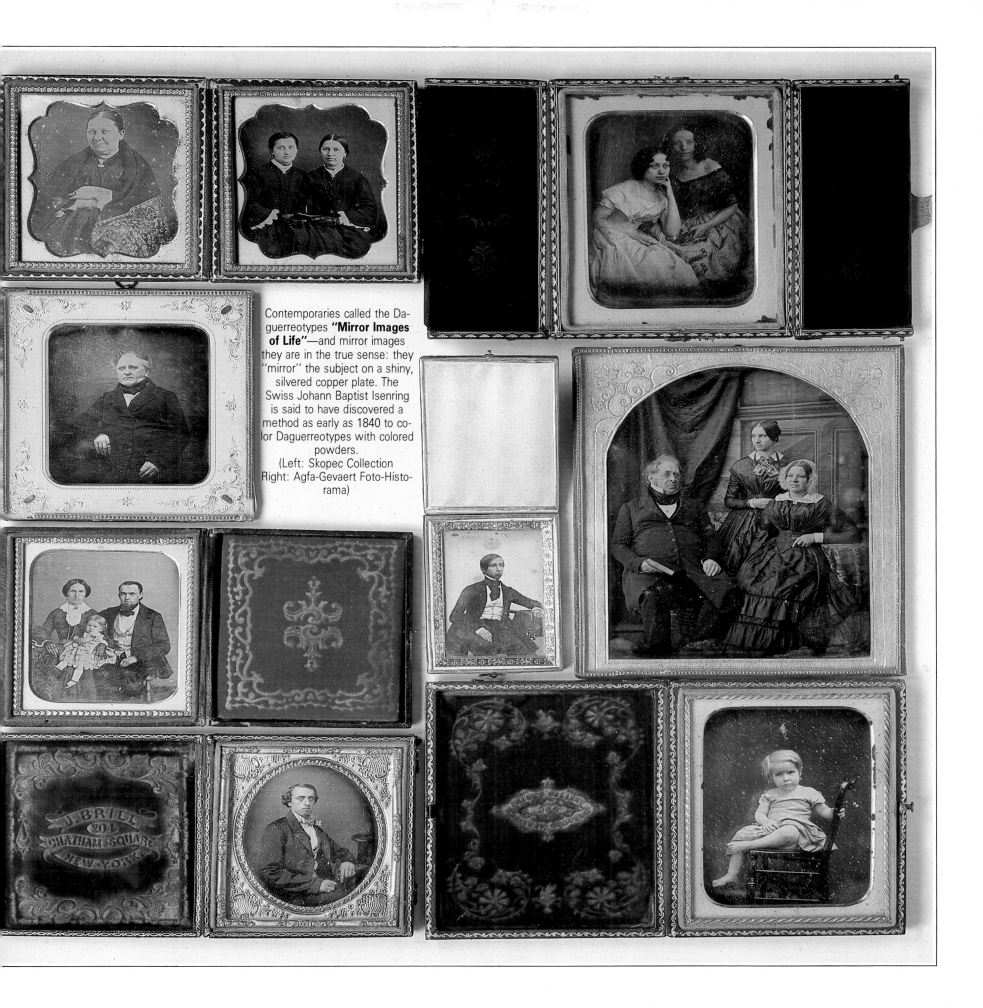

Contemporaries called the Daguerreotypes **"Mirror Images of Life"**—and mirror images they are in the true sense: they "mirror" the subject on a shiny, silvered copper plate. The Swiss Johann Baptist Isenring is said to have discovered a method as early as 1840 to color Daguerreotypes with colored powders.
(Left: Skopec Collection
Right: Agfa-Gevaert Foto-Historama)

Daguerreotype Camera and Accompanying Accessories by Friedrich Voigtländer

In 1840, the Vienna physicist Josef Petzval computed the fastest lens then in existence, which was made especially for photography (149 mm; 1:3.7). To accommodate the lens, the optician Voigtländer built the first all-metal camera (for circular Daguerreotype plates of 9 cm [3¹/₂″] diameter). This combination reduced exposure times from 20–30 minutes to 1¹/₂ to 2 minutes. It was the first camera with which portraits could be made.
(Deutsches Museum)

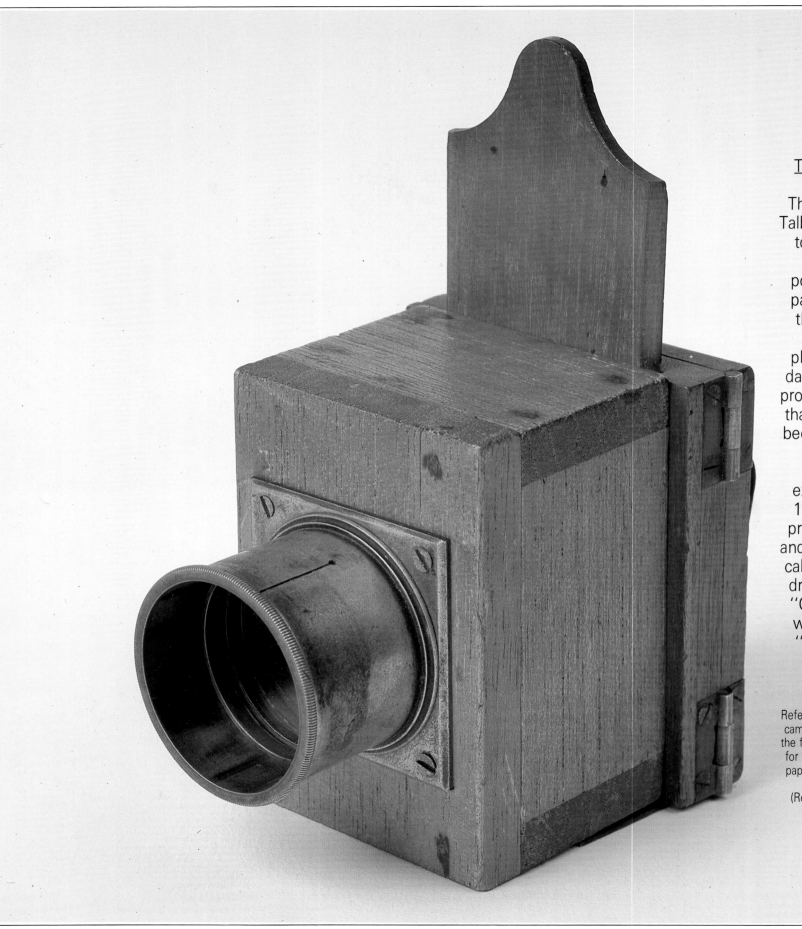

The Father of the Negative.
The Englishman Fox Talbot discovered how to make negatives and from them positive pictures on paper, which forms the basis of black-and-white photography to this day. Long before the proclamation by Arago that photography had been invented, Talbot had carried out photographic experiments (since 1833) with contact prints of plants, lace and feathers on, as he called it, "photogenic drawing" paper. His "Calotype" process was later renamed "Talbotype" in his honor.

Box Camera of 1835
Referred to as "mousetrap," the camera was presumably one of the first types which Talbot used for his photogenic drawings on paper. Height of camera: 6 cm (2¹/₃")
(Royal Photographic Society)

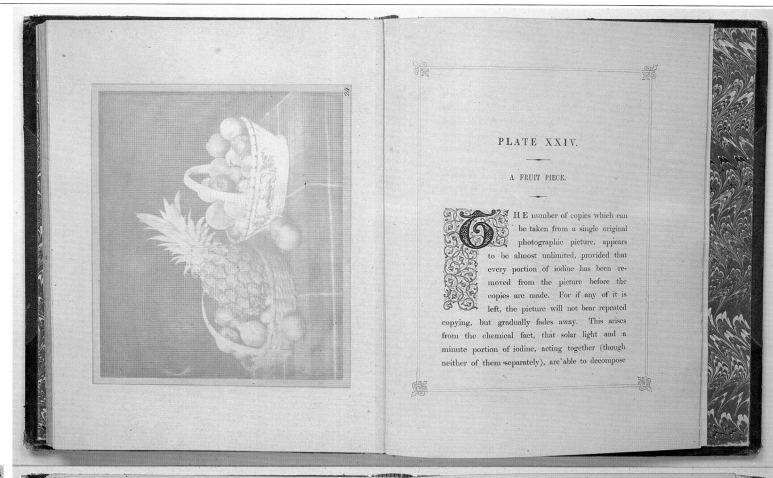

PLATE XXIV.

A FRUIT PIECE.

THE number of copies which can be taken from a single original photographic picture, appears to be almost unlimited, provided that every portion of iodine has been removed from the picture before the copies are made. For if any of it is left, the picture will not bear repeated copying, but gradually fades away. This arises from the chemical fact, that solar light and a minute portion of iodine, acting together (though neither of them separately), are able to decompose

PLATE XIV.

THE LADDER.

PORTRAITS of living persons and groups of figures form one of the most attractive subjects of photography, and I hope to present some of them to the Reader in the progress of the present work.

When the sun shines, small portraits can be obtained by my process in one or two seconds, but large portraits require a somewhat longer time. When the weather is dark and cloudy, a corresponding allowance is necessary, and a greater demand is made upon the patience of the sitter. Groups of figures take no longer time to obtain than single figures would

"The Pencil of Nature"

first book in existence (24 × 30 or 9½″ × 11¾″) to be illustrated with 24 glued-in original photographs by Talbot. It appeared in 4 in an edition of 150 copies. In albot described his method and shed proof of its advantage: the possibility of multiplication. (Agfa-Gevaert Foto-Historama)

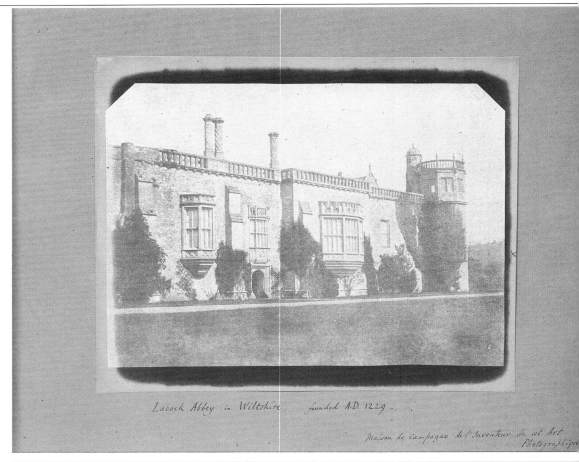

Lacock Abbey in Wiltshire. founded A.D. 1229

Maison de campagne de l'Inventeur de cet Art Photographique

Humboldt Album, 1844
With this present (contents: 22 Talbotypes, made by himself, measuring 26 × 34 cm or 10^1/$_4$″ × 13^1/$_2$″), Talbot wanted to convince the scholar Alexander von Humboldt of the advantages of his process over the Daguerreotype method. Humboldt had been a supporter of the Daguerreotype, but later recognized the quality and advantages of the Talbotype.
(Agfa-Gevaert Foto-Historama)

la Loire à Orléans.

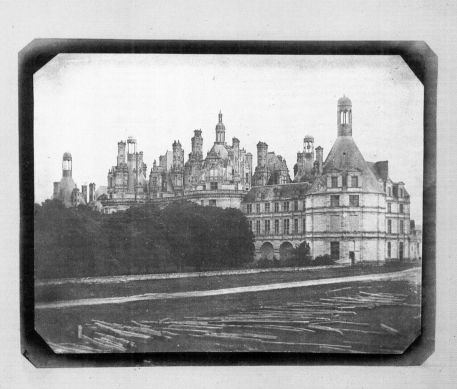

le Château de Chambord
en Juin 1843

Talbotype Paper Negative by Edouard Baldus
Paper was coated with silver nitrate and potassium iodide. Light sensitivity of the silver iodide compound was achieved with solutions of gallic acid and silver nitrate. By applying these solutions a second time after exposure, the picture was developed. Heating the solution, rendered the image visible. The negative was fixed with potassium bromide and then rinsed. The negative shown, made in 1845, has been waxed to achieve greater transparency. (Agfa-Gevaert Foto-Historama)

Daguerreotype (1839 to approx. 1855)

Silvered copper plates were carefully cleaned with nitrous ether and placed in a box with iodine crystals. By means of iodine fumes a layer of light-sensitive silver iodide was obtained. After exposure, the picture was "developed" in mercury vapore (the vapors being created by heating mercury to 120–140 degrees Fahrenheit). Developing time: two to six minutes. The picture was fixed in a solution of sodium chloride or sodium thiosulphate ("hypo").

Ambrotype (1852 to approx. 1865)

Glass plates were coated with collodion and sensitized with a solution of silver nitrate. After exposure and development, the picture was fixed, as in the case of the Daguerreotype. The underexposed and underdeveloped negative was placed on a backing of black velvet or black paper so that it had the effect of a positive. Compared to Daguerreotypes, Ambrotypes could be produced much more cheaply.

Pannotype (1853 to approx. 1863)

The exposed emulsion was removed from the glass plate under water and transferred onto an oilcloth. The chemical process was the same as that of the Ambrotype. Advantage: As opposed to the fragile glass plate, the oilcloth was flexible.

Ferrotype (1853 to approx. 1920)

The light-sensitive substance was applied to a japanned tin plate. The process, after exposure, was similar to that of the Ambrotype, except for one major difference: the plate could be developed in the camera so that the picture was ready in three minutes. The Ferrotype was the first rapid photographic process.

Daguerreotype Camera by C. A. von Steinheil, Munich
This first small-format camera (a replica of the original built in 1839) could produce Daguerreotypes of 8^1/$_2$ × 11 mm
(1/$_3$'' × 1/$_2$'') for pieces of jewelry and medallions. The view finder of this camera shows the object in its actual size.
(Agfa-Gevaert Foto-Historama)

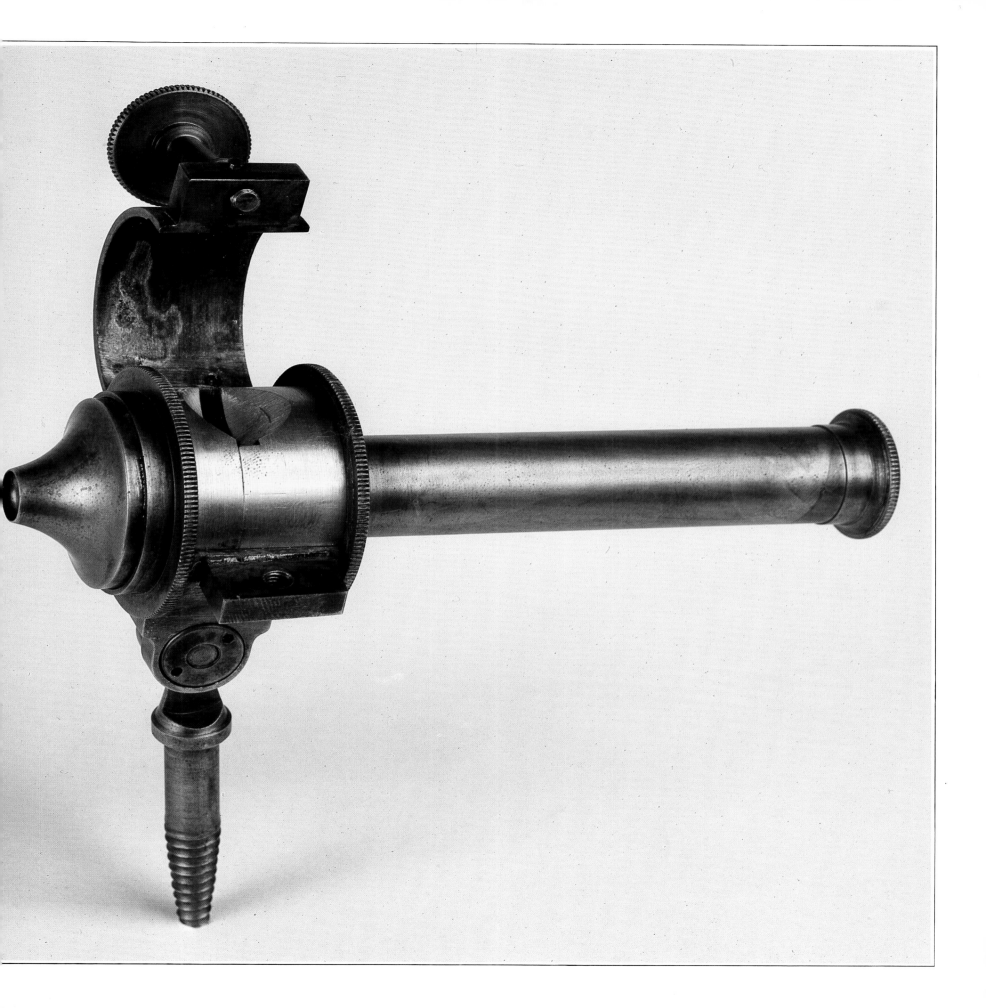

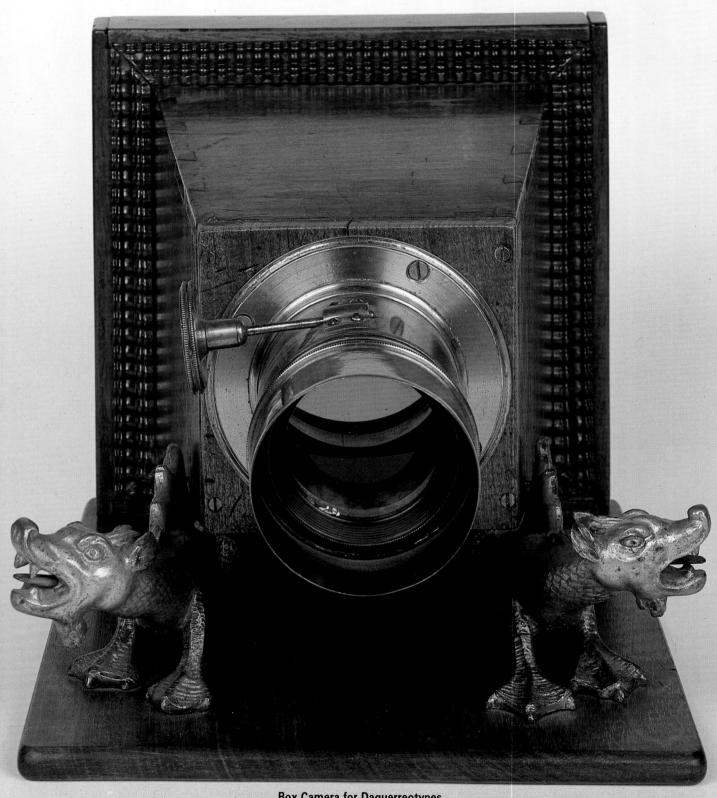

Box Camera for Daguerreotypes
Richly ornamented cameras such as this one could be found in the photo salons which gained particular popularity in the U.S.
(George Eastman House)

Sphinx and Pyramids by Maxime du Camp
A photo from the collection entitled "Egypt, Nubia, Palestine, and Syria," published in 1851. For the first time, pyramids were shown in their natural form and environment. Previously, their dimensions had often been grotesquely exaggerated by painters and engravers. The first major "printing plant"—Blanquart-Evrard in Lille—already produced for this book (format: 34 × 25 cm or 13¹/₃" × 9³/₄"; contents: 125 photographs) 200 to 300 prints per negative daily.
(Agfa-Gevaert Foto-Historama)

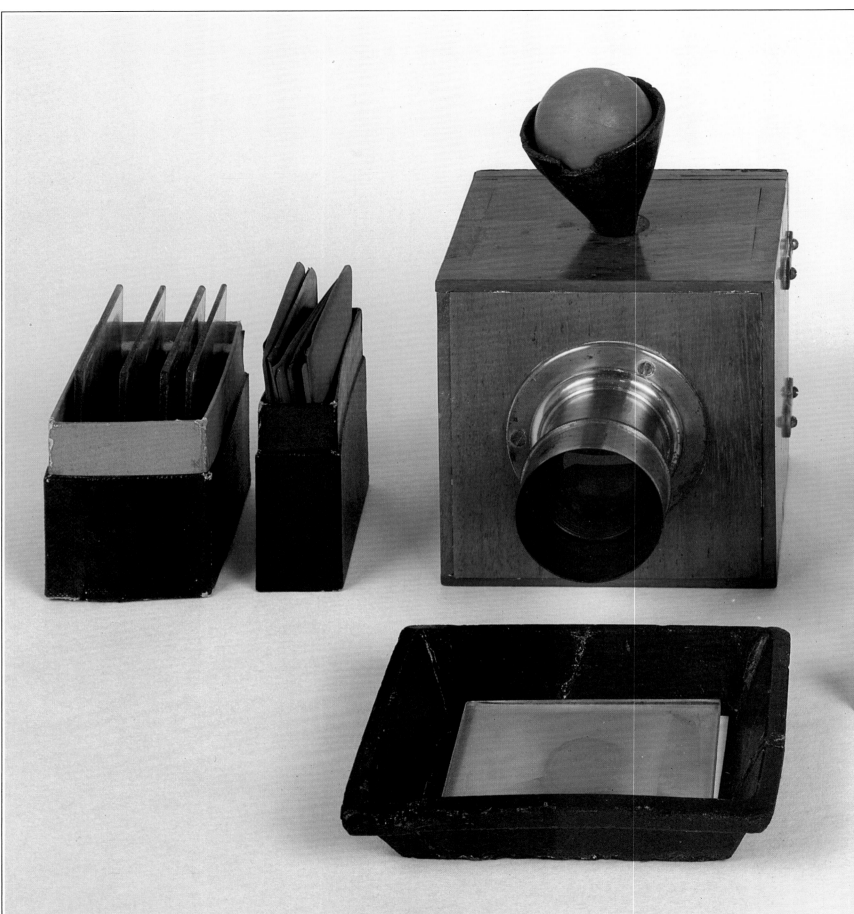

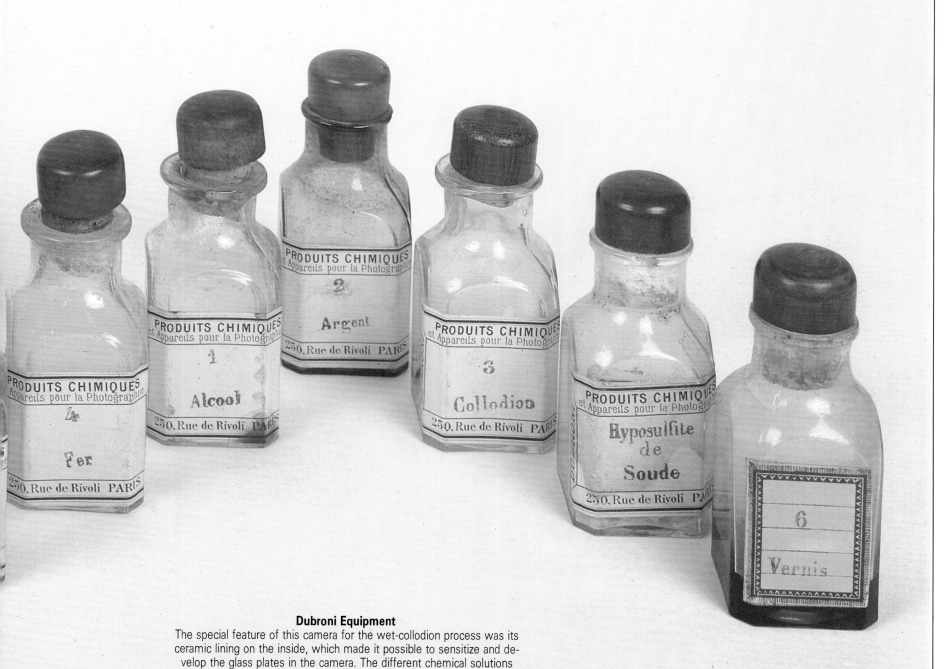

Dubroni Equipment
The special feature of this camera for the wet-collodion process was its ceramic lining on the inside, which made it possible to sensitize and develop the glass plates in the camera. The different chemical solutions were injected and siphoned off with a narrow glass tube (pipette). This method, invented by the engineer Bourdin in 1864, accelerated and simplified the complicated procedure of preparing the plates in the darkroom.
(Agfa-Gevaert Foto-Historama)

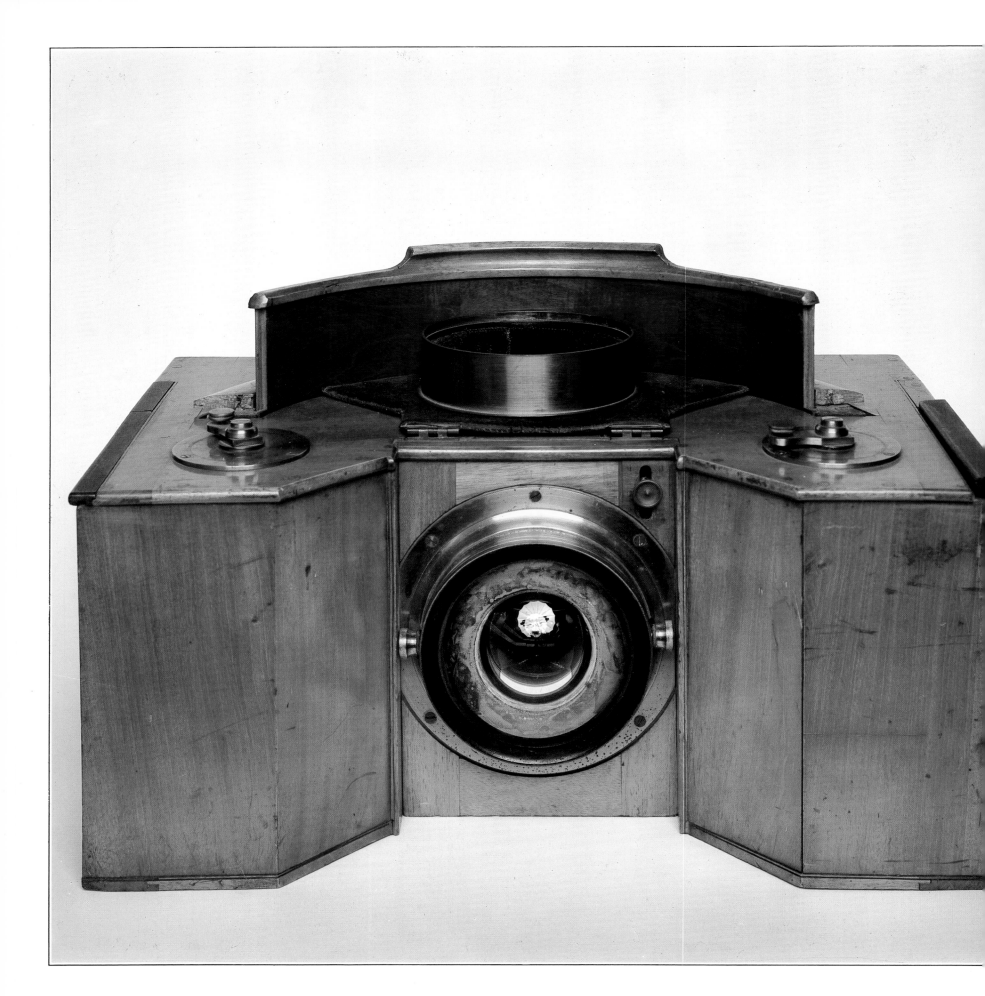

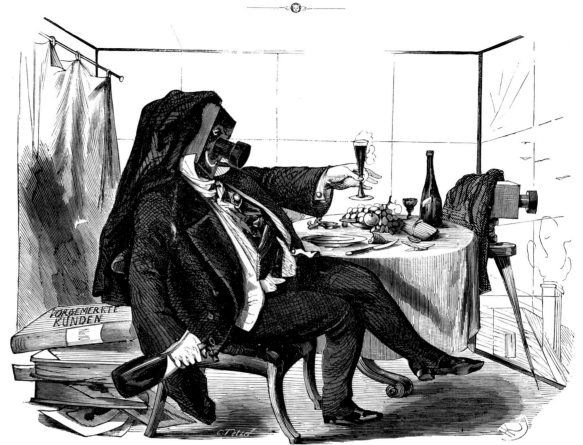

Sutton Panoramic Camera of 1860
The characteristic feature of this wide-angle-lens camera, developed by Thomas Sutton, an Englishman, is a hollow glass sphere filled with water (angle of view: 120 degrees) and a curved focal plane. The model was built by Paul Eduard Liesegang, Elberfeld (Germany), under license and was used to make pictures by the wet-collodion process. This camera is very rare today. (Deutsches Museum)

"As of today, the art of painting is dead."
Thus commented the French painter Paul Delaroche on the appearance of the first Daguerreotype. The caricatures on the right, dated 1865, recall a largely forgotten aspect of the advent of photography: portrait photographers made all the business, while portrait painters were no longer in demand.

"Things are not as bad as all that. Long live business!"

"No commission for two years! The devil take art!"

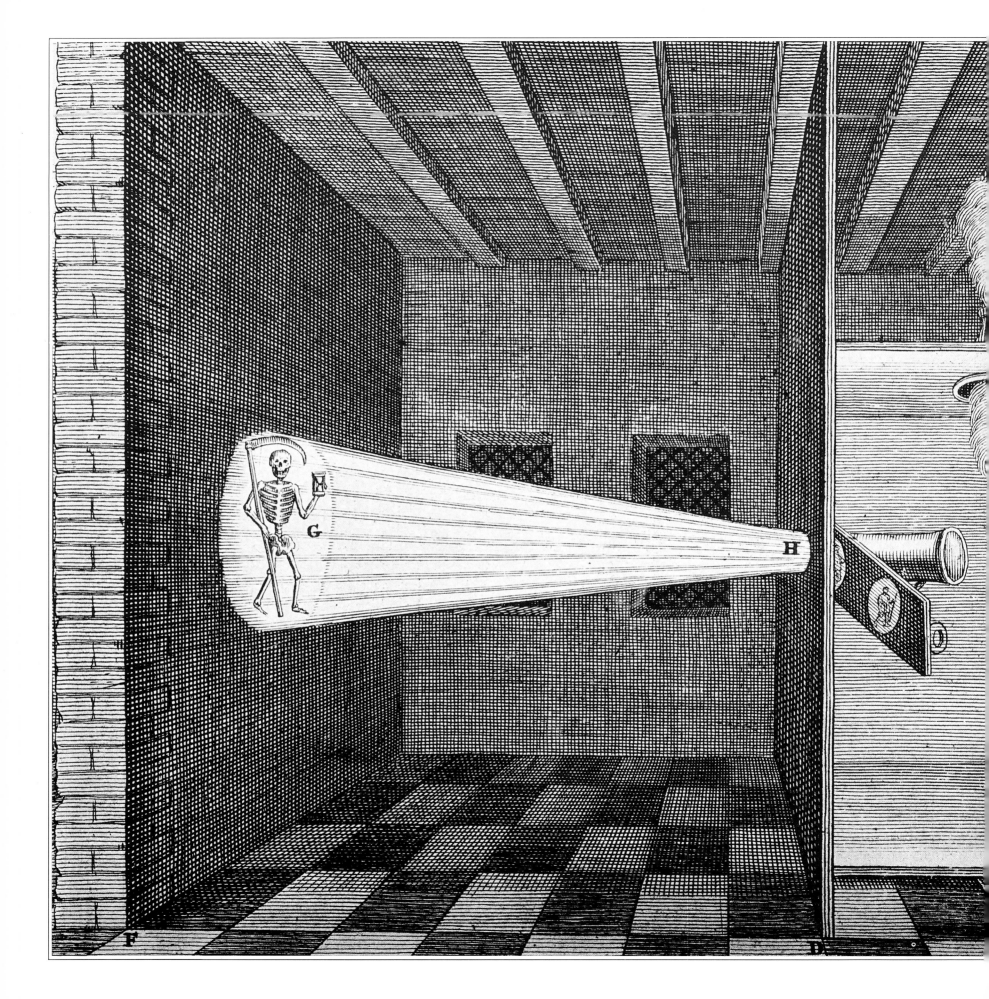

Laterna Magica. The magic lantern, forerunner of the motion picture projector, had been known in the seventeenth century, when it is said to have been invented by Father Athanasius Kircher, a Jesuit priest. Itinerant magic lantern showmen entertained the public on fairgrounds by projecting color-painted glass slides through the lantern.

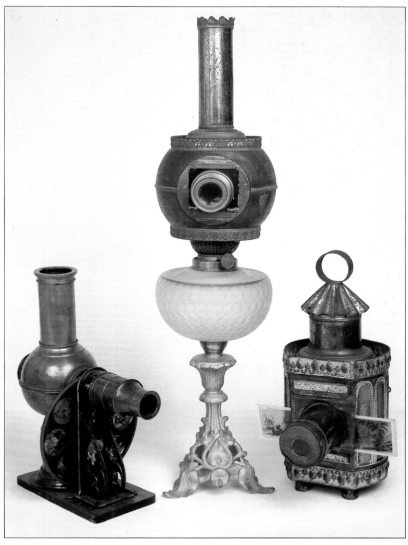

Laterna magica with paraffin lamp and rotating disc (circa 1870)
Laterna magica on paraffin lamp (circa 1870)
Laterna magica illuminated by a tallow candle (circa 1820)
(Agfa-Gevaert Foto-Historama)

Illustration of the Laterna Magica

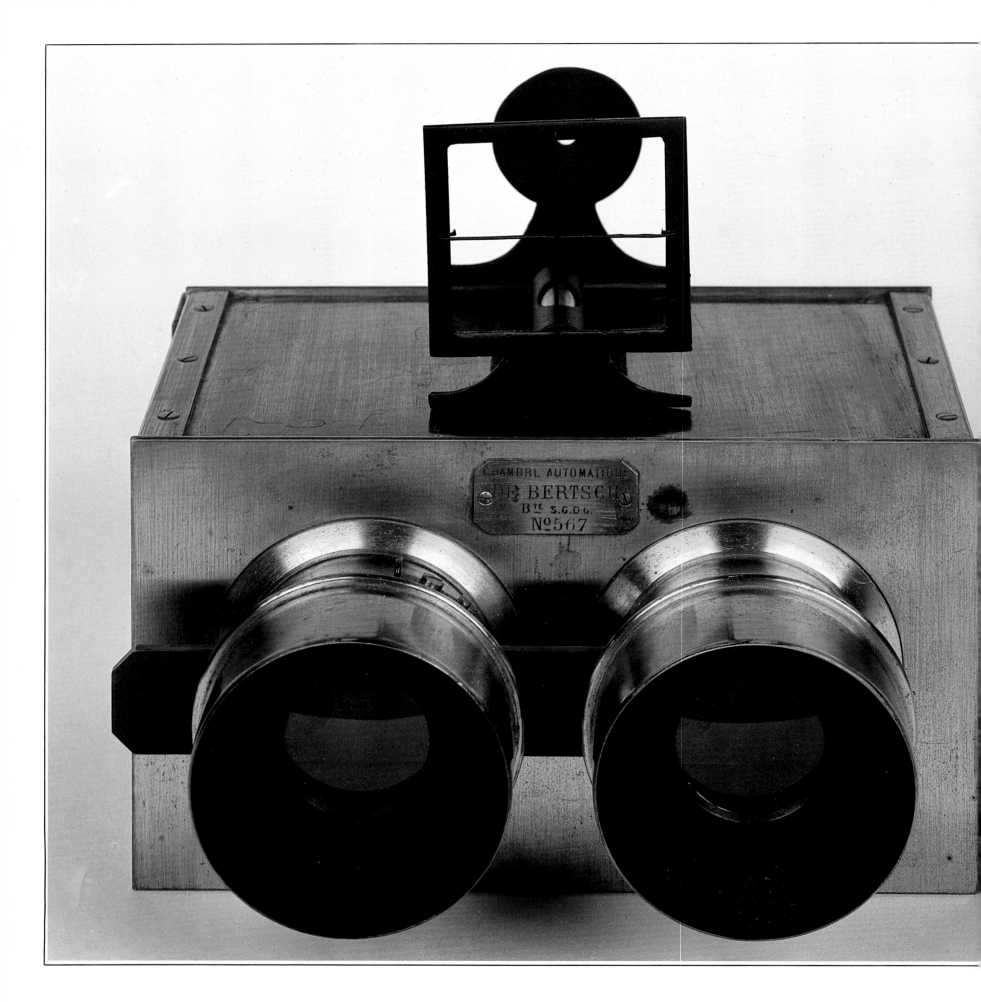

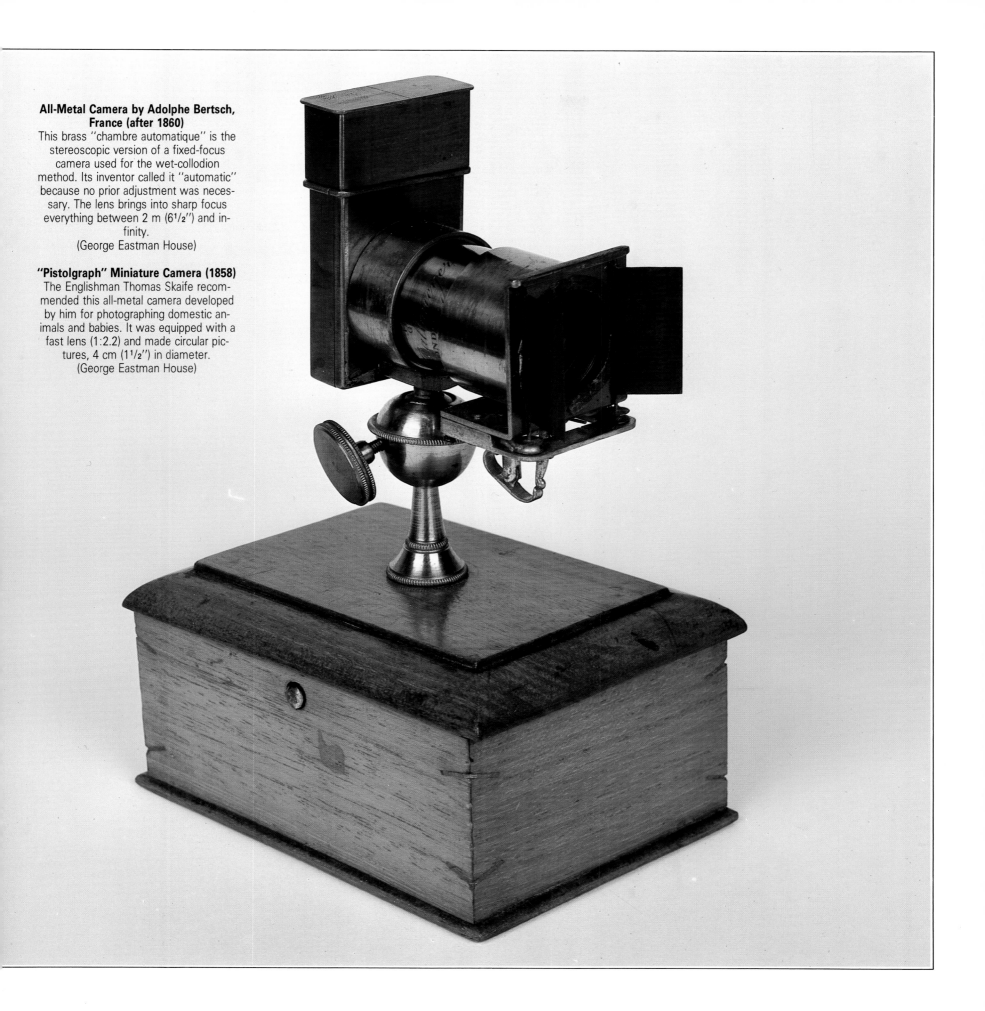

All-Metal Camera by Adolphe Bertsch, France (after 1860)
This brass "chambre automatique" is the stereoscopic version of a fixed-focus camera used for the wet-collodion method. Its inventor called it "automatic" because no prior adjustment was necessary. The lens brings into sharp focus everything between 2 m (6½") and infinity.
(George Eastman House)

"Pistolgraph" Miniature Camera (1858)
The Englishman Thomas Skaife recommended this all-metal camera developed by him for photographing domestic animals and babies. It was equipped with a fast lens (1:2.2) and made circular pictures, 4 cm (1½") in diameter.
(George Eastman House)

The Wet-Collodion Process. For thirty years (from 1851 to approx. 1880), photographers had a specific time problem. The glass plates, or wet plates, had to be sensitized, exposed while still wet, and developed on the spot. The light-sensitive emulsion, consisting of collodion coated with a silver nitrate solution, otherwise dried up within 20 minutes, thus becoming nearly insensitive to light. When working out of doors, the ''darkroom'' had to be transported in tents, handcarts, or horse-drawn carriage. Many famous photographs were made by way of this method, the advantage of which consisted in superior light sensitivity and the rendition of rich detail.

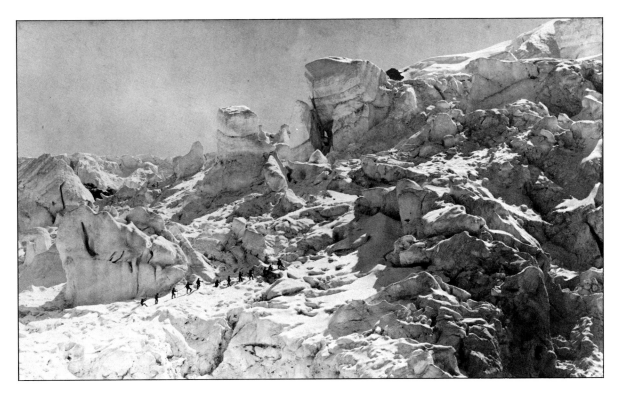

Alpine View by the Bisson Brothers
In order to make this photograph of the Mont Blanc in 1861, 25 men had to lug 550 pounds of equipment up the highest mountain of Europe. After reaching the peak, Auguste and Louis Bisson managed to make three pictures. The water needed was obtained by melting snow over an oil lamp. At the prevailing low temperature, however, the brothers had but a few minutes to process the pictures.
(Agfa-Gevaert Foto-Historama)

Bellows Camera for the Wet-Collodion Process
Built in England, this is one of the first cameras which could be folded. Plate size: 13 × 18 cm (5$\frac{1}{8}$'' × 6'')
(Kodak Museum)

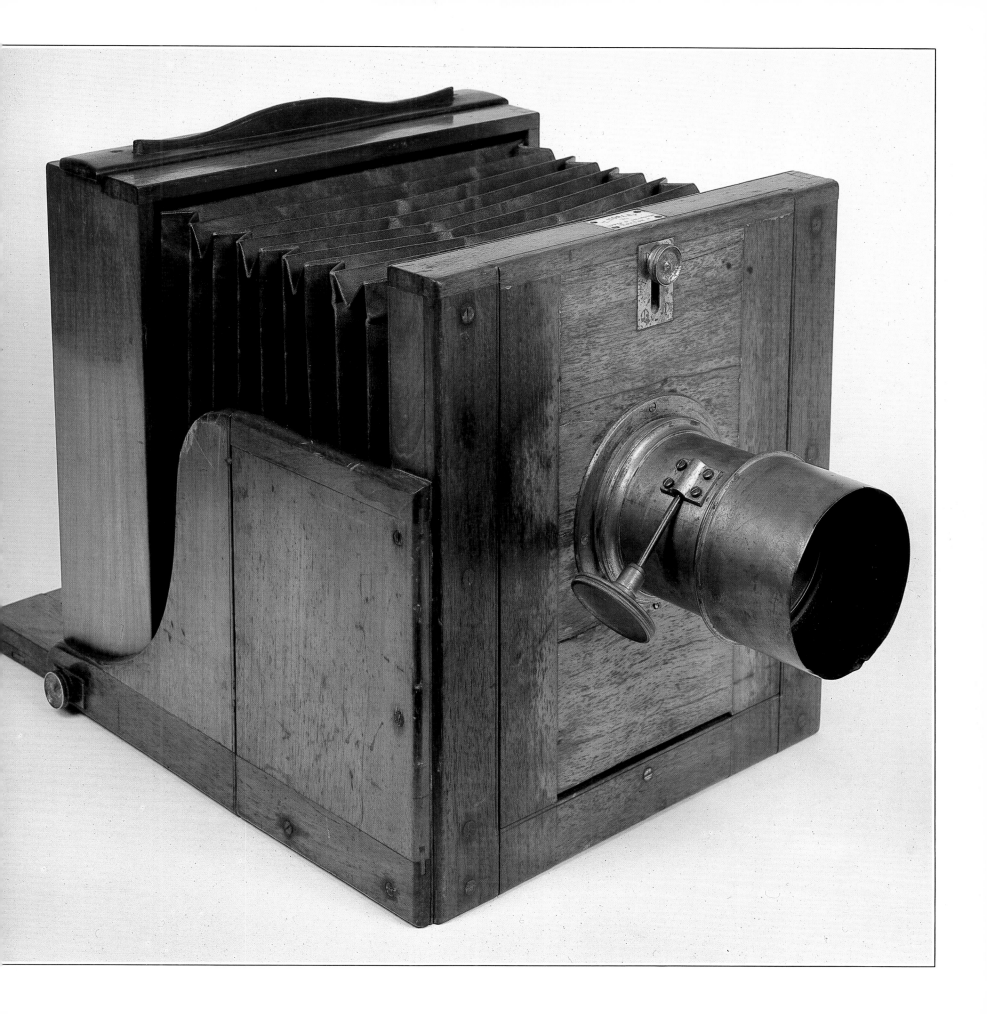

"Carte de visite" Photographs

Parisian photographer André Adolphe Disdéri had the idea for this kind of photograph and even had it patented in 1854. The enormous popularity of these pictures (6 × 9 cm or 2¹⁄₃″ × 3¹⁄₂″) not only gave rise to people exchanging photographs of each other but also to collecting those of famous personalities. The "carte de visite" photograph represented the "daily bread" to photographers until around 1910. The overwhelming demand for these fashionable little pictures resulted in the mass-production of the photographs and in the development of a special type of camera featuring four lenses, which could take four pictures either simultaneously or in rapid succession.
(Agfa-Gevaert Foto-Historama)

E. Encke Görlitz
Elisabeth Str. 10/11.

München Atelier Frankonia Gärtnerplatz 4.

Vilma Schubert STOLP i/Pom.
Blücherplatz 10.

Ph. Dürr GUMMERSBACH

C. Eigner Stallupönen.
Eydtkuhnen.

Ludwig Schradler & Sohn FÜSSEN
Augsburgerstr. 276.

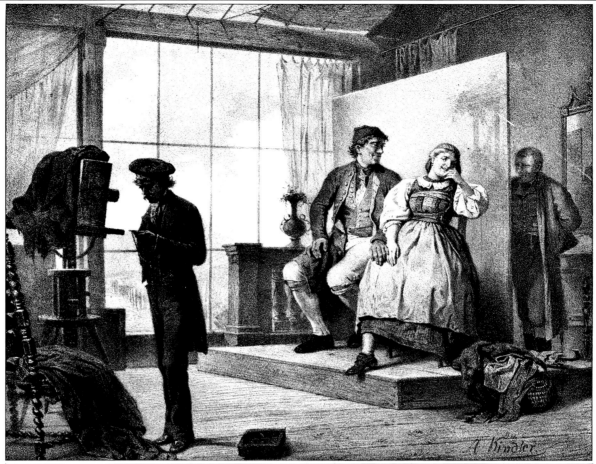

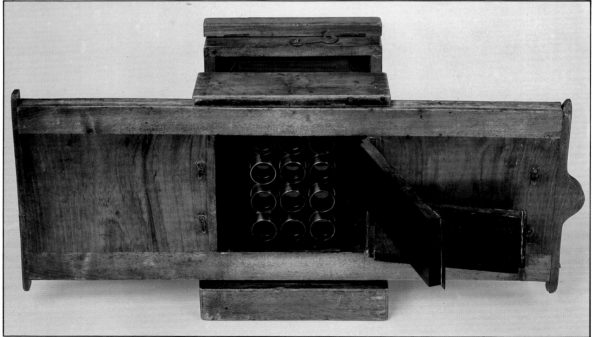

Ferrotype Camera of 1870
This instrument could make either six or 12 photographs simultaneously on one plate (6 × 12 cm or 2¹/₃″ × 3¹/₂″). The sliding front also acted as shutter.

Ferrotype Camera by Eugen Faller, Paris (circa 1900)
After exposure, the plates were developed and fixed in the tank attached to the bottom of the camera. Processing time: two minutes.
(Agfa-Gevaert Foto-Historama)

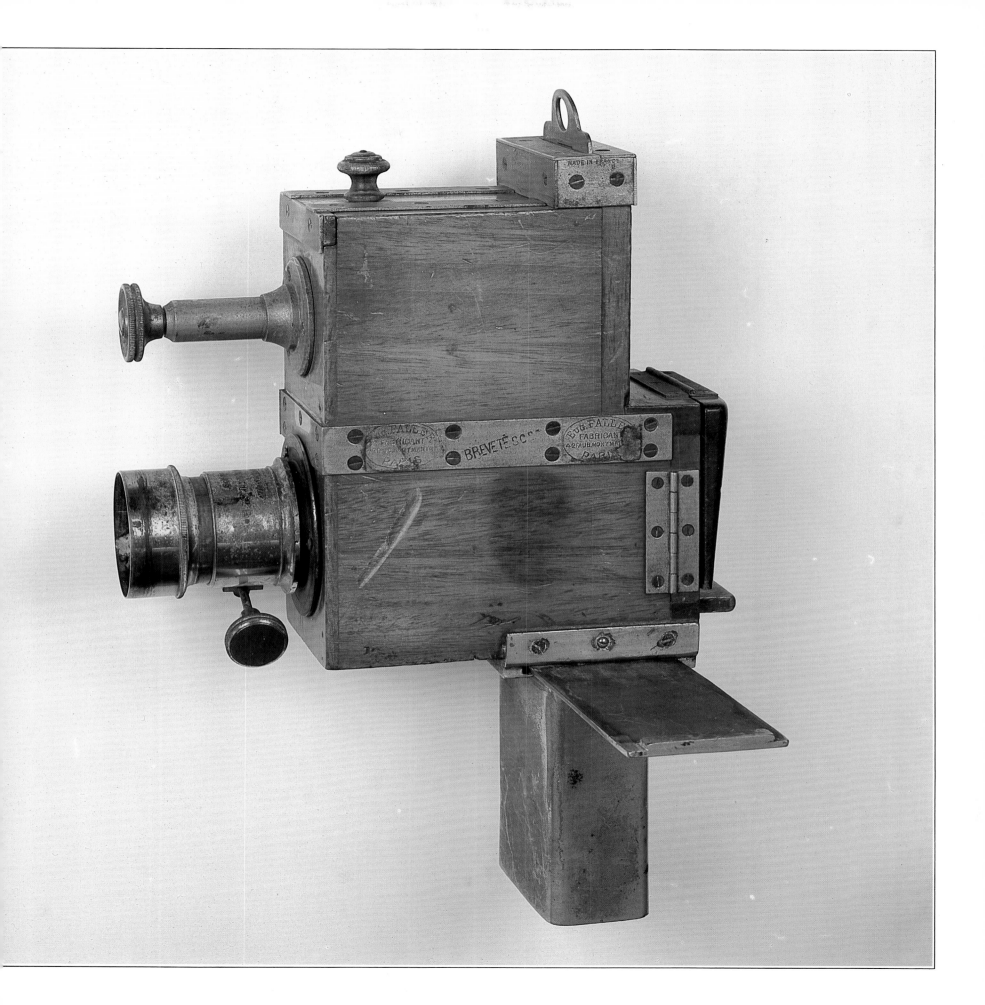

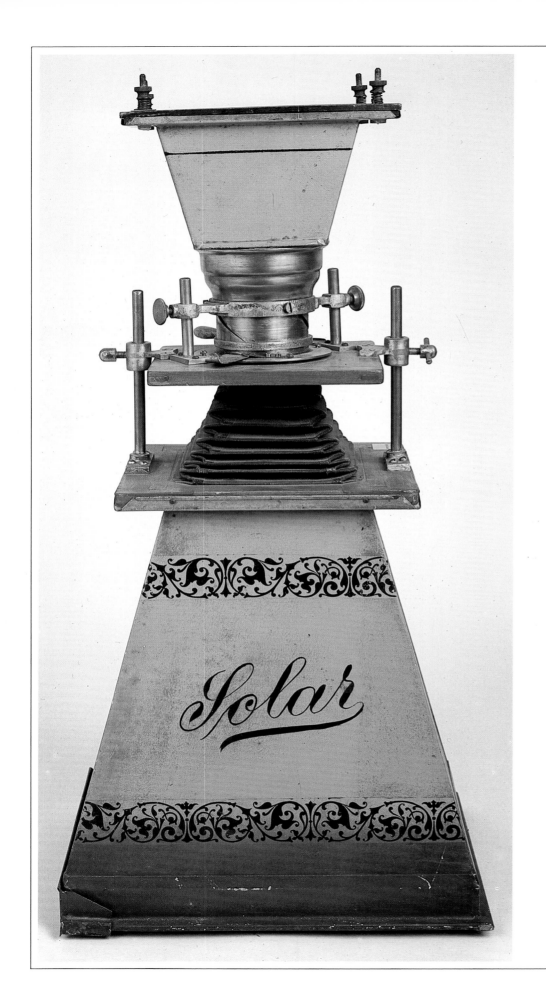

The Darkroom. If the recording of an image took about half of the photographer's time, the other half was spent in the darkroom—in the early beginnings as well as today. In the glimmer of oil lamps, photographers bustled about with chemicals, vises, and contact frames. Many famous photographers made their own enlargements, although the first public "processing plants" had already sprung up in the mideighteen hundreds.

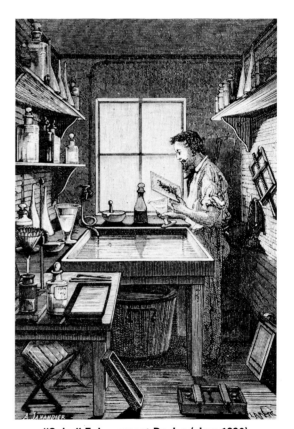

"Solar" Enlargement Device (circa 1890)
Produced by Eduard Liesegang, this apparatus could make enlargements on paper at full daylight. The process of enlargement was controlled by a flap on the side.
(Agfa-Gevaert Foto-Historama)

Photograph on Albumen-Coated Paper
The first commercial photographic paper was produced by an albumen-paper manufacturer in Dresden (Dresdner Albuminpapierfabrik) in the sixties and seventies of the last century and necessitated 60,000 eggs per day. The white of egg was poured onto the paper so that a smooth surface might be obtained. Subsequently, the paper was sensitized by submersion in a bath of silver nitrate. Most of these pictures were later painted over and sold as "middle class" portraits, thus providing miniature painters with a way to earn a living.
(Agfa-Gevaert Foto-Historama)

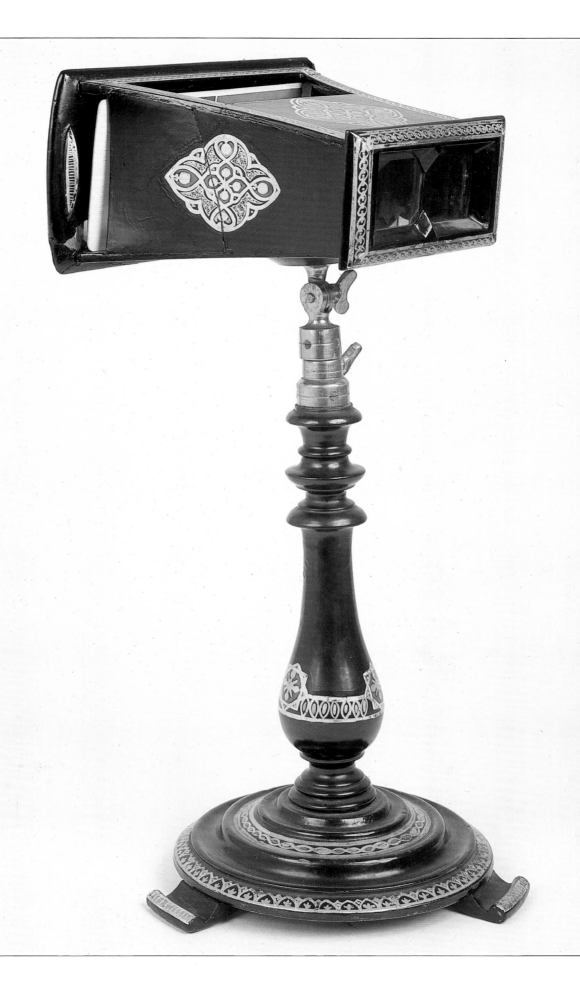

<u>The Third Dimension.</u> While photography was still in its infancy, the two-dimensional picture already no longer satisfied. In 1849, Sir David Brewster introduced the binocular camera for taking stereoscopic (or two slightly dissimilar) photographs, the two lenses being arranged side by side and separated by the same distance as a pair of human eyes (approx. 2$\frac{1}{2}$''). When the two pictures thus taken at slightly different angles were viewed through a stereoscope, the mind blended them into a single image, giving the illusion of depth as in 3D. The success was phenomenal. The stereoscope soon became part of every middle-class household.

Stereoscope (circa 1870) with Stereo Cards
(Agfa-Gevaert Foto-Historama)

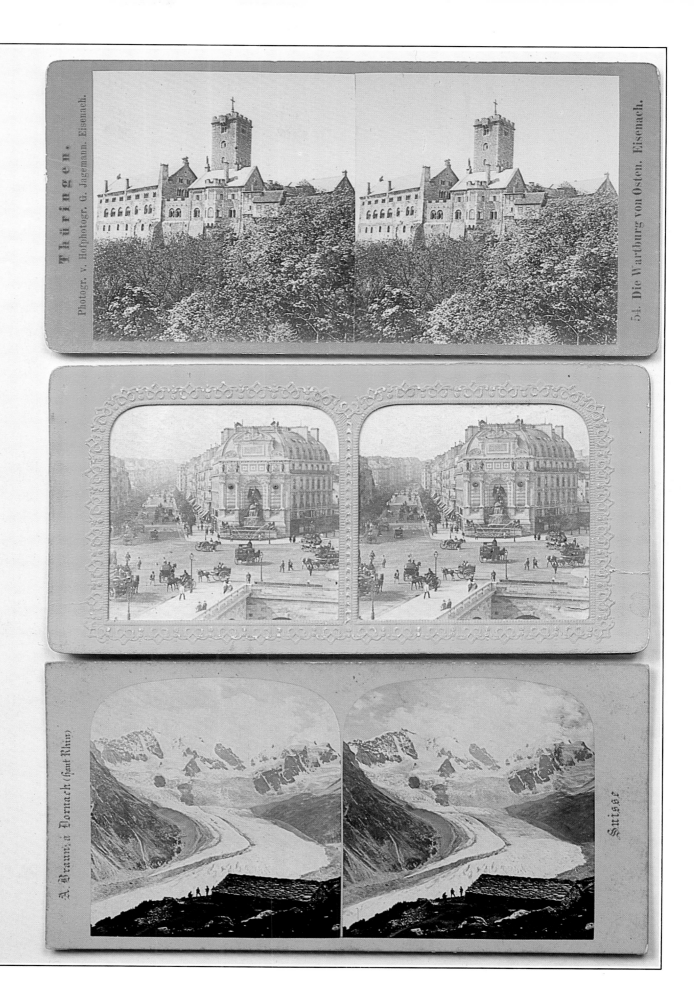

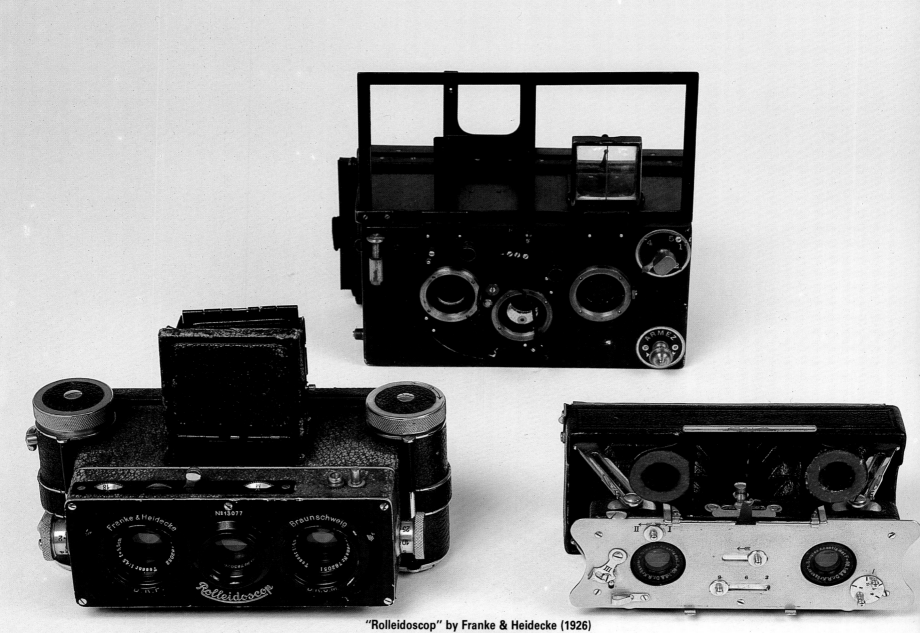

"Rolleidoscop" by Franke & Heidecke (1926)
"Stereo Panoramique" by Leroy (1906)
"Plastoscop" by Dr. Krügener (1900)
(Agfa-Gevaert Foto-Historama)

Folding Stereoscopic Camera by Ernemann, Dresden (circa 1910)
(Museum of Technology)

Stereoscopic models were built of nearly all camera types—from the time of the Daguerreotype via the wet-collodion method to the final roll film. Small-format cameras were equipped with special stereoscopic attachments.

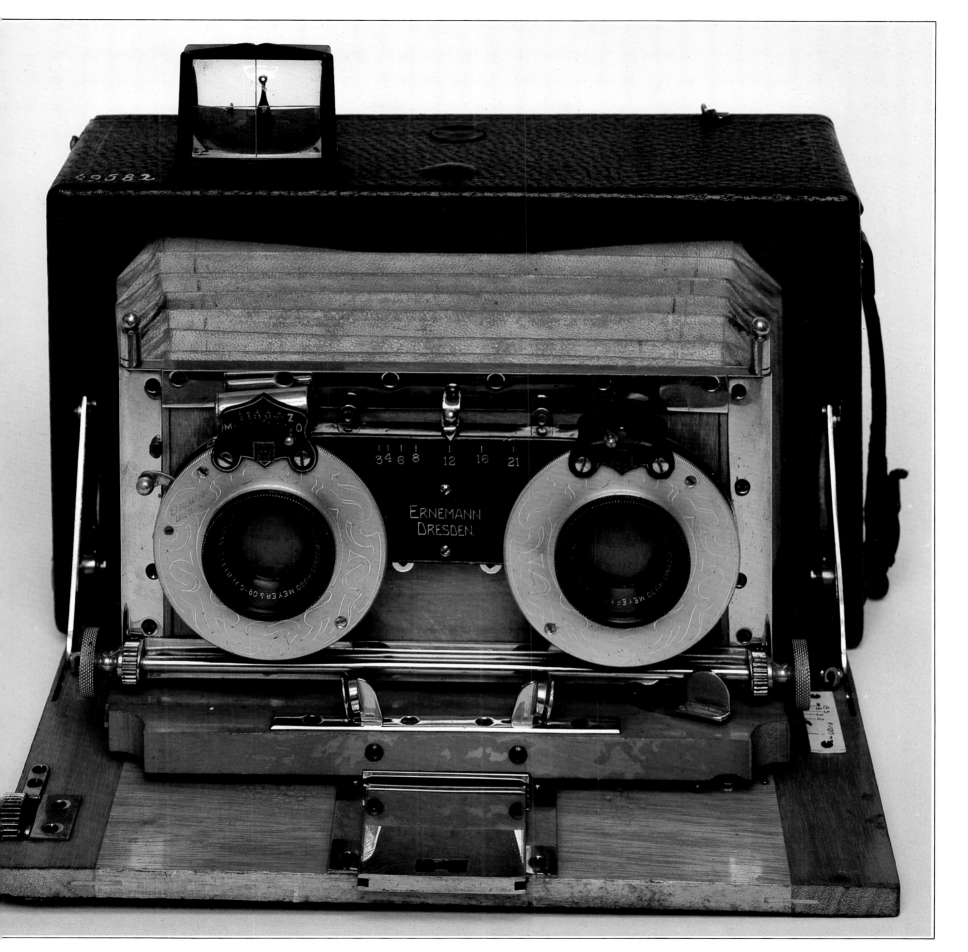

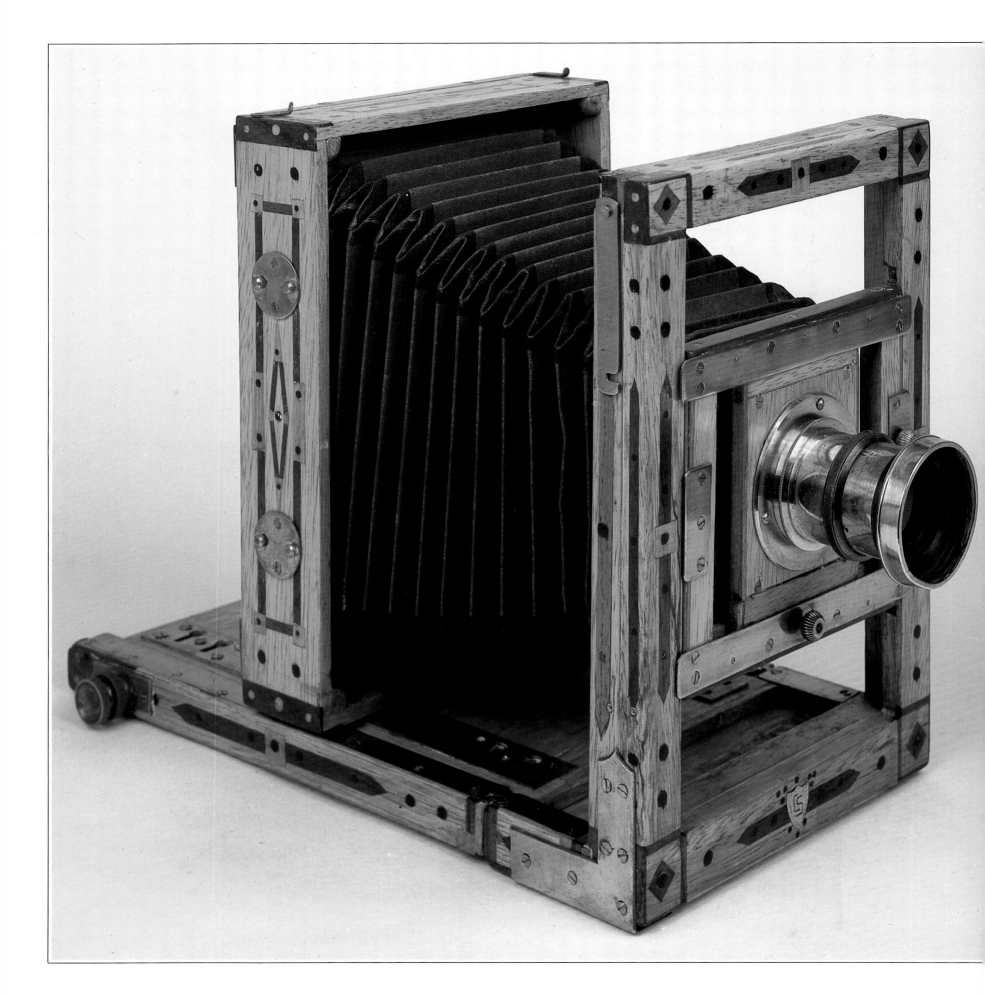

The "Clean" Method. An English doctor, Richard Leach Maddox, had lost his patience: the wet-collodion process was, after all, a messy affair—and in 1871 developed the dry plate, with its sensitive emulsion held in place by a layer of fast-drying gelatin (silver bromide). The plates could now be prepared ahead of time and, therefore, be mass-produced. Due to the simplified operation, the introduction of the dry plate provided the impetus for the production of easily manageable cameras on a larger scale.

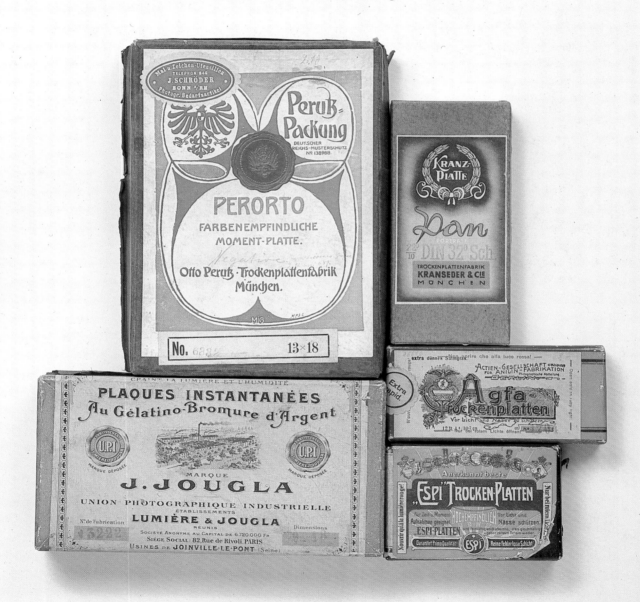

Wooden Field Camera with Inlaid Work (13 × 18 cm or 5¹/₈″ × 6″; 1870)
This model is a typical field camera in that it is foldable. Cameras of this kind were built until approximately 1920. As a rule, they were made by camera craftsmen in small carpenter's shops.
(Agfa-Gevaert Foto-Historama)

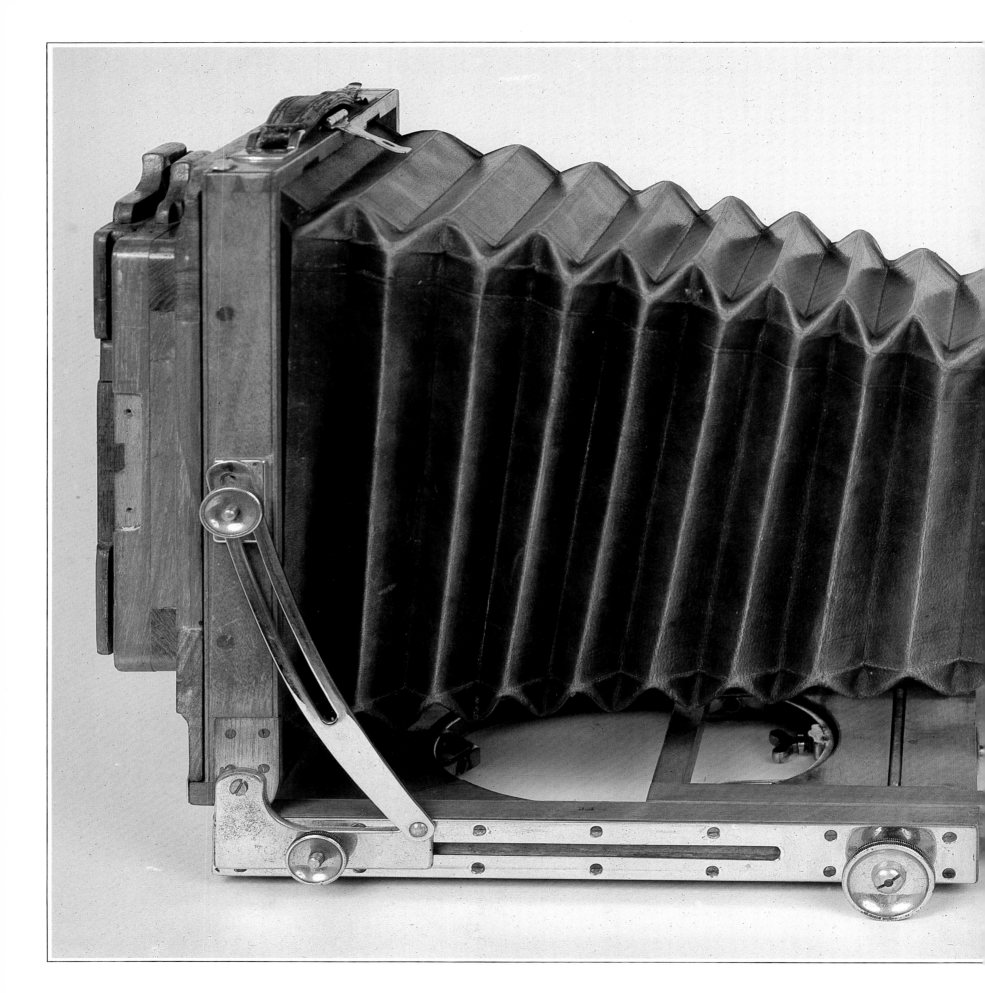

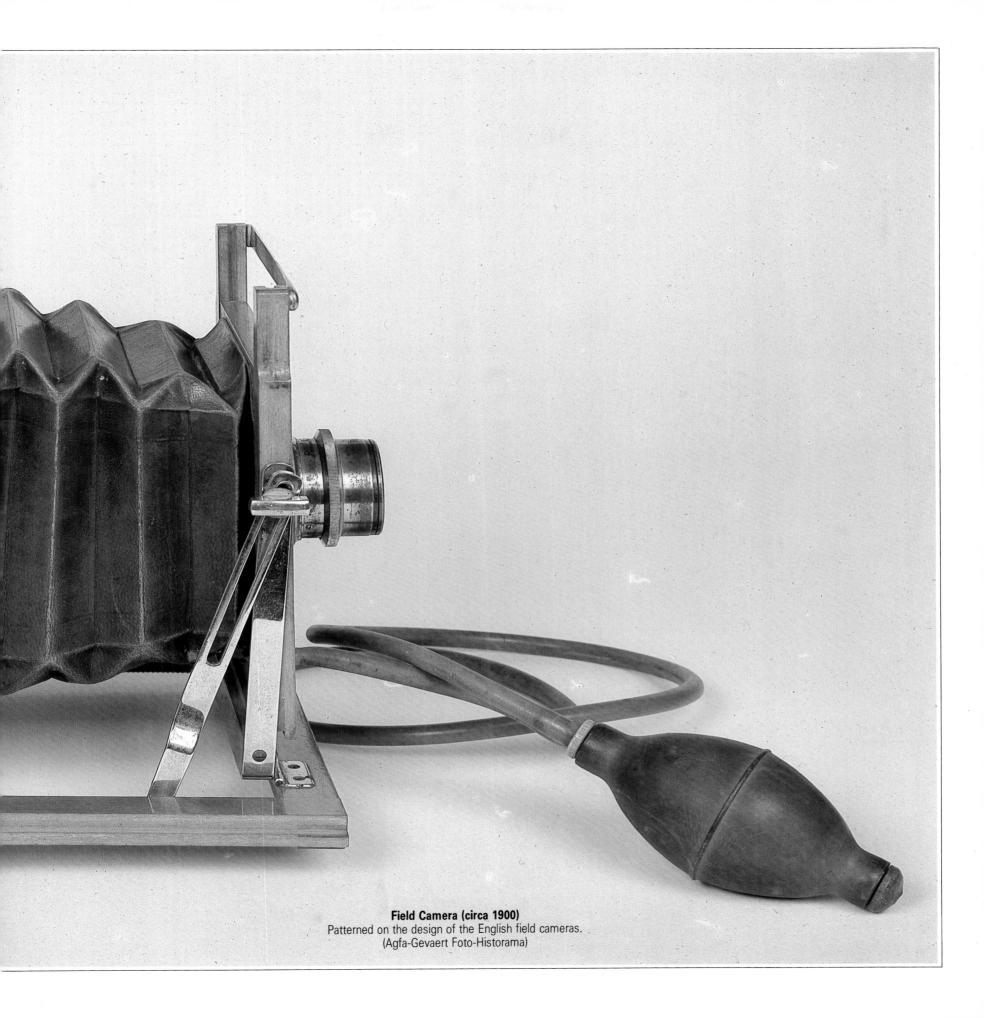

Field Camera (circa 1900)
Patterned on the design of the English field cameras.
(Agfa-Gevaert Foto-Historama)

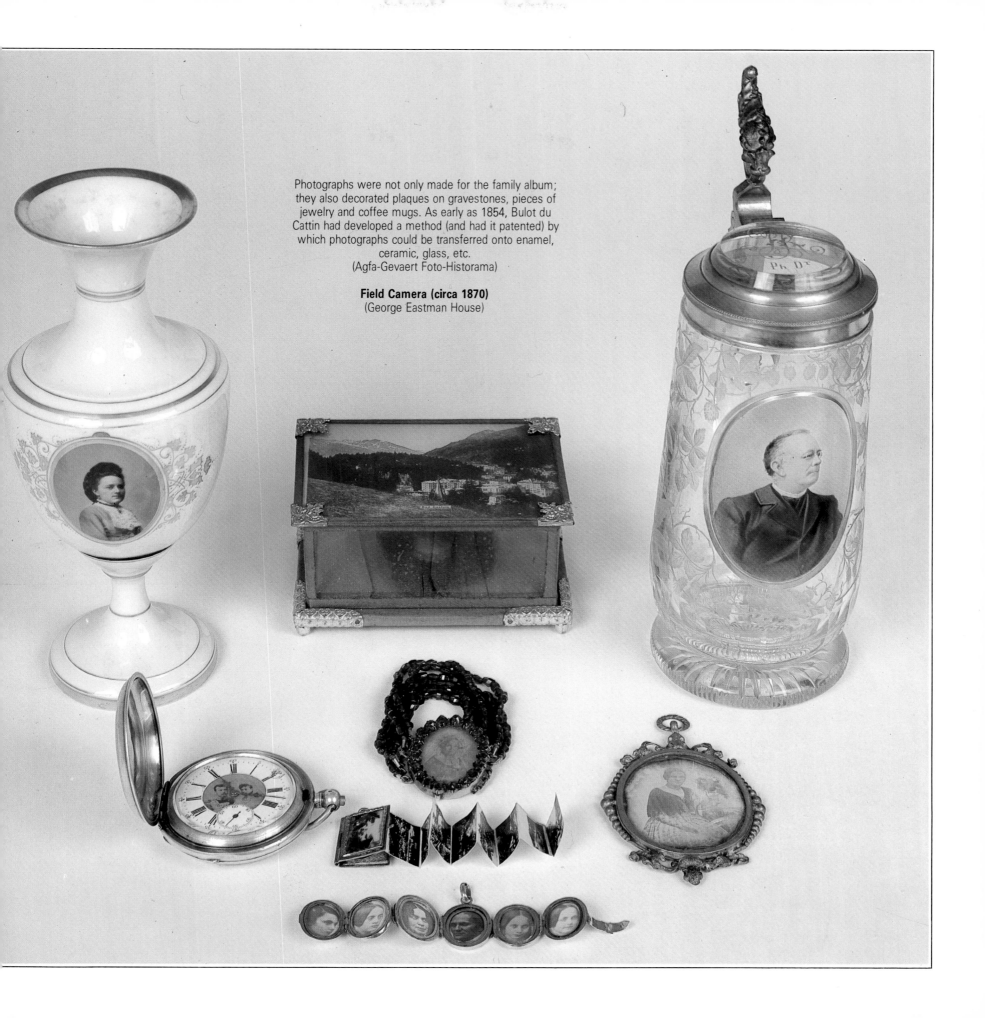

Photographs were not only made for the family album; they also decorated plaques on gravestones, pieces of jewelry and coffee mugs. As early as 1854, Bulot du Cattin had developed a method (and had it patented) by which photographs could be transferred onto enamel, ceramic, glass, etc.
(Agfa-Gevaert Foto-Historama)

Field Camera (circa 1870)
(George Eastman House)

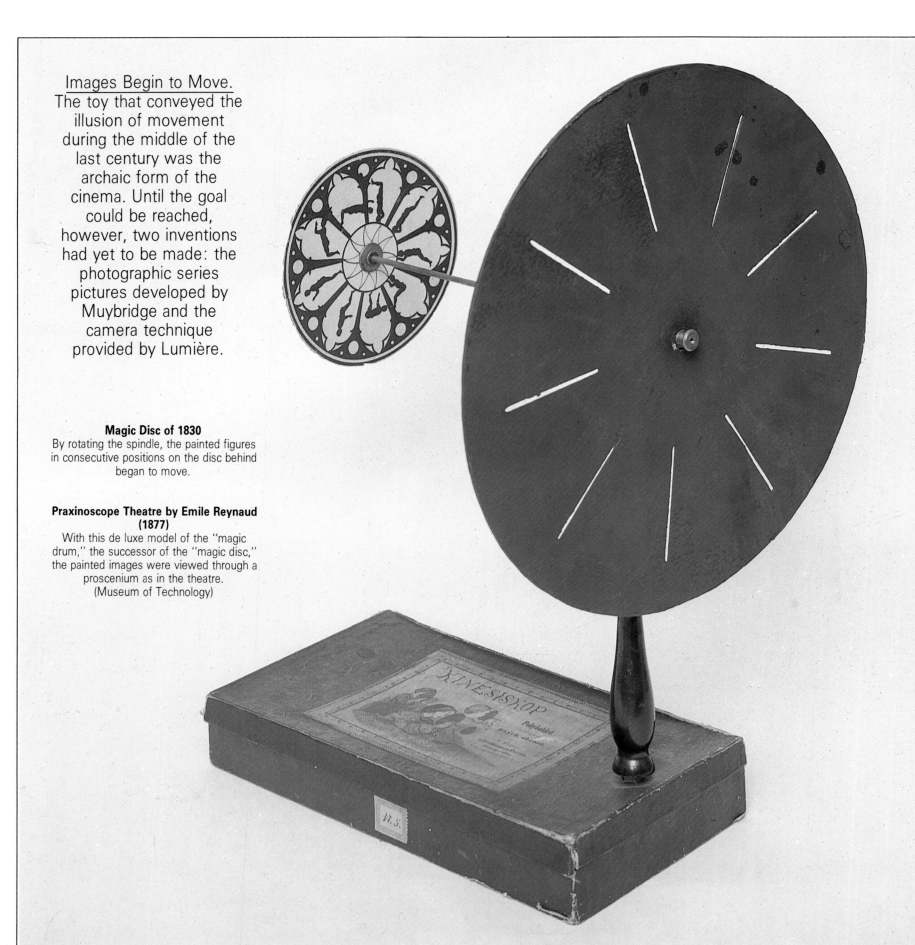

Images Begin to Move.
The toy that conveyed the illusion of movement during the middle of the last century was the archaic form of the cinema. Until the goal could be reached, however, two inventions had yet to be made: the photographic series pictures developed by Muybridge and the camera technique provided by Lumière.

Magic Disc of 1830
By rotating the spindle, the painted figures in consecutive positions on the disc behind began to move.

Praxinoscope Theatre by Emile Reynaud (1877)
With this de luxe model of the "magic drum," the successor of the "magic disc," the painted images were viewed through a proscenium as in the theatre.
(Museum of Technology)

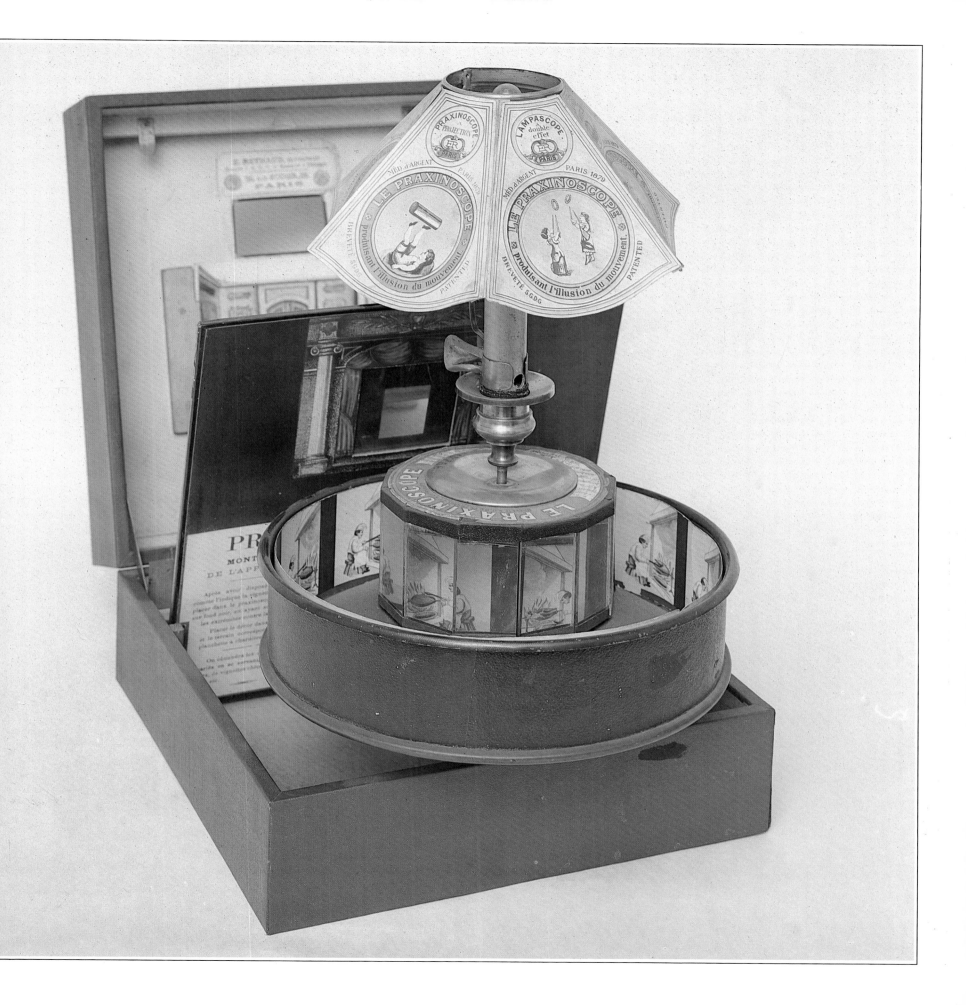

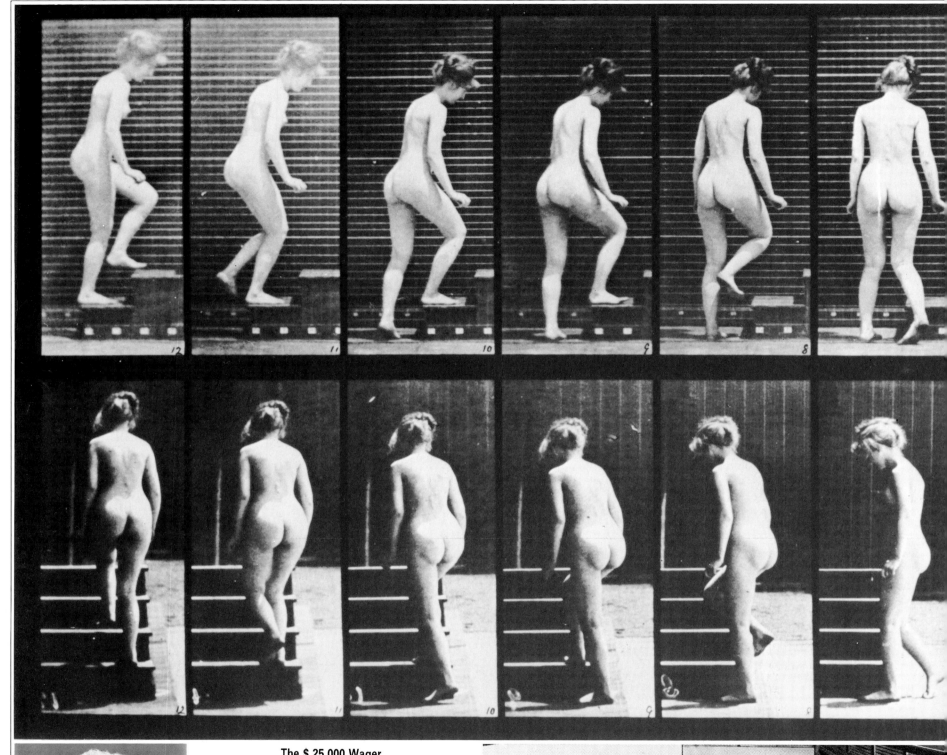

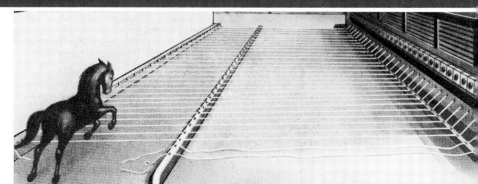

The $ 25,000 Wager
The governor of California made this bet with a horse-lover friend of his. He claimed that a galloping horse at certain moments had all four legs off the ground at the same time. In order to substantiate his claim by way of photographs, he asked Edward Muybridge in 1872 to take consecutive pictures of galloping horses. Thus the first series photographs were made, and Muybridge soon perfected his method to illustrate progressive movement with the camera. The photographic sequences were made by a series of ten to 30 separate cameras which were released by the hoofs of the horse.

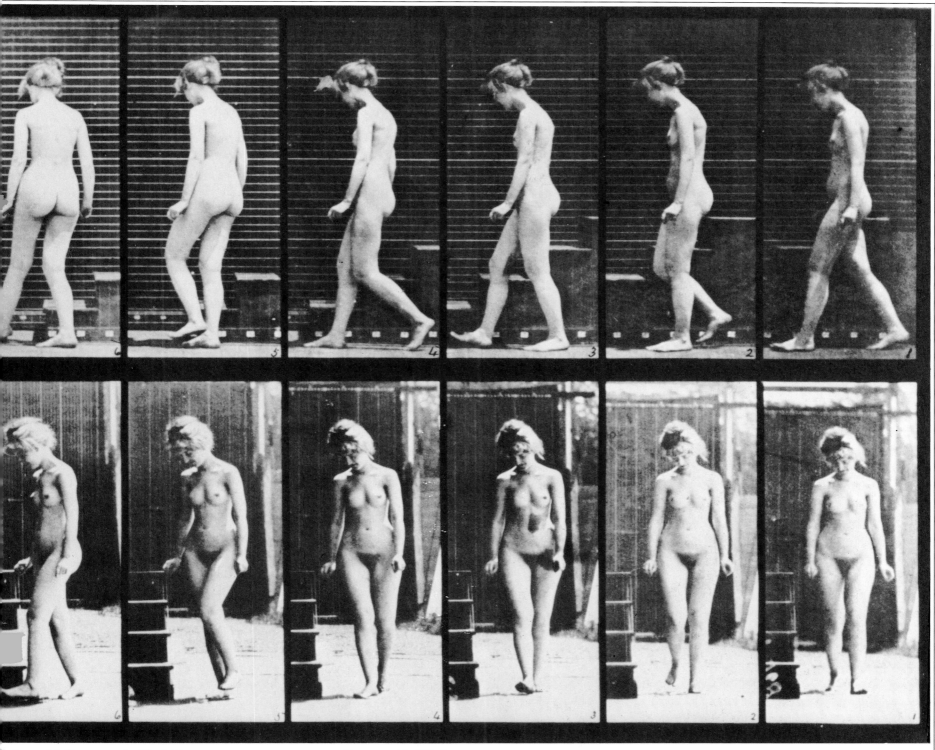

Photographic Sequences by Muybridge

Photographic Rifle by Etienne Jules Marey

With this device Professor Marey of Paris took photographs in rapid succession of human beings and animals for scientific purposes (1882). The camera was designed to take 12 exposures on one glass plate.

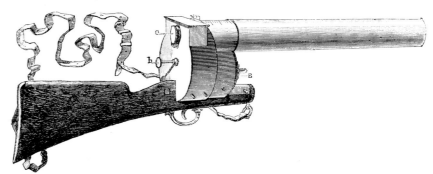

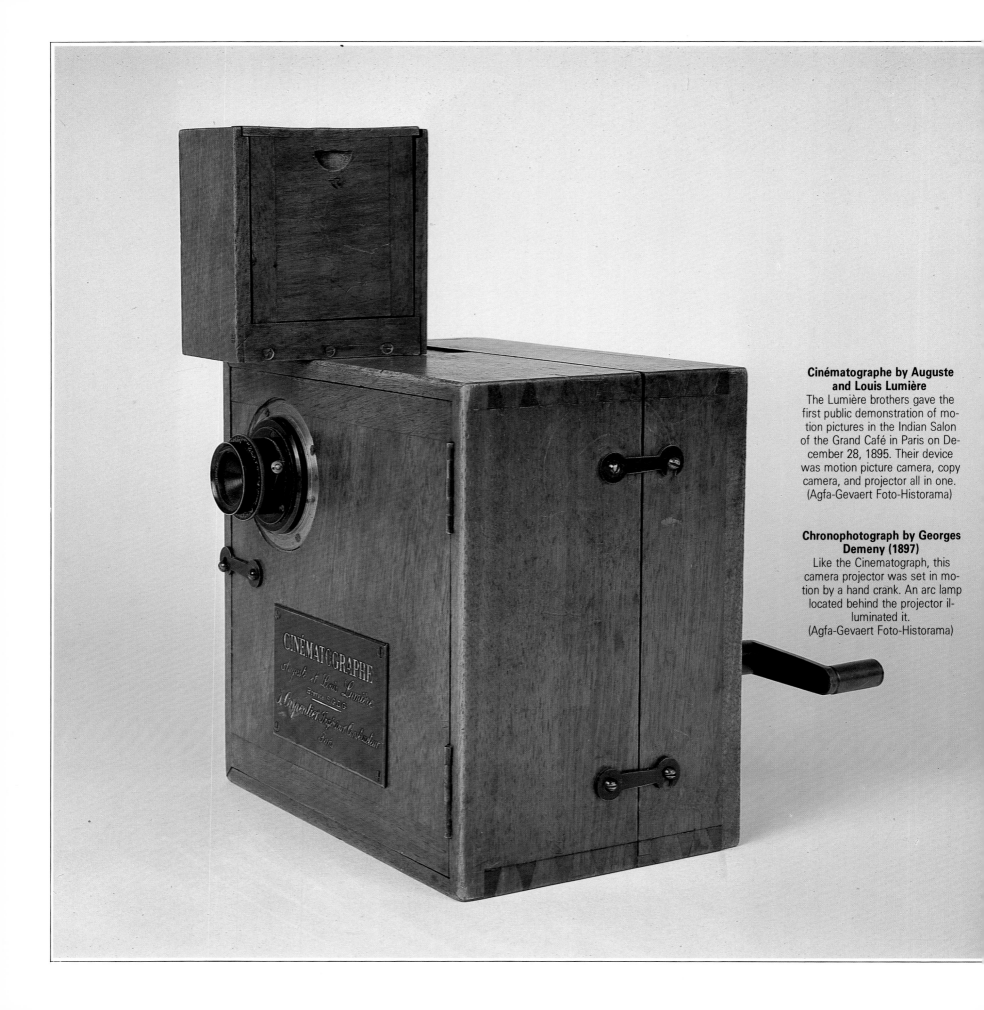

Cinématographe by Auguste and Louis Lumière
The Lumière brothers gave the first public demonstration of motion pictures in the Indian Salon of the Grand Café in Paris on December 28, 1895. Their device was motion picture camera, copy camera, and projector all in one.
(Agfa-Gevaert Foto-Historama)

Chronophotograph by Georges Demeny (1897)
Like the Cinematograph, this camera projector was set in motion by a hand crank. An arc lamp located behind the projector illuminated it.
(Agfa-Gevaert Foto-Historama)

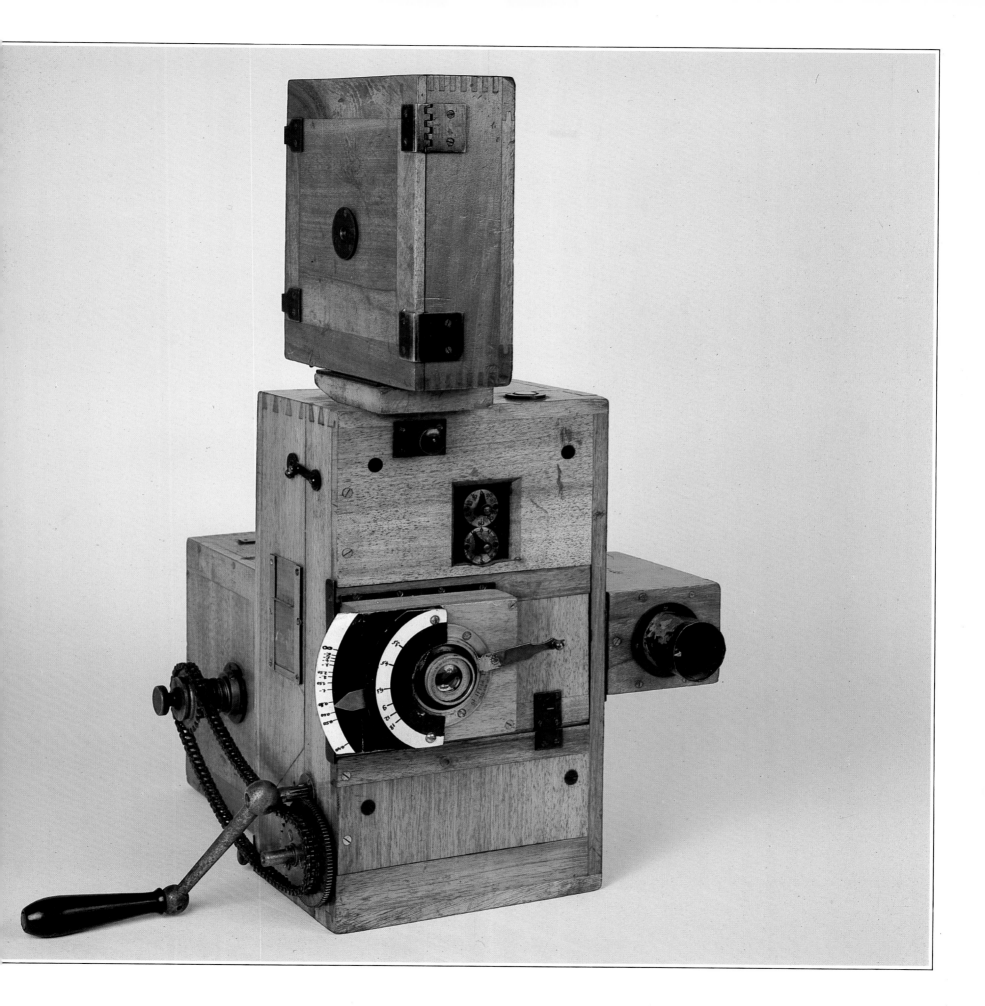

A Picture for 50 Pfennig.*
A photograph made by the
"coins-in-the-slot" automatic
camera was that costly. Since 1890,
one could take one's own picture
at fairgrounds and amusement
parks. The Bosco automatic device
made it possible.
* approx. $ 0.12

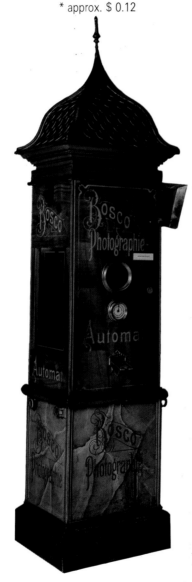

Bosco Automatic Camera by C. Bernitt, Hamburg (1894)
It took three minutes to make a picture. After exposure, the ferrotype was developed, fixed and rinsed automatically. The tin-plate photograph with its turned-up edges also served as developing and fixing tray.
(Deutsches Museum)

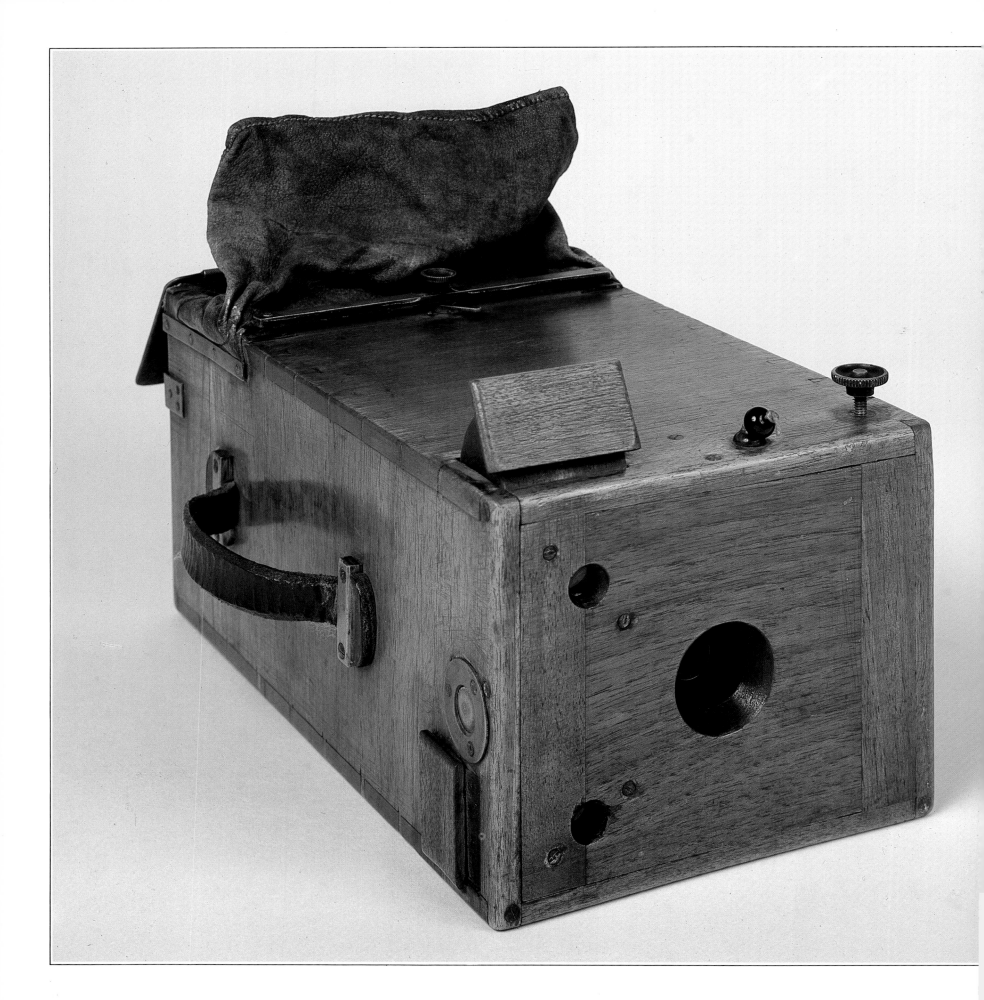

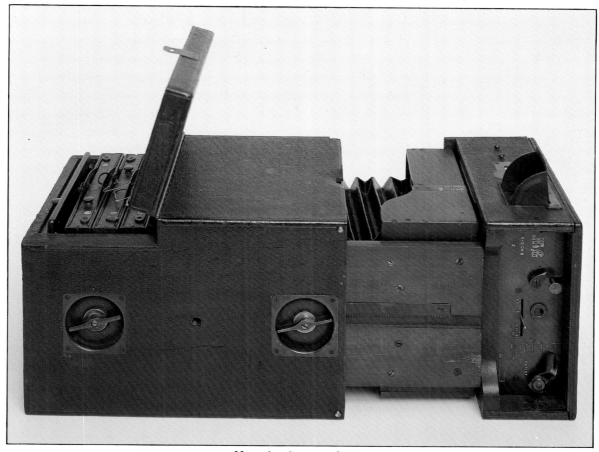

Magazine Camera of 1895
The extra-long bellows extension of this camera built by Newman & Guardia (London) made possible extreme close-up photographs. The lens could be swiveled to correct the image distortion.
(Wendel Collection)

Magazine Camera of 1892
The camera contains a magazine holding 12 plates of 9 × 12 cm (3¹/₂″ × 4³/₄″). After exposure, the individual plate was moved from front to back in the light-proof leather bag. This camera type was referred to as "detective camera" since it enabled the photographer to take pictures rather inconspicuously (hand-held) without the use of tripod and black cloth.
(Agfa-Gevaert Foto-Historama)

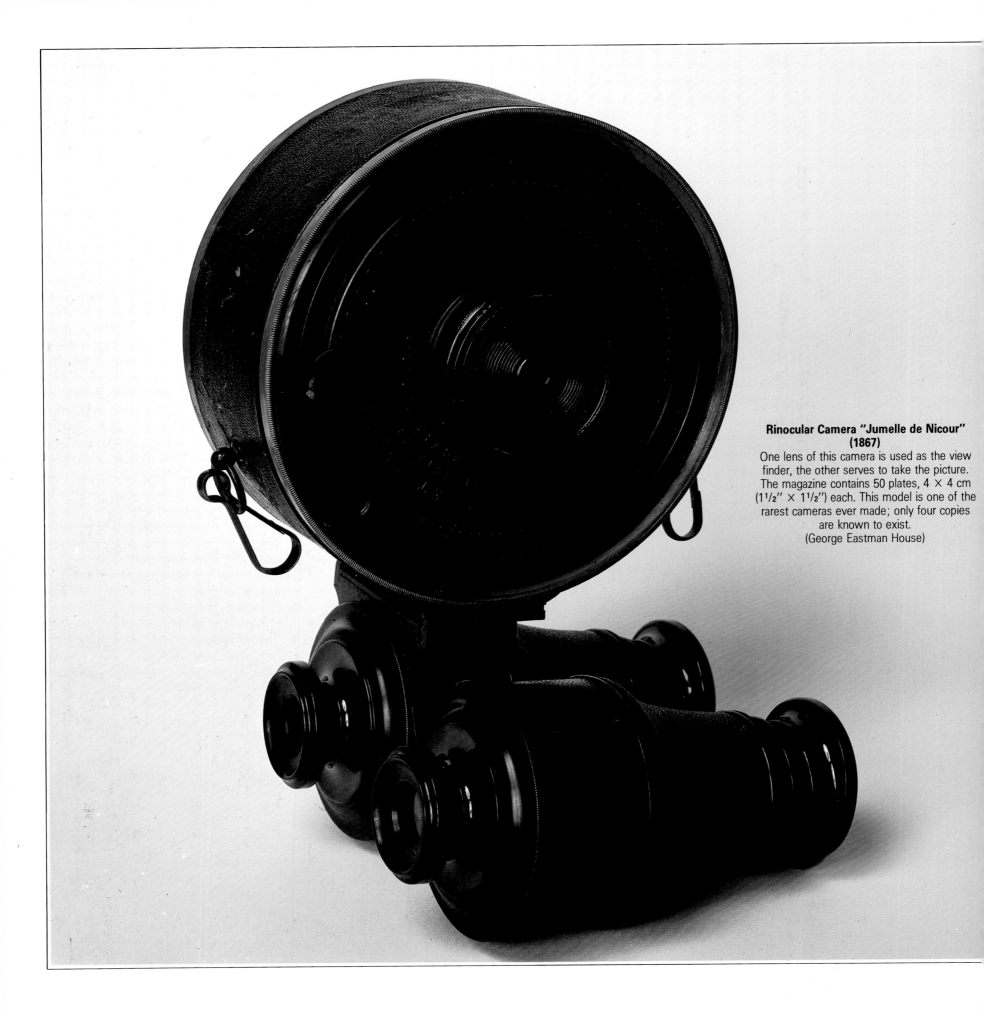

Rinocular Camera "Jumelle de Nicour" (1867)
One lens of this camera is used as the view finder, the other serves to take the picture. The magazine contains 50 plates, 4 × 4 cm (1¹/₂″ × 1¹/₂″) each. This model is one of the rarest cameras ever made; only four copies are known to exist.
(George Eastman House)

The Court-Photographer

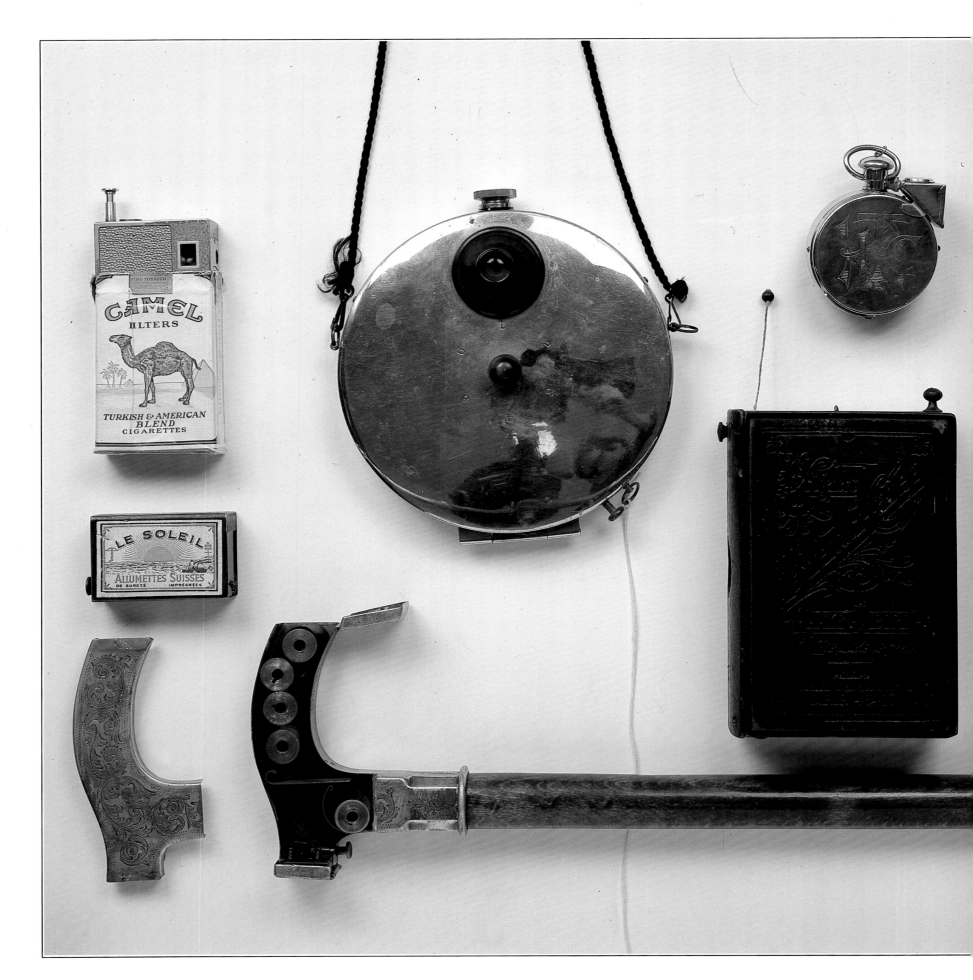

Detective Cameras. The invention of the dry plate resulted in a camera specialty which quickly gained in popularity. With cameras concealed in top hats, books, or walking sticks, candid shots could be made unperceived by the subject. The best-known of this type was the "Patented Detective Camera" by C. P. Stirn, which could take pictures through a buttonhole.

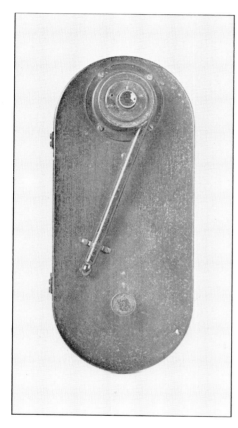

Photo Cravate
The most sophisticated way to take clandestine photographs was introduced by Edmond Bloch in Paris in 1890. The tie clip acted as the lens, which was attached to a small box containing six plates of 2.5 × 2.5 cm (1″ × 1″) size.
(Sterckshof Museum)

Photo Cravate
(Wendel Collection)

Matchbox Camera by Kodak (1943)
Camera in cigarette pack by Whittaker (1950)
"Ben Akiba" Photographic Cane (1903)
Buttonhole Camera by C. P. Stirn (1886)
"Ticka" Pocket-Watch Camera by Houghtons (1907)
Notebook Camera by Dr. Krügener (1888)
(Agfa-Gevaert Foto-Historama)

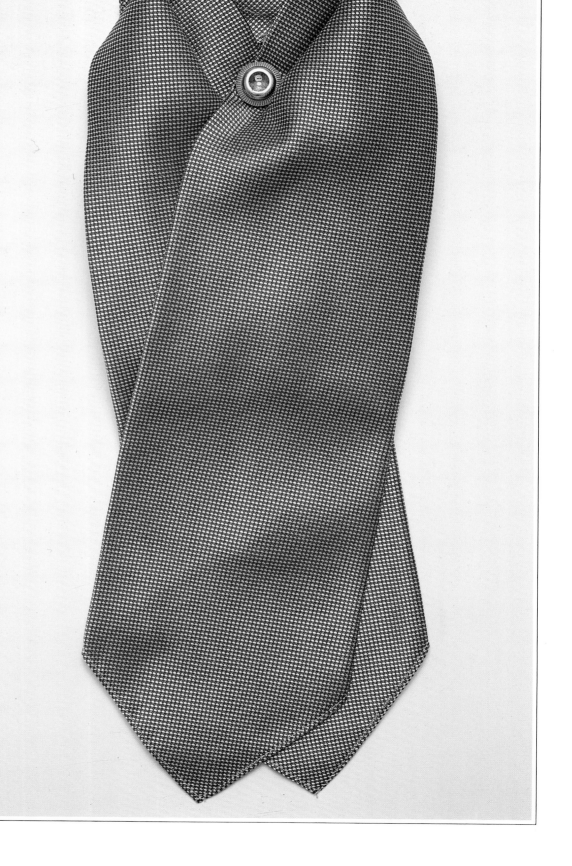

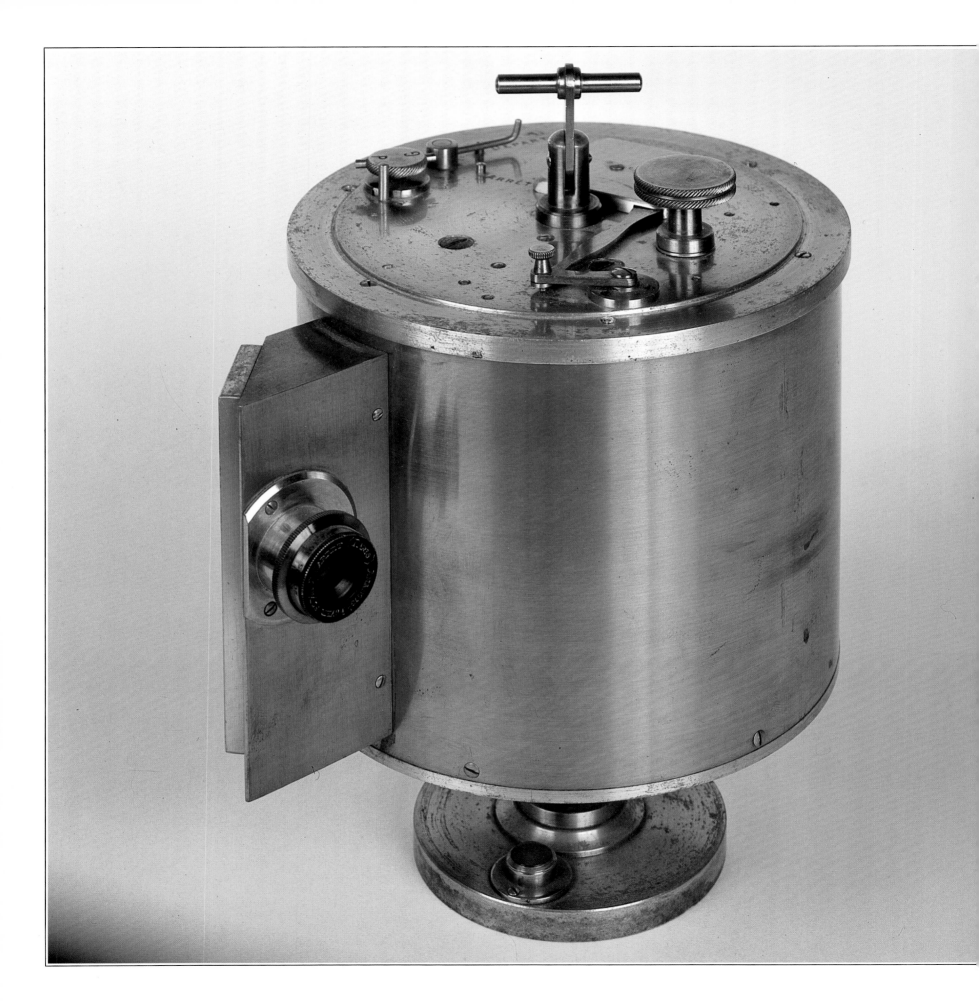

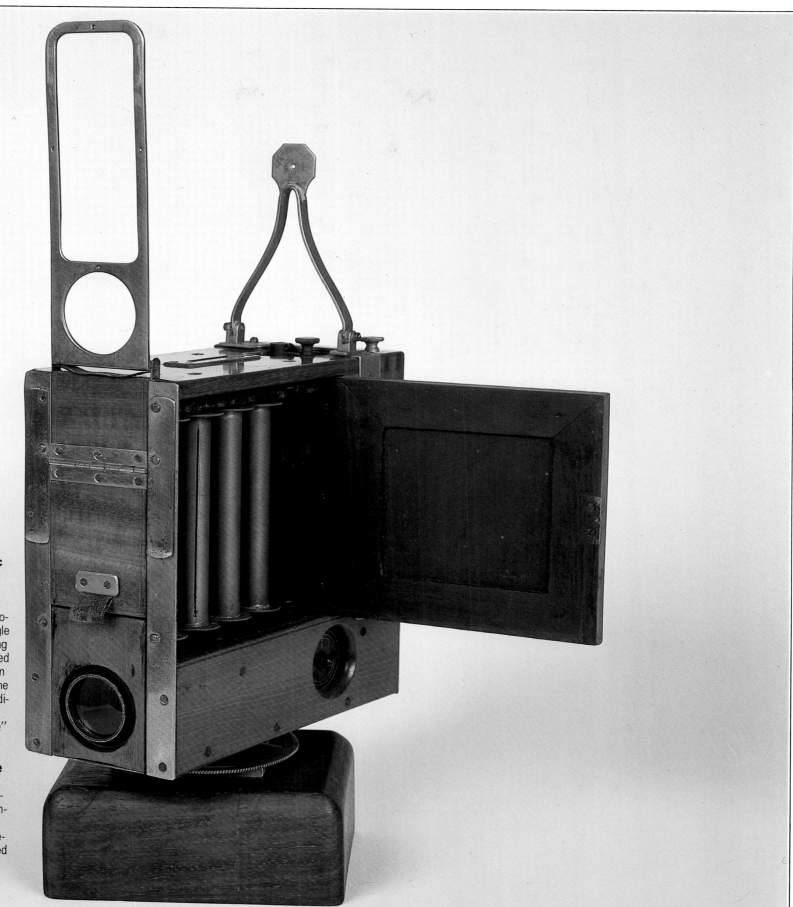

"Cyclographe" Panoramic Camera by M. Damoizeau, Paris (1894)

This apparatus could take photographs at a 360-degree angle of view. By means of a spring mechanism the camera rotated around its axis, while the film was pulled past the lens at the same speed in the opposite direction. Size of the finished photograph: 9 × 80 cm (3½″ × 31½″).

"Le Périphote" by Lumière (1901)

As in the case of the "Cyclographe", the body of this camera revolved around its axis (360 degrees), but the film remained stationary. The finished photograph was 7 × 38 cm (2¾″ × 15″) large. (George Eastman House)

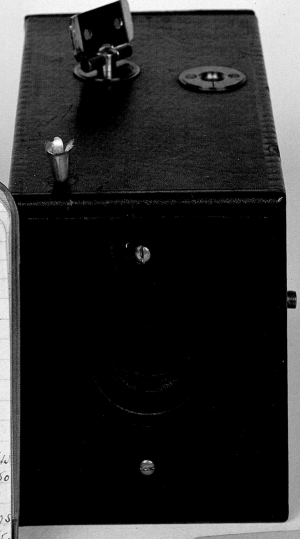

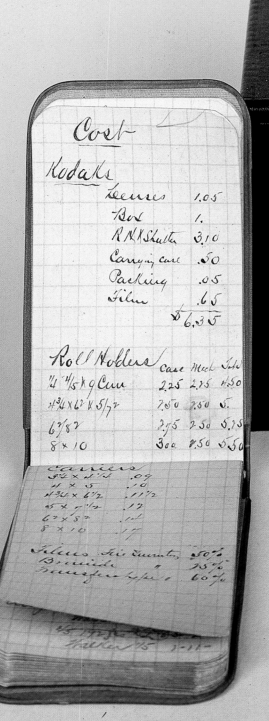

Cost

Kodaks

Lenses 1.05
Box 1.
R N K Shutter 3.10
Carrying case .50
Packing .05
Film .65
$6.35

Roll Holders Case Mech Total
1/4 4/5 x 9 Cun 2.25 2.25 4.50
4 3/4 x 6 1/2 x 5/72 2.50 2.50 5.
6 x 8 2 2.75 2.50 5.25
8 x 10 3.00 2.50 5.50

Carriers
3 3/4 x 4 1/4 .09
4 x 5 .10
4 3/4 x 6 1/2 .11 1/2
5 x 7 1/2 .12
6 x 8 2 .14
8 x 10 .17

Films Fire Inventory 50%
Bromide " 75%
Transfer type " 60%

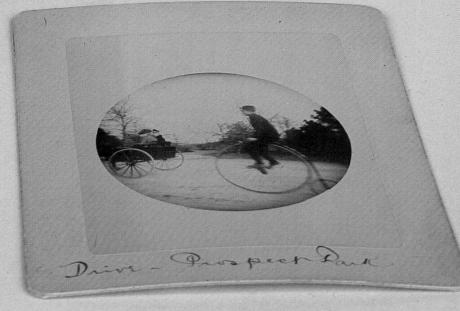

Drive - Prospect Park

Photography Becomes an Industry. George Eastman's idea to simplify the procedure of photography so that all one had to do was "press the button" was pivotal in opening photography to everybody. Eastman utilized the invention of the roll film (principle: celluloid coated with silver-bromide gelatin; patented by Hannibal Goodwin in 1887) and constructed a camera in large quantities to hold the film: the Kodak No. 1. As a consequence, his factory emerged as the largest photographic concern in the world.

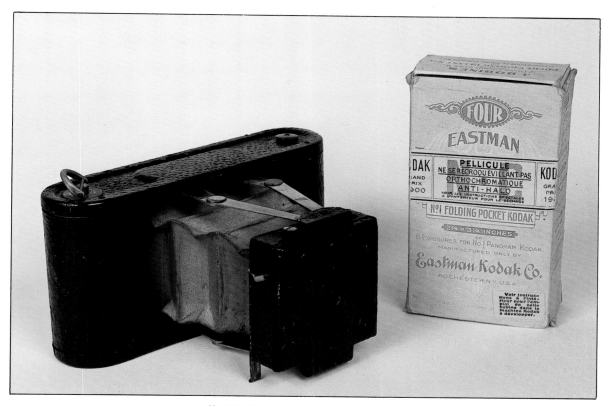

Kodak "Folding Pocket No. 1" (1897)
The decisive breakthrough for the idea of the pocket camera followed 65 years later, with the introduction of the "Instamatic." The films were furnished in easily exchangeable cartridges. The pocket camera shown above was simple to operate and could be folded into a flat package.
(George Eastman House)

The Kodak (1888)
The first model in a long production series of box cameras. It made circular pictures of 6.5 cm (1½") diameter. The manufacturing costs, a recorded by Eastman in his notebook, were $ 6.35. A similar booklet was supplied to the customer with the camera so that an account might be kept of photographic data as the camera was not yet equipped with an exposure counter. It was the world's first roll film camera.
(George Eastman House)

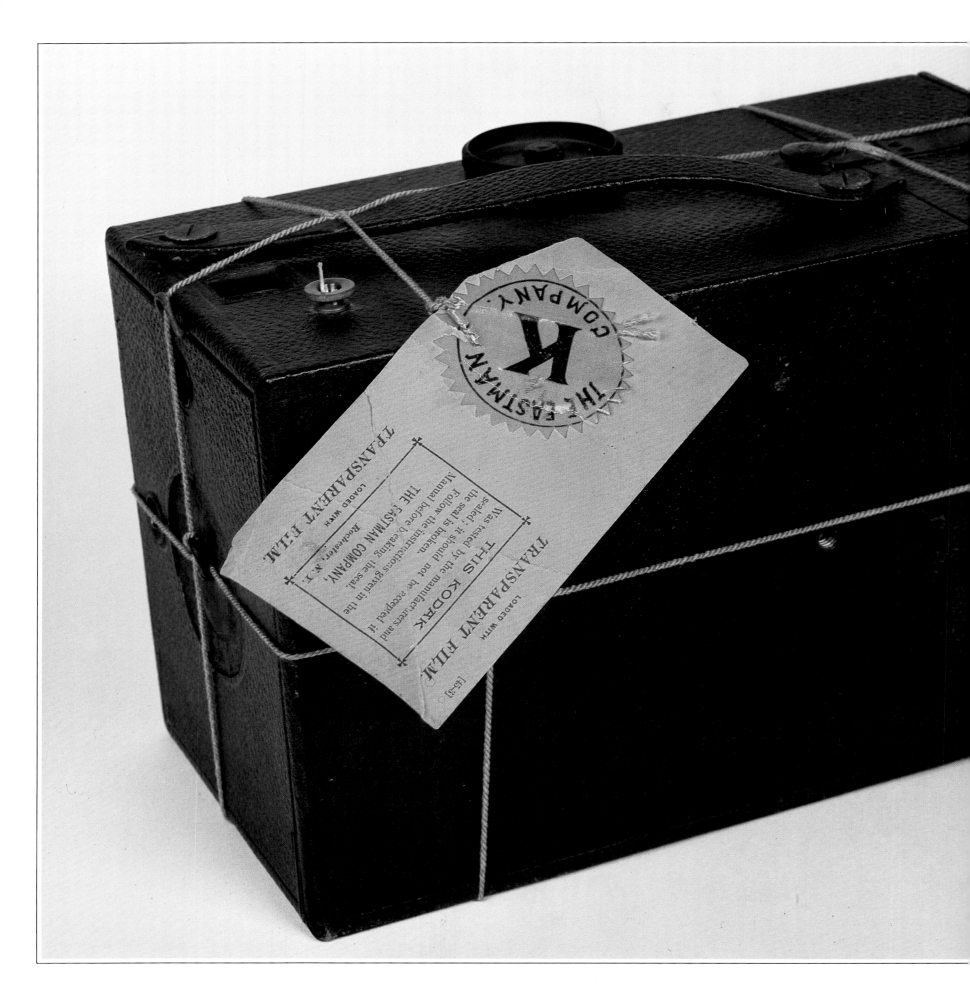

"You press the button, we do the rest."
Eastman's slogan was the result of a carefully studied marketing strategy: to sell cameras in combination with film as part of a special service. His offer included the following: The film was installed at the factory. After 100 snapshots, the camera was mailed to the Eastman Company where, for $10, the pictures were developed, printed and then returned to the customer, with the camera freshly loaded.
(George Eastman House)

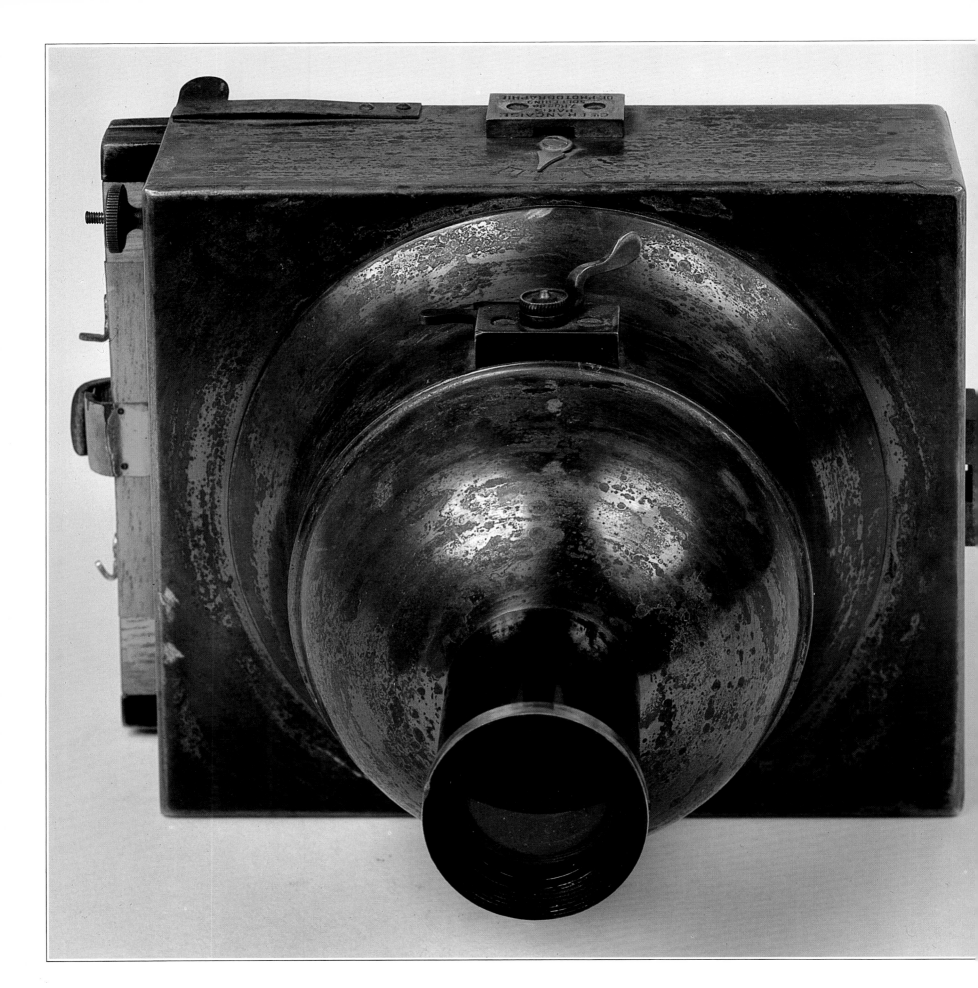

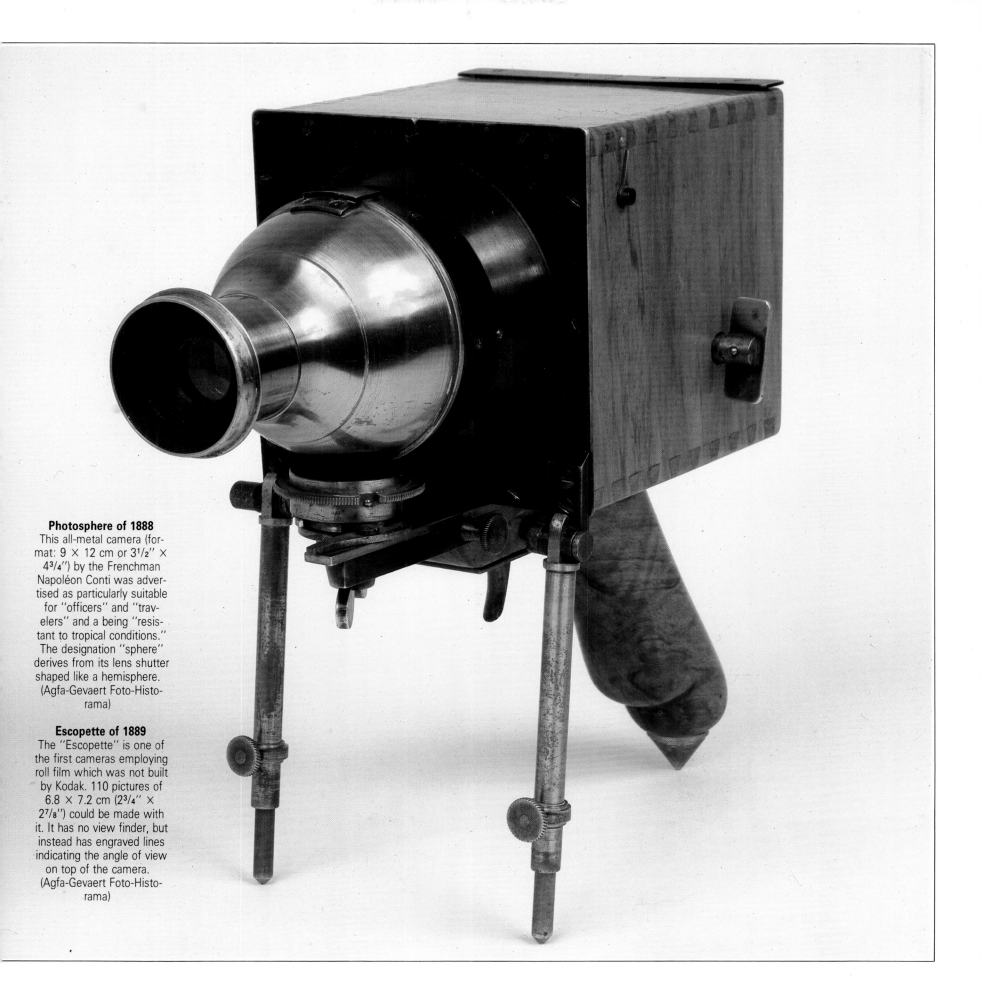

Photosphere of 1888
This all-metal camera (format: 9 × 12 cm or 3¹/₂″ × 4³/₄″) by the Frenchman Napoléon Conti was advertised as particularly suitable for "officers" and "travelers" and a being "resistant to tropical conditions." The designation "sphere" derives from its lens shutter shaped like a hemisphere. (Agfa-Gevaert Foto-Historama)

Escopette of 1889
The "Escopette" is one of the first cameras employing roll film which was not built by Kodak. 110 pictures of 6.8 × 7.2 cm (2³/₄″ × 2⁷/₈″) could be made with it. It has no view finder, but instead has engraved lines indicating the angle of view on top of the camera. (Agfa-Gevaert Foto-Historama)

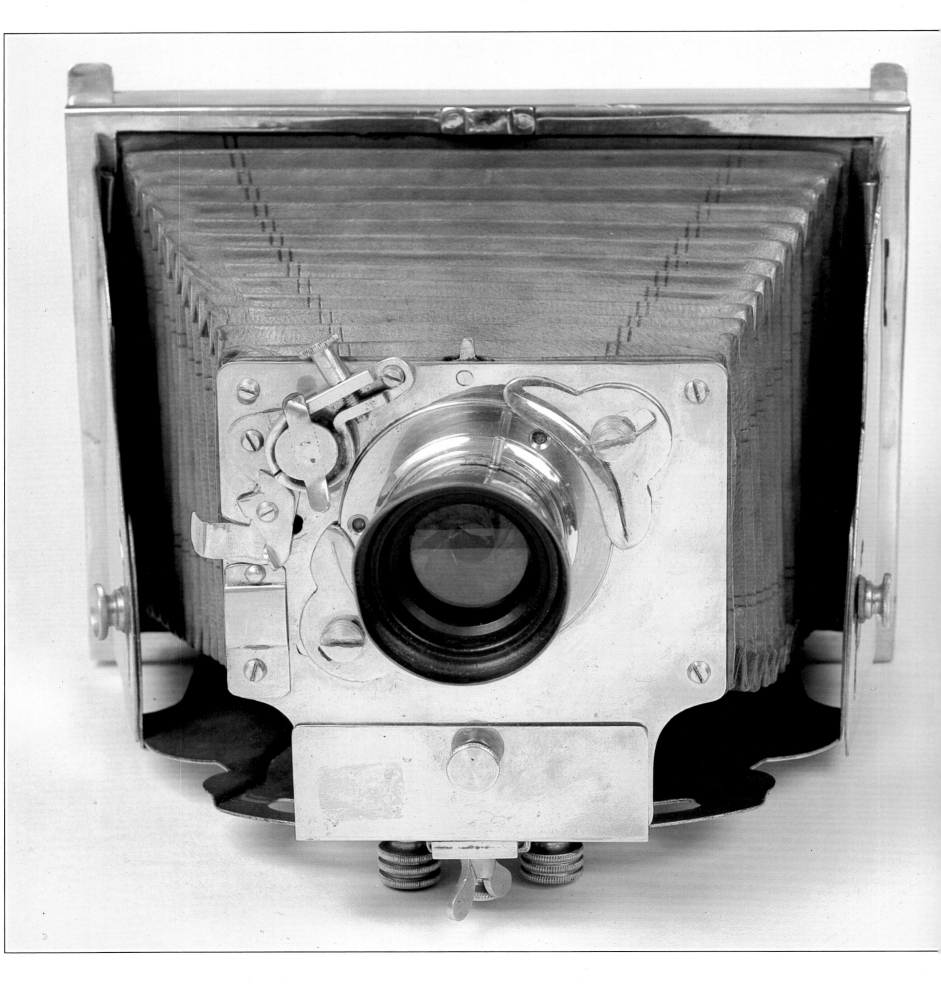

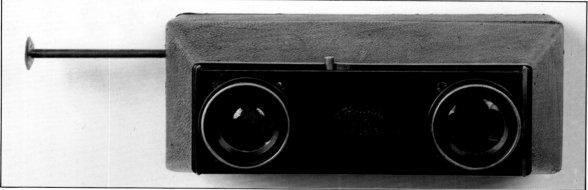

"Kombi" of 1893
Miniature camera, supplying 25 pictures (27 × 27 mm or 1'' × 1'') on roll film. Manufacturer: Alfred C. Kemper, Chicago.
With the back detached, the camera also acted as a viewer for the finished picture.
(Wendel Collection)

Photo Jumelle of 1890
Prototype of a new camera design, which was mainly produced in France. The principle of the device invented by Carpentier resembles that of the field-glass cameras: one lens acting as view finder, the other used for picture taking. The camera contained 12 plates, 4.5 × 6 cm (1³/₄'' × 2¹/₃'') each.
(Agfa-Gevaert Foto-Historama)

"Invincible" of 1898
This portable camera by H. Mader, made of chromium-plated tin, incorporated all the possibilities of adjustment of the field camera and folded into an extremely flat instrument of only 3 cm (1¹/₆'') width.
(Agfa-Gevaert Foto-Historama)

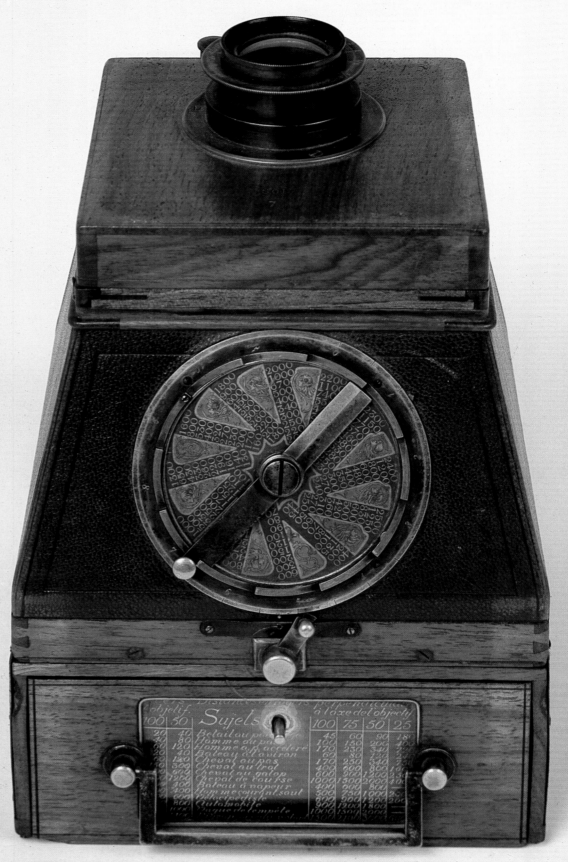

"Jumelle Sigriste" of 1900
The Swiss Jean Guido Sigriste was a painter of race horses, working from photographs rather than sketches. Since the shutter speeds of all better-known cameras were too slow for his purposes, he built his own camera. Its distinction was a focal-plane shutter which reduced exposure time from $1/40$ to $1/10,000$ sec. Spring tension and shutter speed were set by dial on a clockface-type scale.
(Agfa-Gevaert Foto-Histo-rama)

Goerz-Anschütz Camera of 1888
Ottomar Anschütz took his well-known "instantaneous" photographs of animals with a precursor of this camera. The shutter consists of a roller blind made of fabric, which passes in front of the plate. This made possible exposures of up to $1/1000$ sec. The press camera, in use until approximately 1930, evolved from this camera type.
(Agfa-Gevaert Foto-Histo-rama)

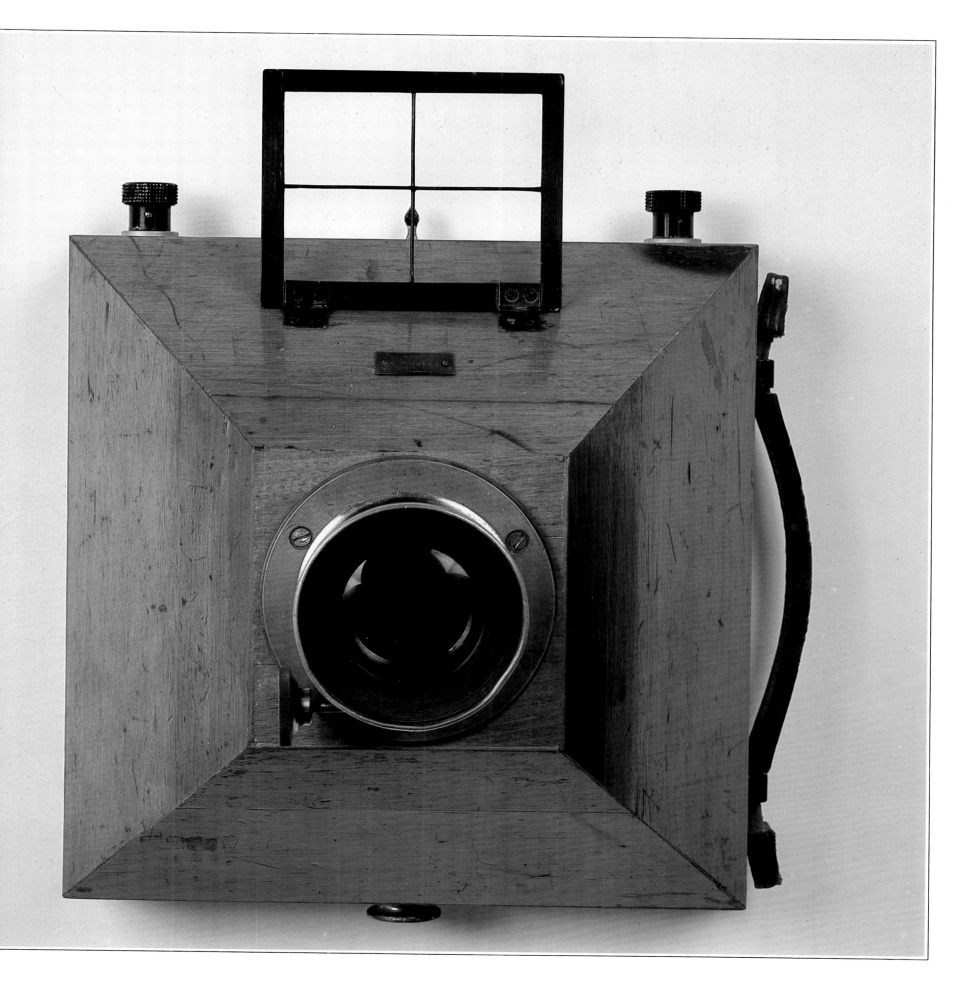

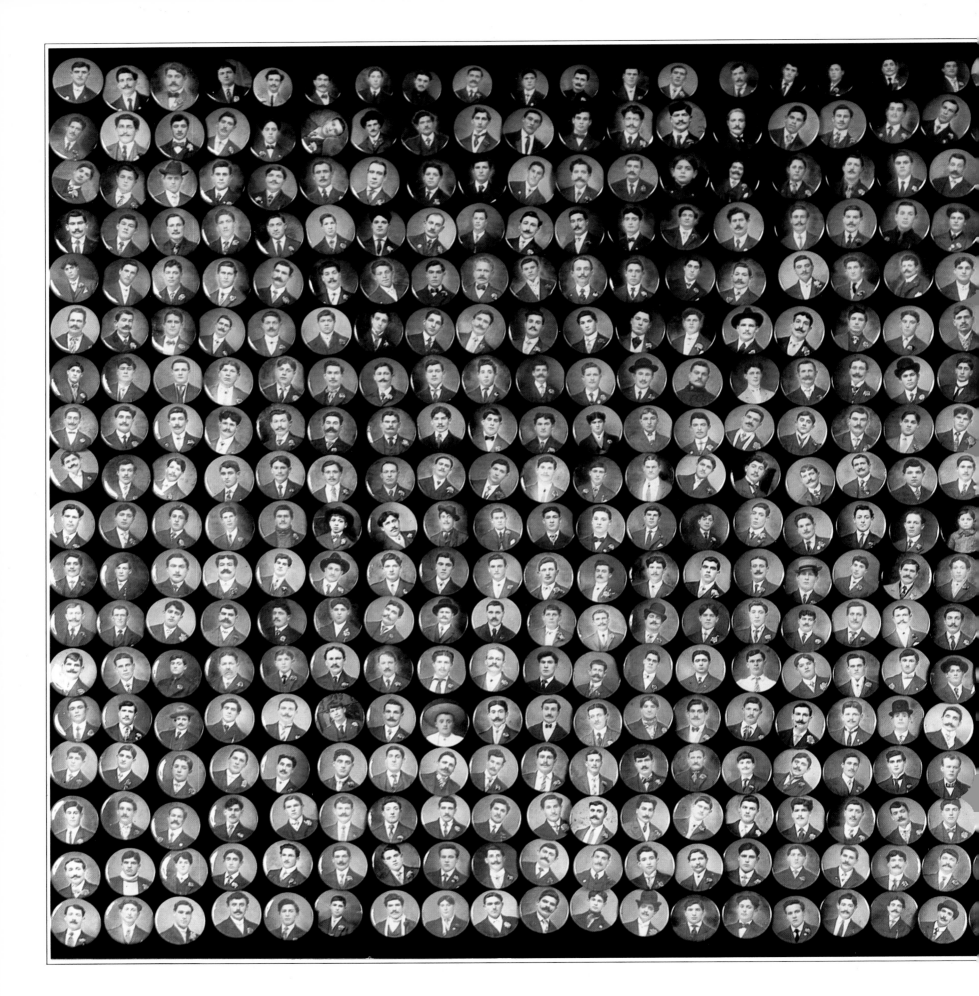

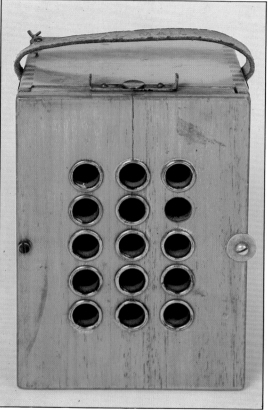

Royal Mail Copying Camera of 1910
This instrument made ''postage stamp photos'' which, of course, had no postal value, but were used a min-
iature-portrait inlays for jewelry. Manufacturer: Butcher & Sons, London.
(Agfa-Gevaert Foto-Historama)

Portraits of Immigrants in Chicago
These hand-colored ''buttons'' were produced for the purpose of ethnological research in the 1920's.
(George Eastman House)

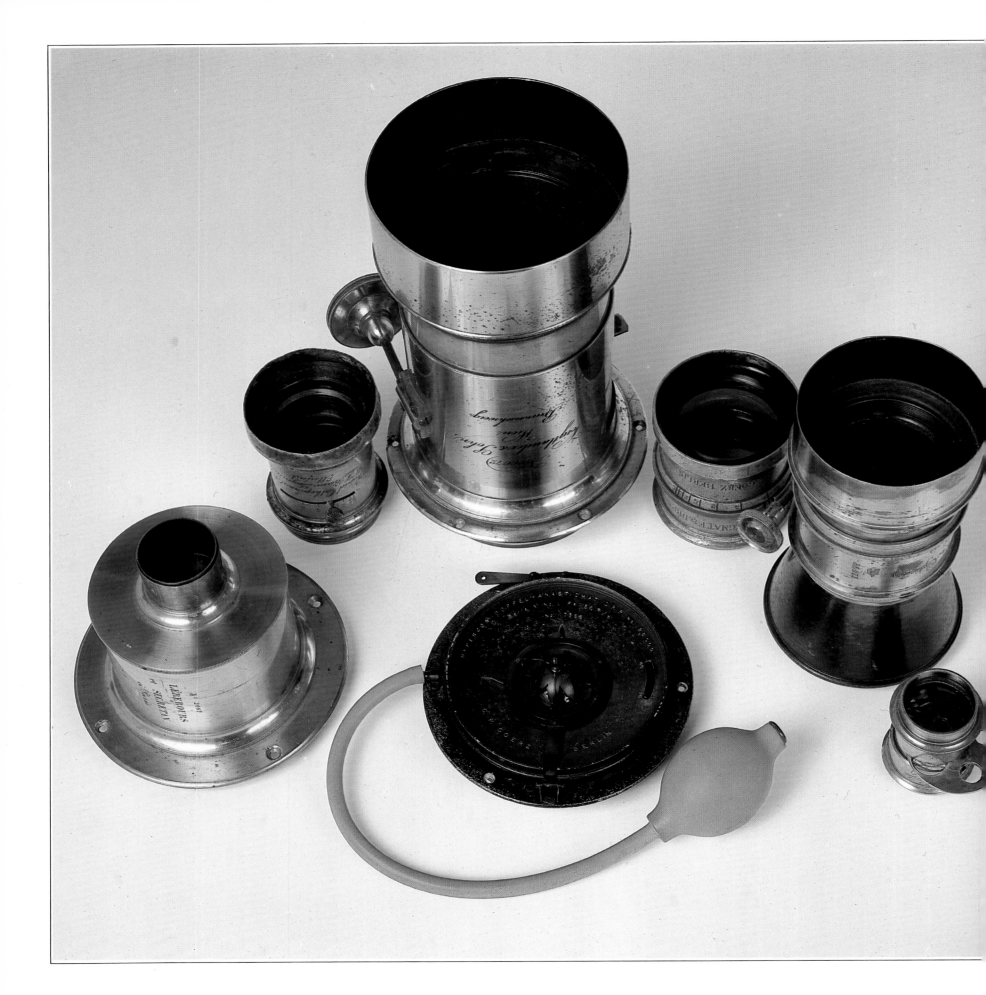

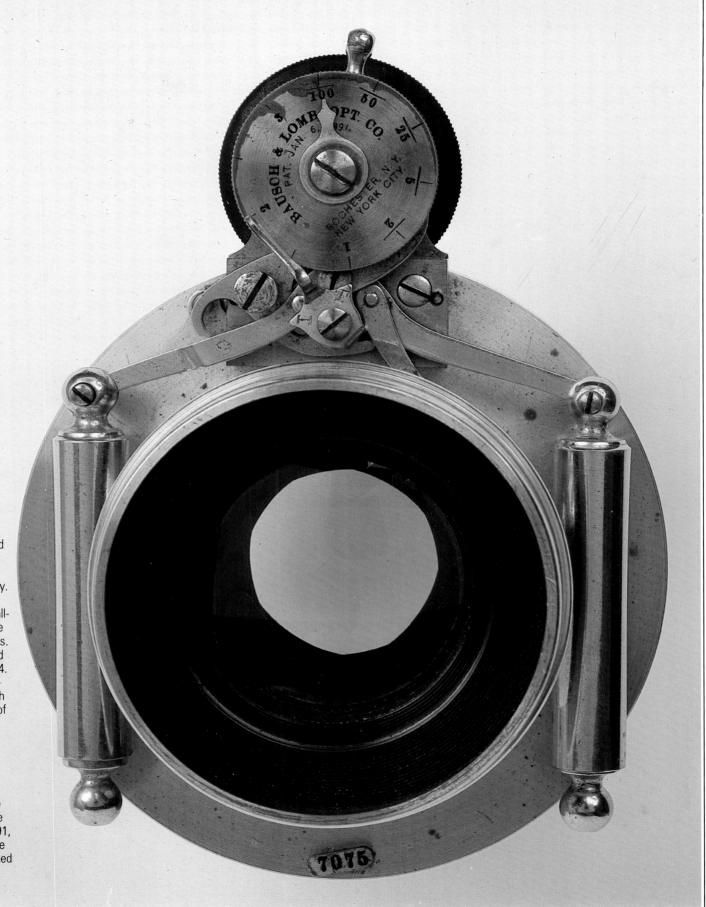

Lenses

ntil the turn of the century, the photographer had
o choose the right lens according to his specific
eed, suitable, for instance, for landscape photo-
phy, portraiture, or "instantaneous" photography.
Companies such as Voigtländer in Vienna and
unswick, Steinheil in Munich, Goerz in Berlin, Dall-
eier & Ross in England, and Lèrebours in France
d specialized in the production of different lenses.
technical speciality is the "Hypergon," designed
Emil von Hoëgh for the Goerz Company in 1904.
t has an angle of view of 140 degrees. The star-
aped diaphragm opening from the center, which
s activated by air pressure, corrected the loss of
light near the edges of the lens.
(Agfa-Gevaert Foto-Historama)

Shutters

As photoreceptors became more sensitized, the
speed of lens shutters grew. At first, there were
illotine-type or roller-blind shutters; then, in 1891,
3ausch & Lomb invented the central shutter. The
des mounted between the lens elements opened
and closed pneumatically.
(Agfa-Gevaert Foto-Historama)

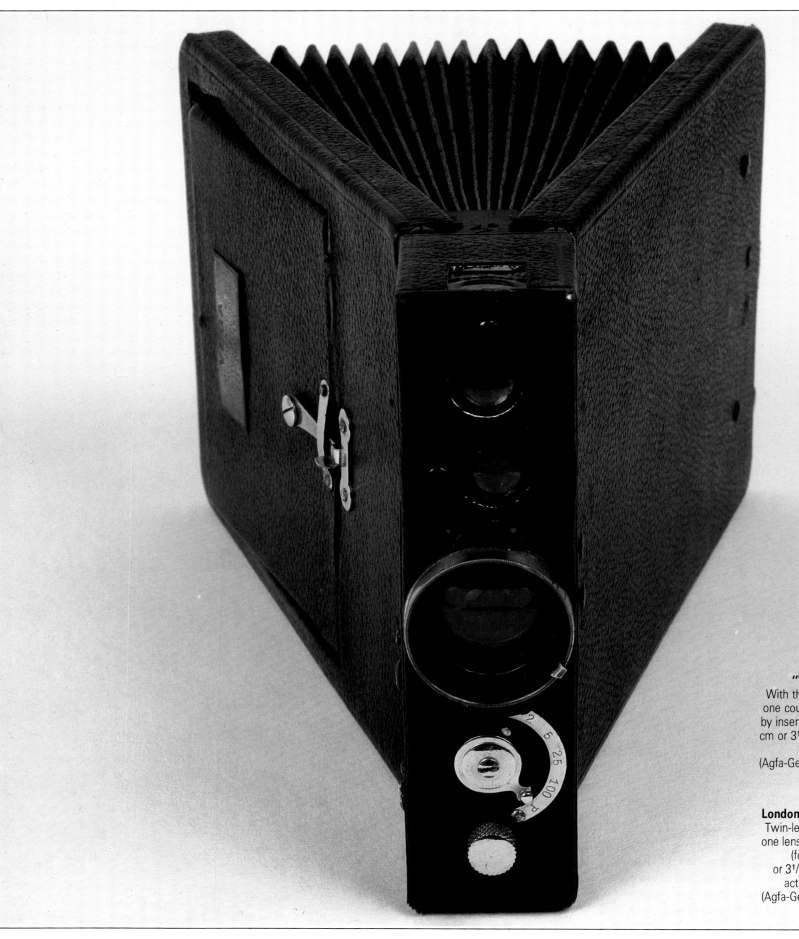

"Vega" of 1900
With this flat-folding model, one could make an exposure by inserting the plate (9 × 12 cm or 3¹/₂″ × 4³/₄″) from the side.
(Agfa-Gevaert Foto-Historama)

London Stereoscopic of 1910
Twin-lens reflex camera, with one lens used for picture taking (format: 9 × 12 cm or 3¹/₂″ × 4¹/₂″), the other acting as view finder.
(Agfa-Gevaert Foto-Historama)

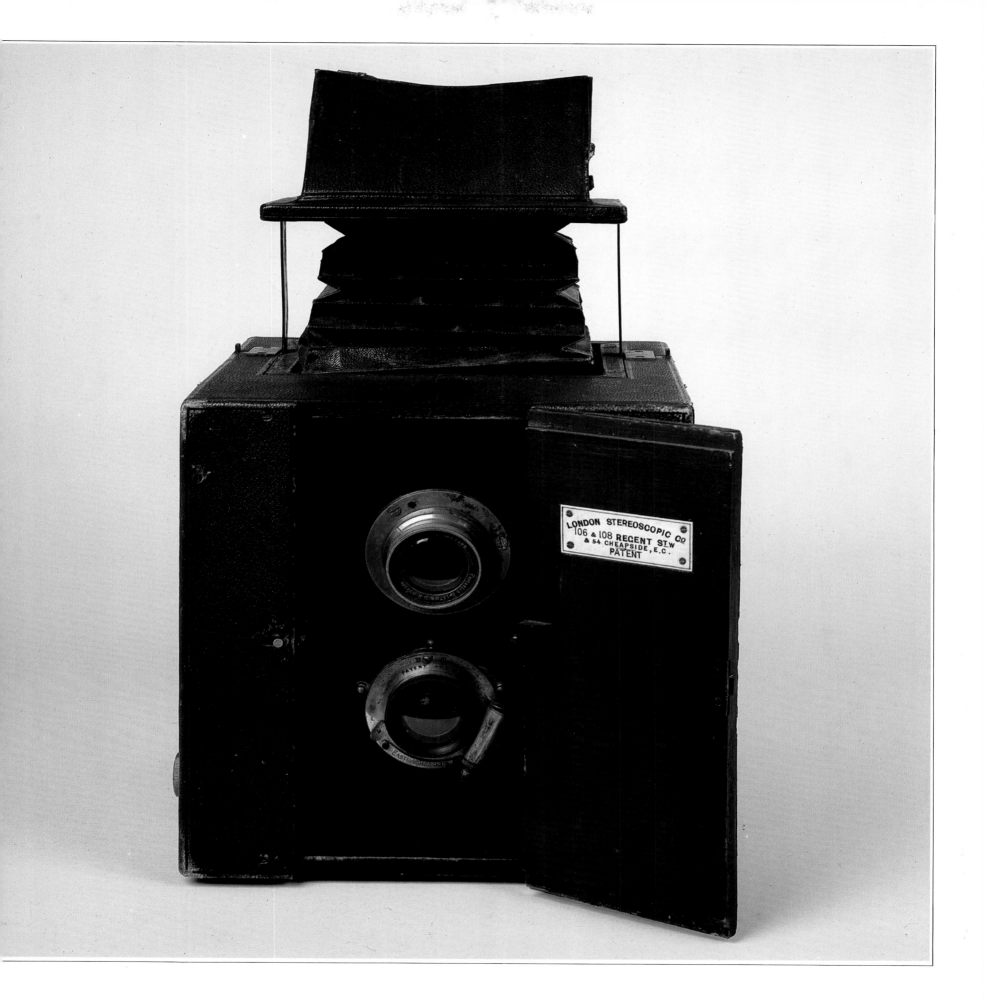

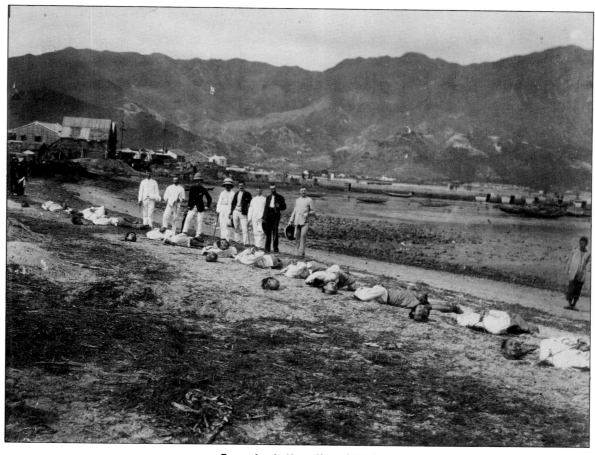

Execution in Hong Kong (1880)
This photograph of the slaying of rebels in China is a powerful example of one fundamental aspect of photography: as a means of documentation, having much greater impact than the written word.
(Agfa-Gevaert Foto-Historama)

Reflex Camera by Adams & Co., Made for the Tropics, 1925
Some camera types were produced in special editions—in most cases made of mahogany and brass, materials that were best suited to the special climatic conditions of the tropics.
(George Eastman House)

The "Artificial Sun" An insignificant gray material (discovered Bunsen and Roscoe in 1859) brought to light significant things: in 1865, Charles Piazzi Smyth used magnesium light for photographs inside the pyramid of Cheops. To the horror of their customers, photographers for decades worked with explosive compounds of magnesium, potassium chlorate, sulphantimonide, and other chemicals (introduced by Adolf Miethe and J. Gaedicke in 1887). An end was put to the light alchemy in 1925, when Dr. Paul Vierkötter invented the flash bulb filled with tin foil.

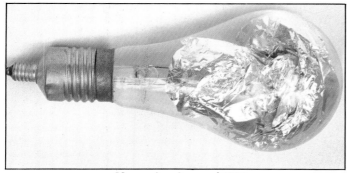

Magnesium Lamp of 1880
A magnesium wire, advanced by a spring mechanism, burned off continuously.

Flash Bulb Filled with Tin Foil (circa 1935)
(Agfa-Gevaert Foto-Historama)

Haka Flash Unit with Self-Timer
A spring mechanism moved the small candle toward the strip of paper which, in turn, ignited the magnesium powder.
(Museum of Technology)

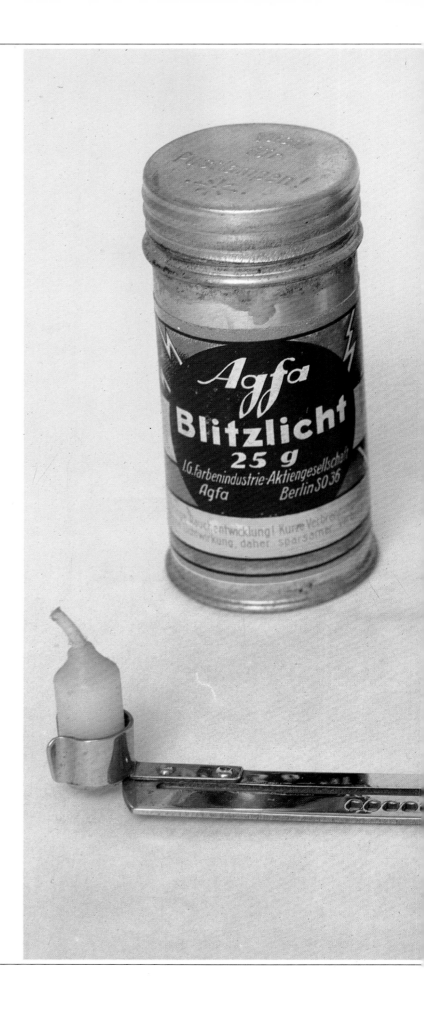

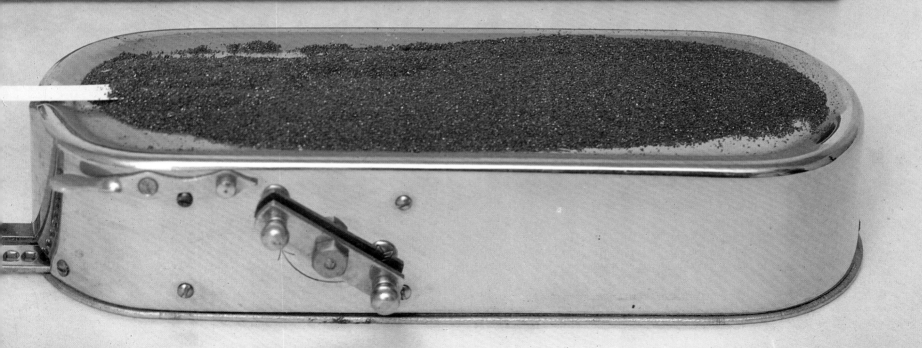

Art Nouveau Photo Album of 1900
(Wendel Collection)

Picture Cassettes (circa 1860)
(Agfa-Gevaert Foto-Historama)

Since the beginnings of photography, pictures were kept in albums, cassettes, and shoe boxes. For the preservation of Daguerreotypes, specially decorated "Union Cases" were produced, made primarily of leather or bakelite.

"Vest Pocket" Strut Camera by Kodak, 1913
Folding Camera by Dr. Krügener, 1902
"Billy" Folding Camera by Agfa, 1928
"Clack" Folding Camera by Rietzschel, 1900

The three models shown below are typical amateur cameras using roll film. The "Clack" camera was the first model of the Munich camera factory Heinrich Rietzschel, which later became the Agfa Camera Works. It can be used with 9 × 12 cm (3½″ × 4¾″) plates as well as with roll film.
(Agfa-Gevaert Foto-Historama)

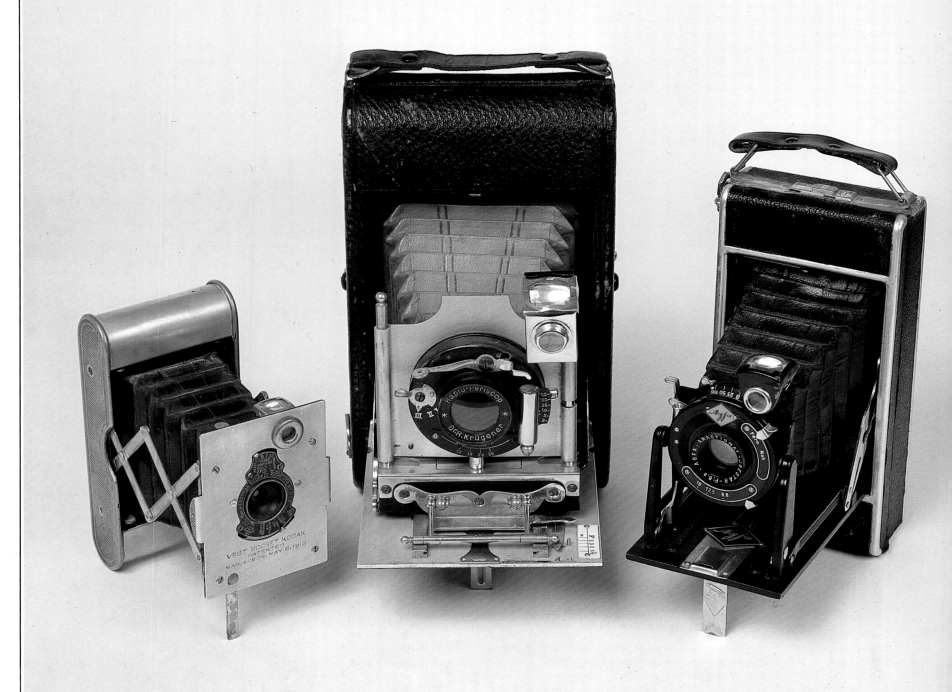

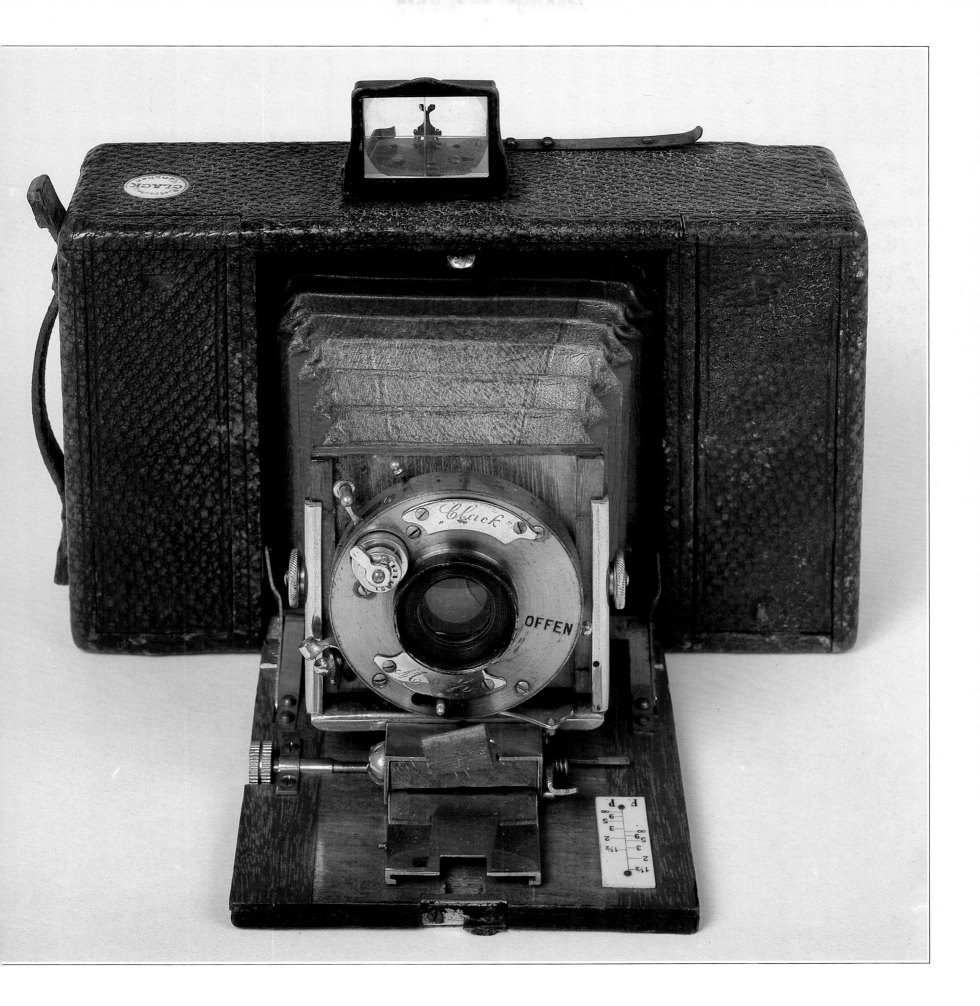

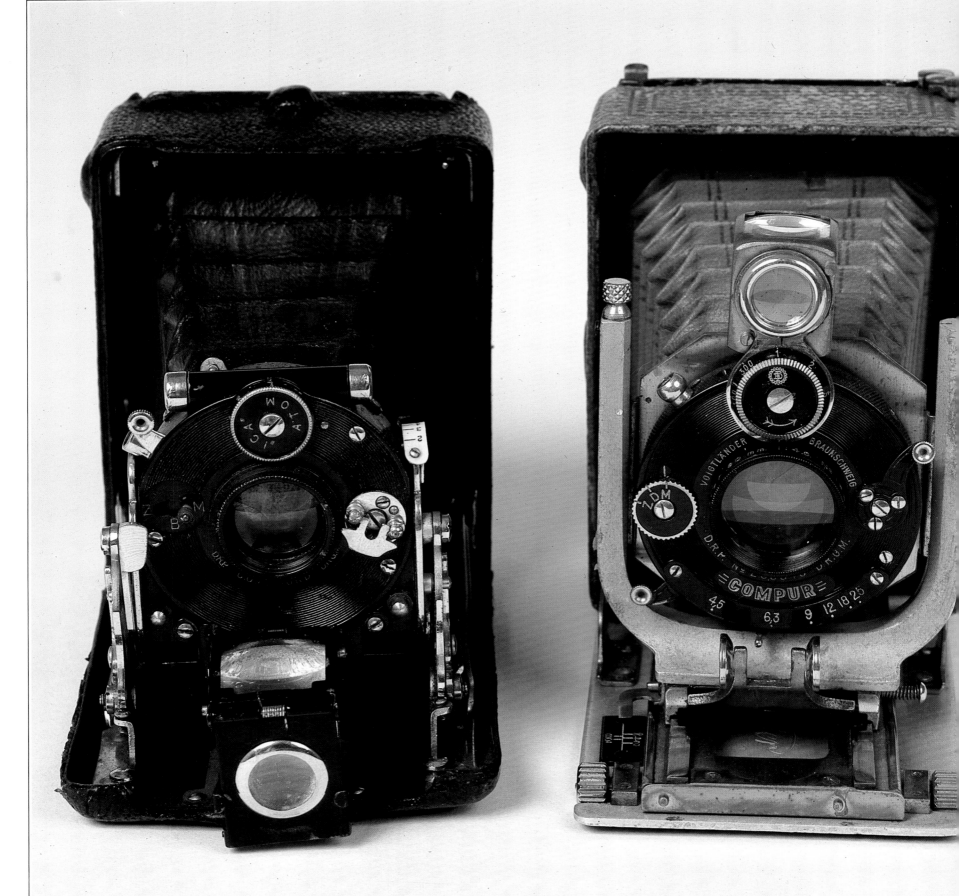

"Ica Atom," 1913
Upon opening the camera, the lens was in position and ready for picture taking. With other folding cameras, it had to be pulled out on a rail.

"Bergheil" by Voigtländer of 1930
De luxe model, finished in leather, of 4.5 × 6 cm (1³/₄″ × 2¹/₃″) folding camera; in great demand because of its precision and Voigtländer "Heliar" lens.
(Agfa-Gevaert Foto-Historama)

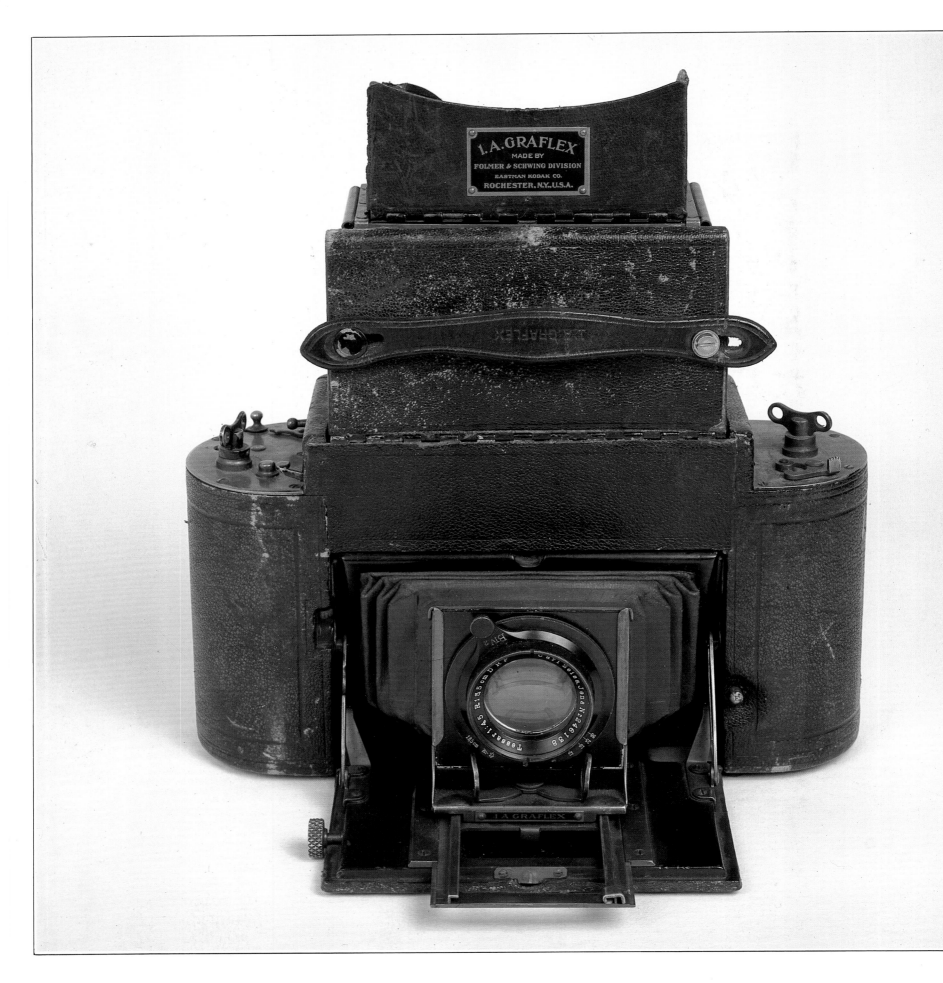

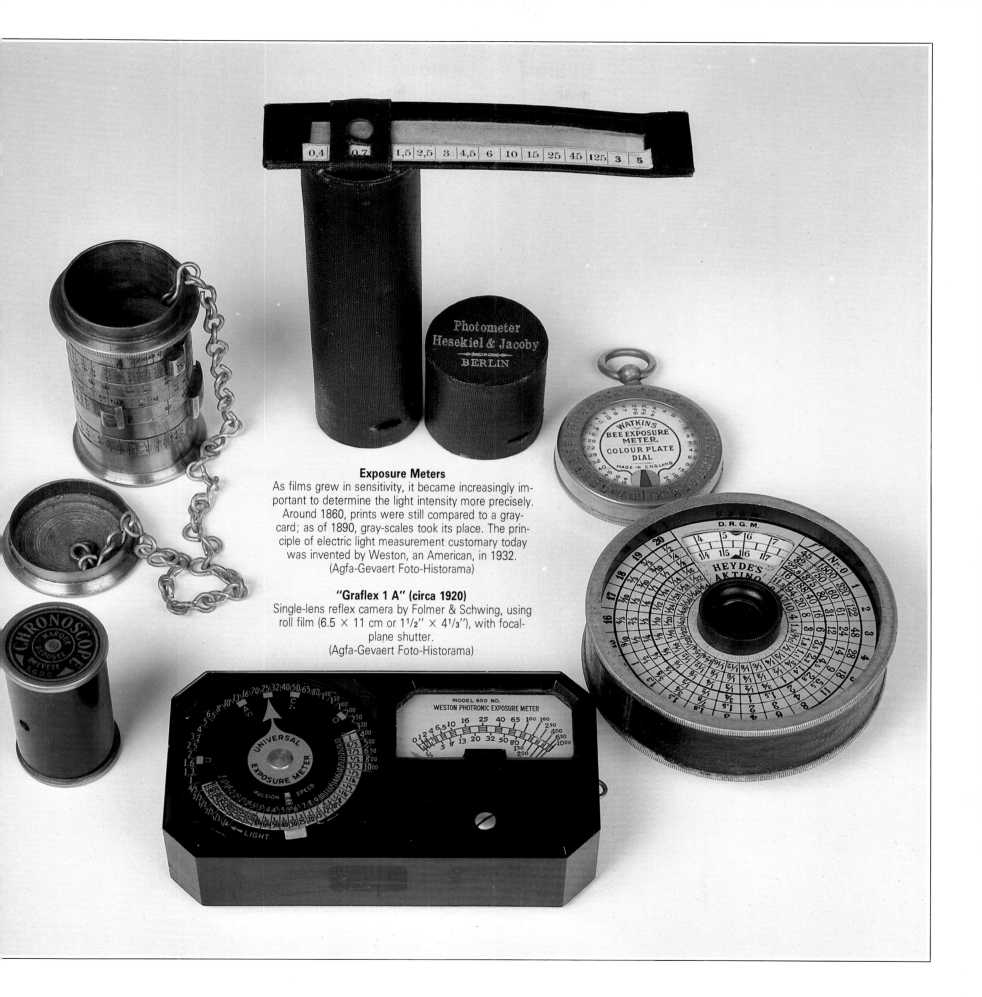

Exposure Meters

As films grew in sensitivity, it became increasingly important to determine the light intensity more precisely. Around 1860, prints were still compared to a gray-card; as of 1890, gray-scales took its place. The principle of electric light measurement customary today was invented by Weston, an American, in 1932.
(Agfa-Gevaert Foto-Historama)

"Graflex 1 A" (circa 1920)

Single-lens reflex camera by Folmer & Schwing, using roll film (6.5 × 11 cm or 1¹/₂" × 4¹/₃"), with focal-plane shutter.
(Agfa-Gevaert Foto-Historama)

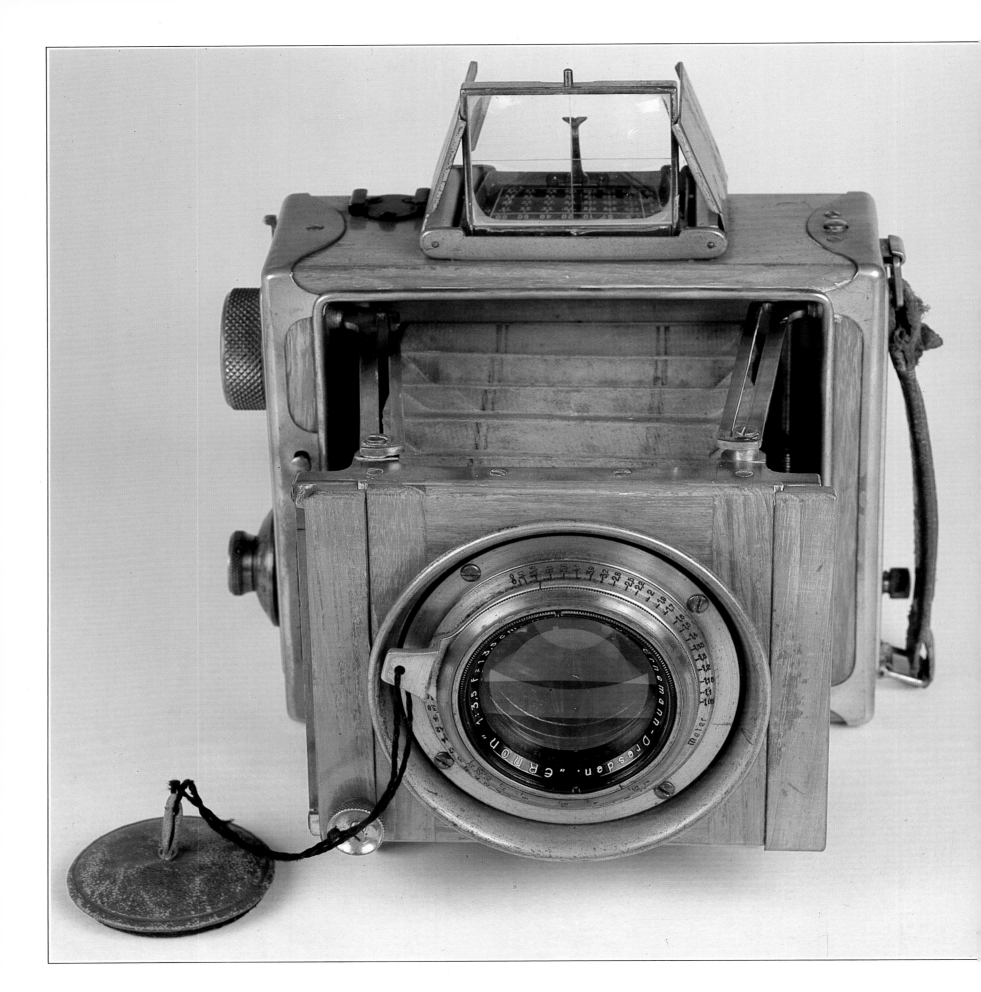

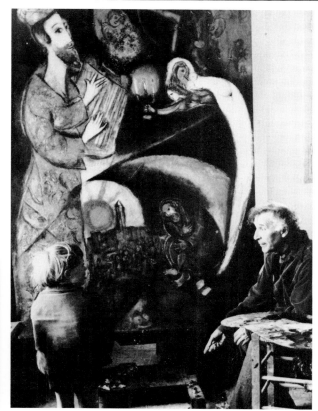

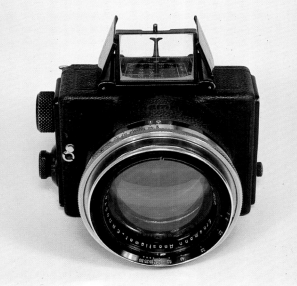

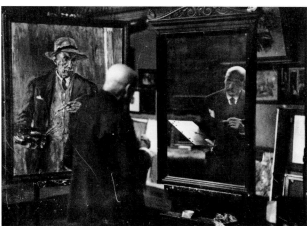

"Ermanox" of 1924
With the very fast lens of 1:2, live photographs could be taken in adverse light conditions for the first time.

Photographs by Felix H. Man
These pictures from the years 1926 to 1936 mark the beginning of a new chapter in the history of photography. Together with Salomon, Felix Man originated live photography. At first, he worked with an Ermanox camera, then with a Leica. (From left, clockwise) Hindenburg, Toscanini, Chagall, Mussolini, Liebermann.

Ernemann Strut Camera, Adapted to Tropical Climates, of 1925
The Heinrich Ernemann Company, founded in Dresden in 1889, built a series of famous cameras and motion picture devices before it was merged with the Zeiss-Ikon AG in 1926. Ernemann cameras as shown here were normally used by photojournalists between 1900 and 1930.
(Agfa-Gevaert Foto-Historama)

The World of Color Photography. The colorful appearance was deceptive. The first color photographs were actually black-and-white pictures which subsequently were colored over. The first genuine color photograph was made by the Englishman James Clerk Maxwell in 1861. It was a three-color picture which, however, could only be viewed through a projector. Until Kodak and Agfa put the modern three-layer color film on the market in 1935/36, hundreds of experiments were undertaken, all of which led to the same dead end: the material was not suitable for the ordinary camera.

Three-Color Picture by Ducos du Hauron (1869)
Hauron invented the subtractive method of color mixing (tri-color separation). He photographed the subject with a green, orange, and violet filter respectively. The different negatives were exposed on thin gelatin sheets containing red, blue, and yellow carbon pigments. The three separate pictures were superimposed to form the finished color photograph.

Photograph on Agfa Color Plate (1916)
Through improvements of the grain-impression system of the transparency, shorter exposure times became possible.

Microscopic Grains

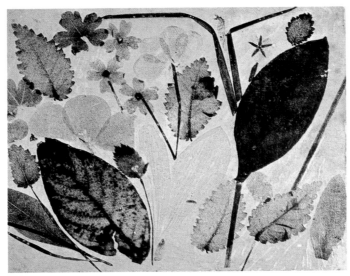

Photograph on a Lumière Autochrome Plate (1913)
The screening method suggested by Ducos du Hauron in 1869 was patented by the Lumière Brothers in 1904. Natural-color photography had now left the stage of experimentation behind. The process was based on the following principle: a glass plate was coated with microscopic grains of starch, dyed red, blue, and green, which were covered with a thin black-and-white layer. With development, the blackened particles were then dissolved and the plate was exposed a second time, reversing the image, thus creating a positive transparency made up of tiny colored grains—similar to the modern color TV picture. (Agfa-Gevaert Foto-Historama)

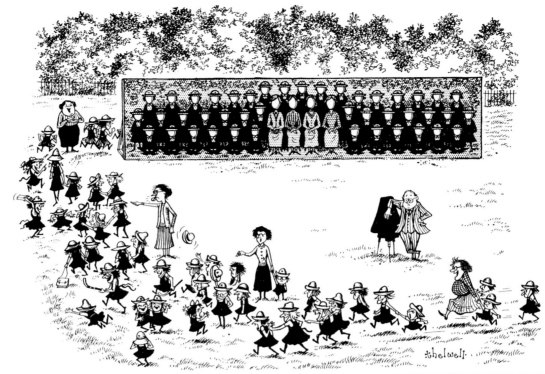

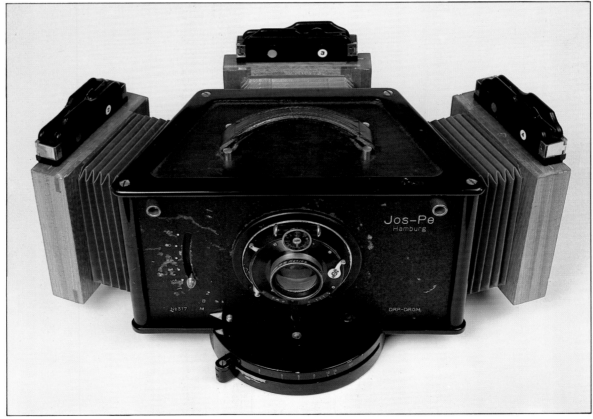

"Jos-Pe" Three-Color Camera of 1925

In contrast to the first color cameras, which required taking separate photographs, this camera was capable of taking all three black-and-white negatives simultaneously, utilizing semitransparent mirrors. Color filters were mounted in front of the individual plates. The negatives were recopied onto pigment sheets and subsequently recomposed into one color photograph.

Sellechrome (after 1895)
Uvachrome (1930)
(Agfa-Gevaert Foto-Historama)

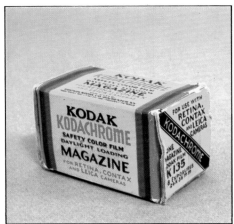 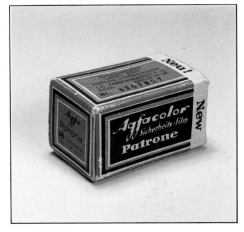

Still from the Film "Münchhausen"
One of the first full-length motion pictures in color, lasting a whole evening, was produced by Ufa on Agfacolor, which used the negative-positive process developed by Agfa in 1939. It was based on the principle that color enlargements or copies on positive film could be made from a negative in complementary colors.

Kodachrome Film of 1935

Agfacolor Film of 1936
Within only few months of each other, the leading photographic companies, Kodak and Agfa, put almost the same product on the market: the three-layer color film, which simplified color photography dramatically. The film could be used in normal cameras and could be developed in specially equipped laboratories. The three color layers were poured onto a film base, which, combined, was no thicker than an ordinary black-and-white film. The Agfacolor method served as a model for many subsequent processes, such as "Gevacolor" or "Ferraniacolor," which were developed after World War II.

Color Photograph of Berlin on Agfacolor-Diafilm (before 1939)
(Agfa-Gevaert Foto-Historama)

The Story of the Leica. Oskar Barnack, an engineer at the Leitz factory in Wetzlar, built the original Leica in 1913. It became the prototype and symbol for a whole new outlook on cameras. The fact that the instrument originally designed to be an exposure testing device for motion pictures would come to be the embodiment of precision and 35 mm photography, was the result of a lone decision by a man in management: in 1924, owner Ernst Leitz decided to mass-produce the camera.

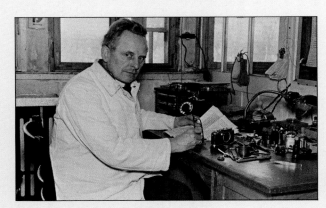

Oskar Barnack

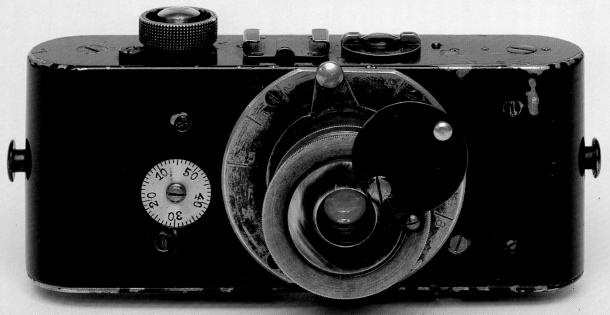

Prototype Leica, 1913

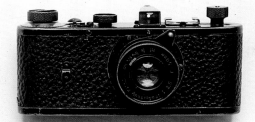

Pre-production Model, 1923

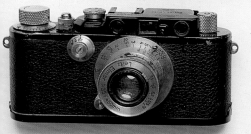

Compur Leica, 1926

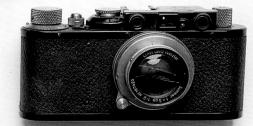

Leica II, 1932

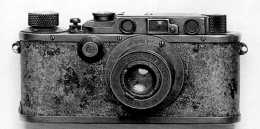

Leica III, sunk with sailing ship "Niobe"

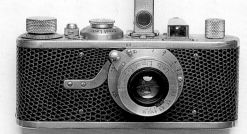

Leica I Luxus, 1930

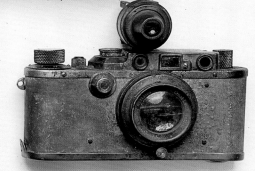

Leica III, burned with "Hindenburg" zeppelin

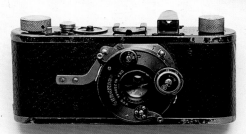

Leica III, 1933

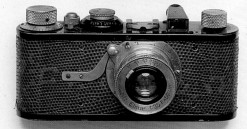

Leica I Luxus, 1930

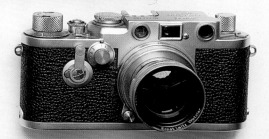

Leica III f, 1950

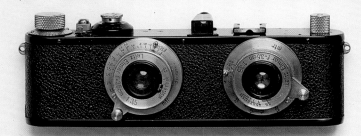

Leica Stereoscopic Prototype

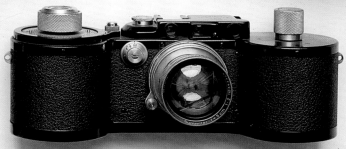

Leica 250, 1935

The Twin-Lens Camera. Another type of camera touching off a whole new way of life was the "Rollei," built for the first time by Franke & Heidecke in 1929. It had evolved from the stereoscopic camera "Rolleidoscop" and continued to be manufactured for 40 years with only few modifications. The introduction of the 6 × 6 cm (2¹/₄" × 2¹/₄") format was made possible by the compromise between the size of the camera and the small-format photograph. The combination of sturdiness and precision of this camera, at first made exclusively for amateurs, soon came to be valued by professional photographers as well.

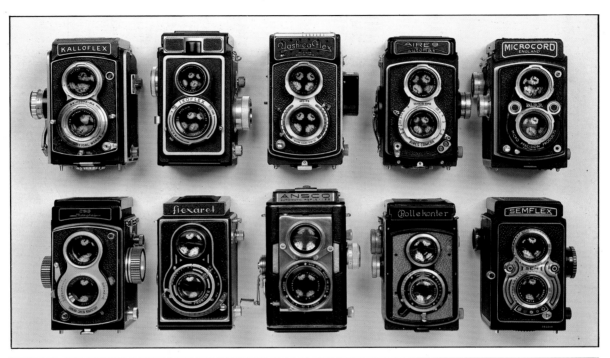

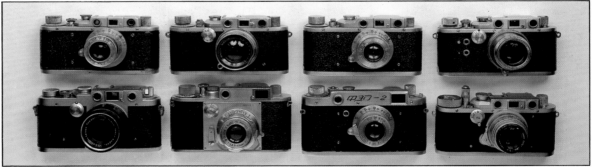

Two Cameras with One Common Fate
The excellent technical quality of the Rollei and Leica cameras and the aura surrounding them as superior products were, however, accompanied by negative aspects as well: they were scrupulously copied. Japanese, Chinese, Americans, Frenchmen, Englishmen, Czechs, Russians, even Germans themselves, tried to profit from the splendid image of the two models. Particularly in the case of the Leica, one did not hesitate to copy the original even in its most minute detail.
Rollei Cameras: Rollei Works
Leica Cameras: Agfa-Gevaert Foto-Historama

Rolleiflex of 1929
Twin-lens reflex camera using 6 × 6 cm (2¹/₄" × 2¹/₄") roll film.
(Agfa-Gevaert Foto-Historama)

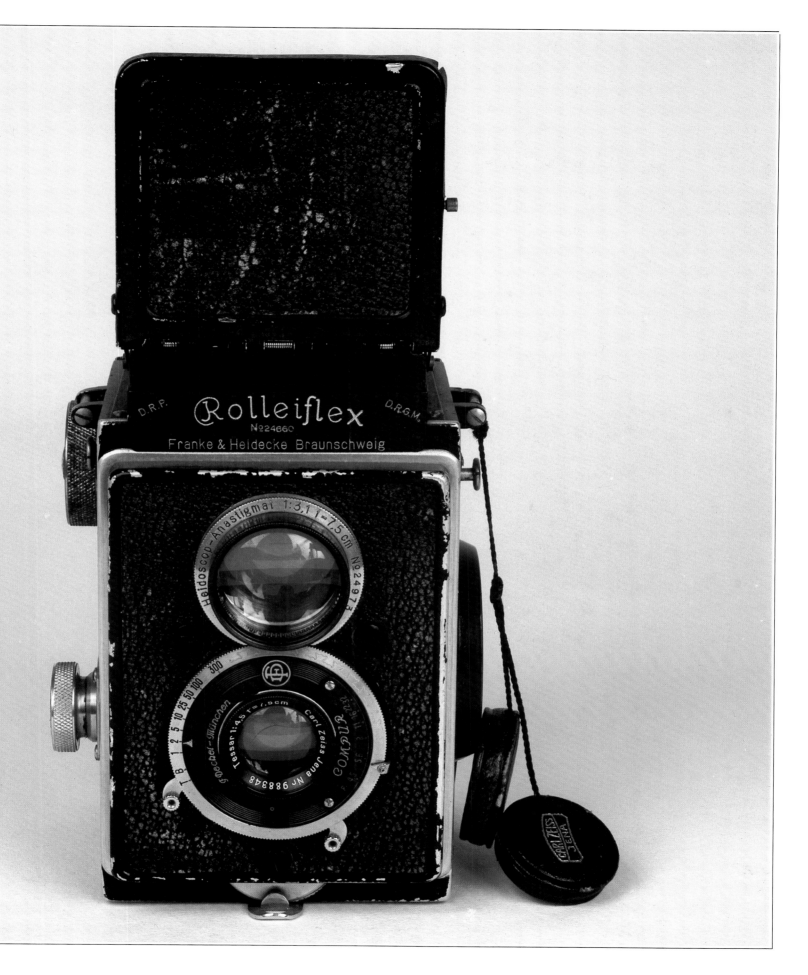

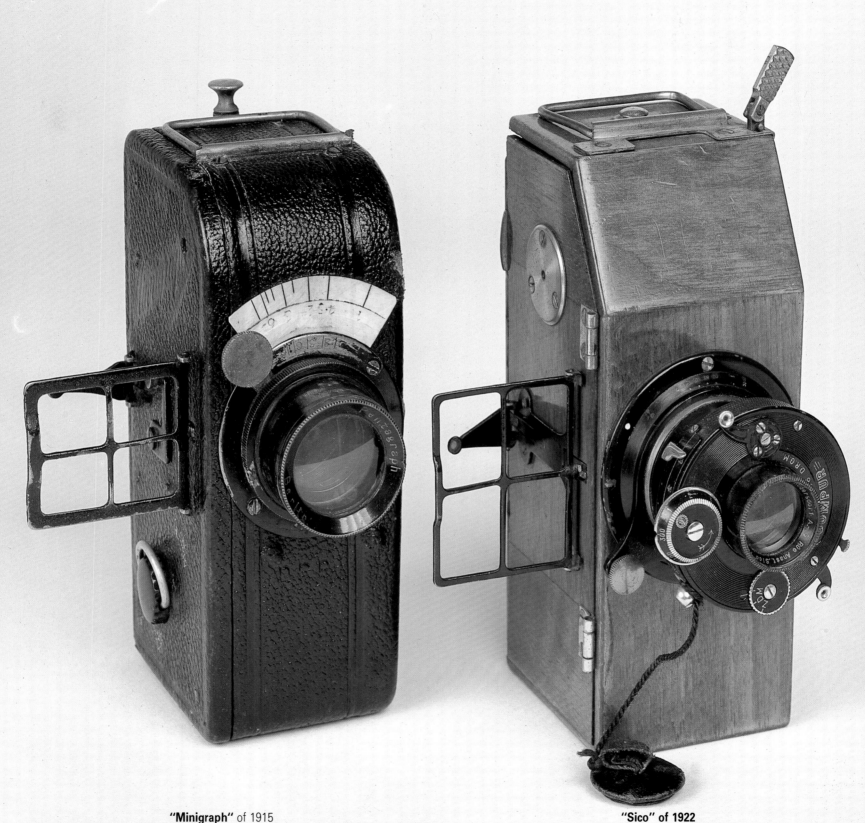

"Minigraph" of 1915
Small-format camera by Levy-Roth, Berlin, designed to use perforated 35 mm film in special cartridges. It made 50 pictures, 18 × 24 mm (³/₄″ × 1″).
(Agfa-Gevaert Foto-Historama)

"Sico" of **1922**
Small-format camera by Wolfgang Simons, Berne, for 25 exposures, 30 × 40 mm
(1¹/₆″ × 1¹/₂″).
(Agfa-Gevaert Foto-Historama)

The Triumph of the 35 mm Format. The Leica popularized what was actually meant for motion picture use, i.e., the perforated 35 mm film. The use of this film stock in the beginning ("Leica Photography") was attended by additional popularity and lower film costs for the photographic industry. Ernst Leitz said that ten 35 mm pictures equal the cost of one photo made on a plate. A further result was that cameras were built to accommodate the respective format of the film—depending, of course, on the efficiency of the film material.

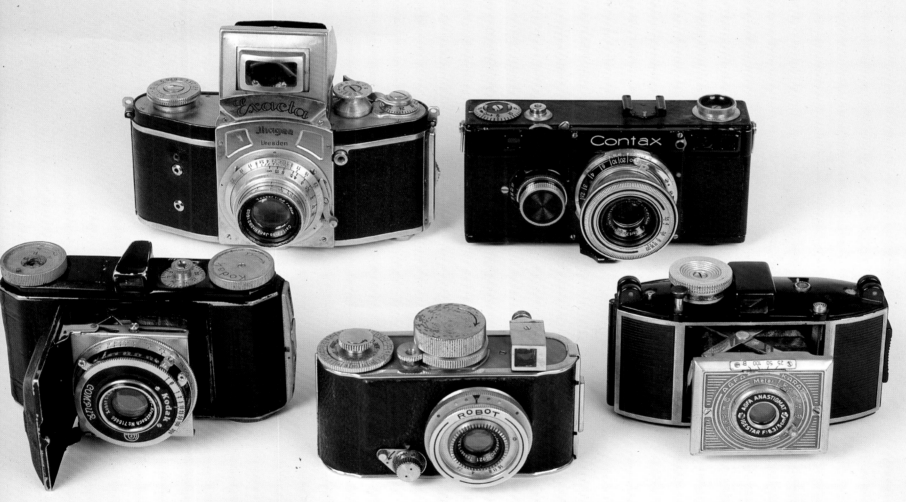

Kine-Exakta, 1936
Single-lens reflex camera for 35 mm format
(Sterckshof Museum)

Contax, 1932
Rival model to the Leica

Retina, 1934
35 mm folding camera with retractable lens

Robot, 1934
35 mm camera with automatic film advance

Agfa-Karat, 1937
With automatic film threading

(Above four models: Agfa-Gevaert Foto-Historama)

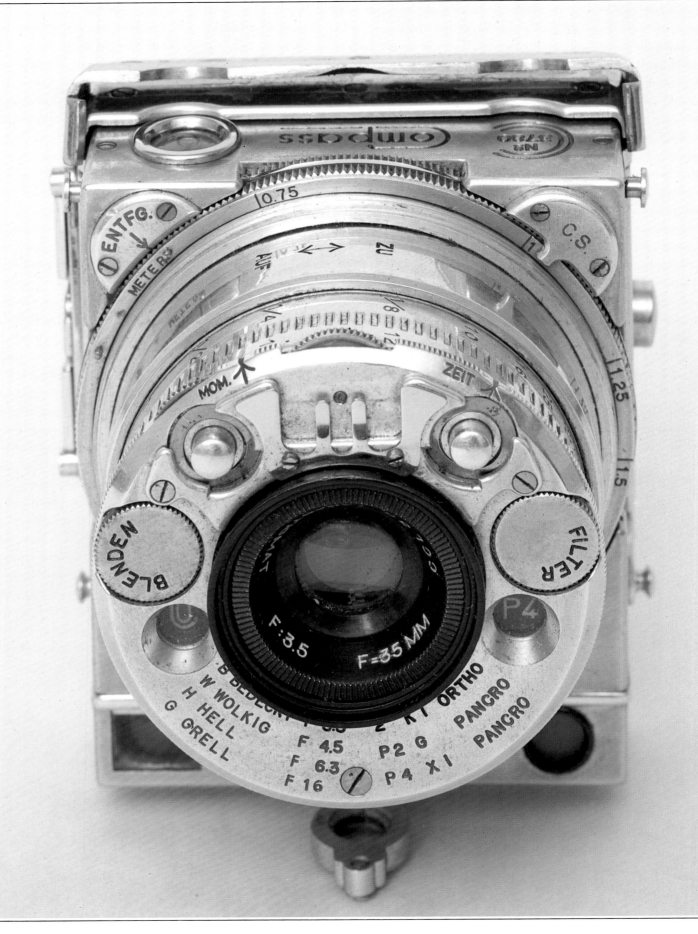

Mini-Cameras. Compared to the enormous cameras of the beginnings of photography, the mini-cameras seem like toys. In many cases, they are miniature editions of their larger counterparts; just as often, they are the end product of independent developments incorporating special refinements. The best-known model of this type is the "Minox." Adequately improved film material made miniature photography possible.

"Mini-Fex" with Astro Telemeter, 1932
For roll film, 14 × 18 mm ($^1/_2$" × $^3/_4$")

Krauss Photo Revolver, 1921
Camera back designed to hold 48 plates, 18 × 35 mm ($^1/_2$" × 1$^1/_3$"), or roll film for 100 pictures.

"L'Aiglon," 1934
For eight pictures, 12 × 14 mm ($^1/_2$" × $^1/_2$")

"Minox," 1937
First model of miniature camera still built today without basic modifications. 50 exposures, 8 × 11 mm ($^1/_3$" × $^1/_2$")
(Agfa-Gevaert Foto-Historama)

"Compass" of 1937
Special features of this miniature camera built in Switzerland by Le Coultre: coupled range finder, bright-frame view finder, optical exposure meter, built-in filters, panoramic head, interchangeable camera backs for 35 mm film or plates. Despite all these extras, the camera is only 5.7 cm (2$^1/_4$") high.
(Museum of Technology)

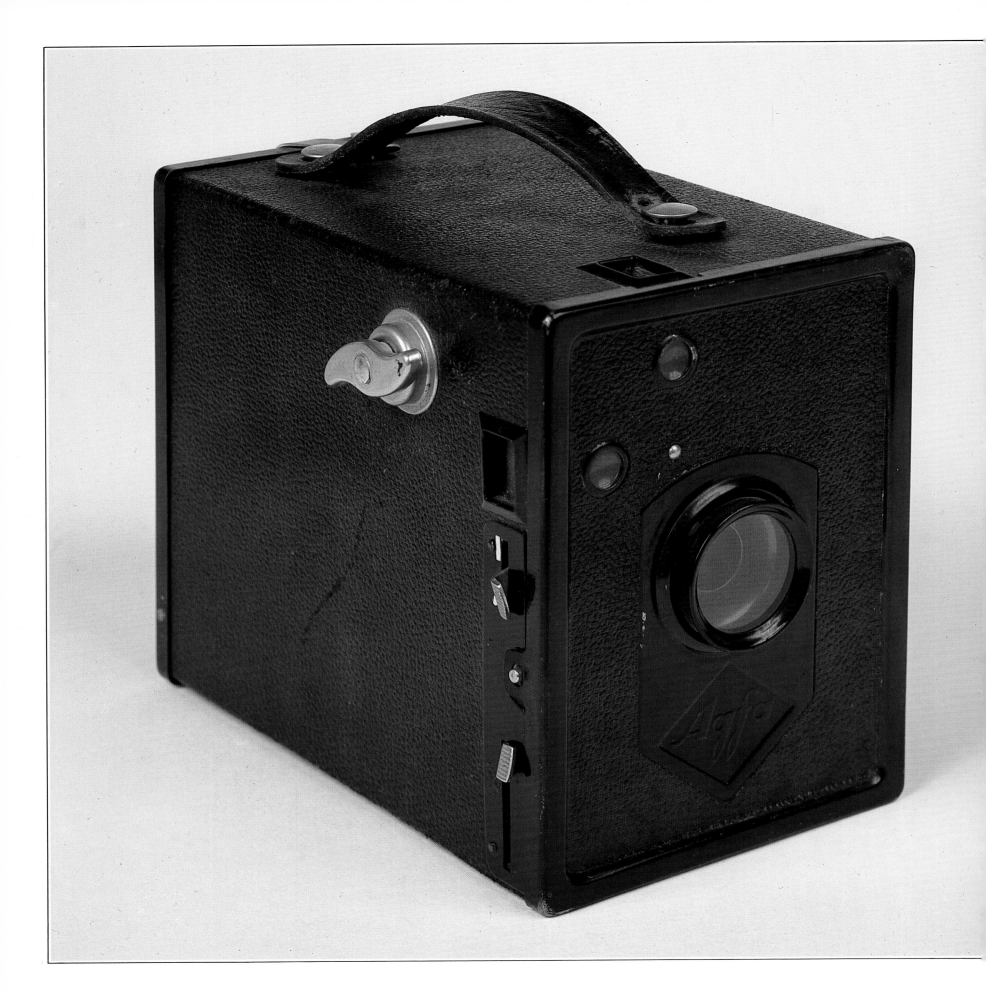

Four Marks(*) Was All It Took.

A phenomenal success was based on a curious idea. In order to stimulate the sale of film material, Agfa began to sell its "box" below cost in 1932. The result was entirely unexpected. The advertising slogan that "four Marks could get you the camera with the four letters AGFA" generated such a demand that 800 additional workmen had to be employed to satisfy the needs. Within few months, more than one million cameras were sold—the throes of a world economic crisis notwithstanding.

(*) $ 0.95

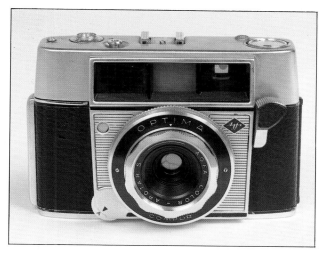 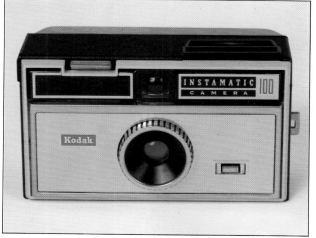

Agfa Optima, 1959
The first camera featuring automatic exposure control. Dr. Rudolf Kremp had simultaneously solved two problems while pursuing one idea: always accurate exposure and the necessary consistency required for the processing of the color photograph. Thus, for technical reasons in the laboratory, a type of camera was created which allayed the fear of many a hobby photographer of not being able to handle the technical aspects of photography.
(Agfa-Gevaert Foto-Historama)

Kodak Instamatic, 1963
This mass-produced camera's popularity was based on two aspects: the simplification of operation by merely adding new cartridges, and a color photograph obtained at low cost through automation. Here, too, the automatic exposure control was a prerequisite.
(Sterckshof Museum)

Agfa Box Camera, 1932

A Picture That Made History. This photograph showing American soldiers hoisting the U.S. flag on the Japanese island of Ivo Jima in the Pacific is typical of the profession of the war correspondent—always in the dead center of action. Although the photograph was posed for subsequently, photographer Joe Rosenthal was awarded the Pulitzer prize for it. It was made with a Graflex on February 19, 1945.

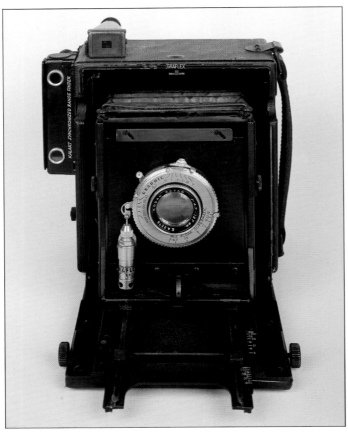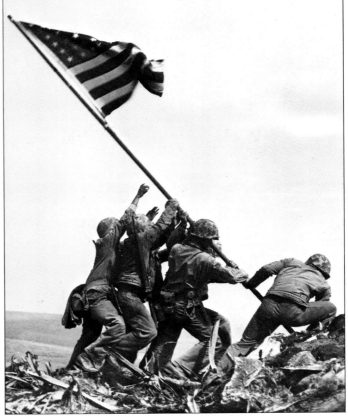

Graflex Folding Camera, 1935
Easy to operate due to its coupled range finder, the Graflex was the typical press camera in America during the 1940's and 1950's. The back of the camera provided space for plates or roll films.
(George Eastman House)

Early Studio Camera, circa 1925
Austrian photographer Heinrich Kühn designed the model for all later studio cameras in 1916. He based his design on the "David Watzek Camera" of 1895. Kühn's instrument was built by the Berlin camera factory Stegemann. The first camera using the monorail-mounted system ("optical bench") can be traced back even further: it had been designed by another Austrian, Petzval, in 1857.
(Sterckshof Museum)

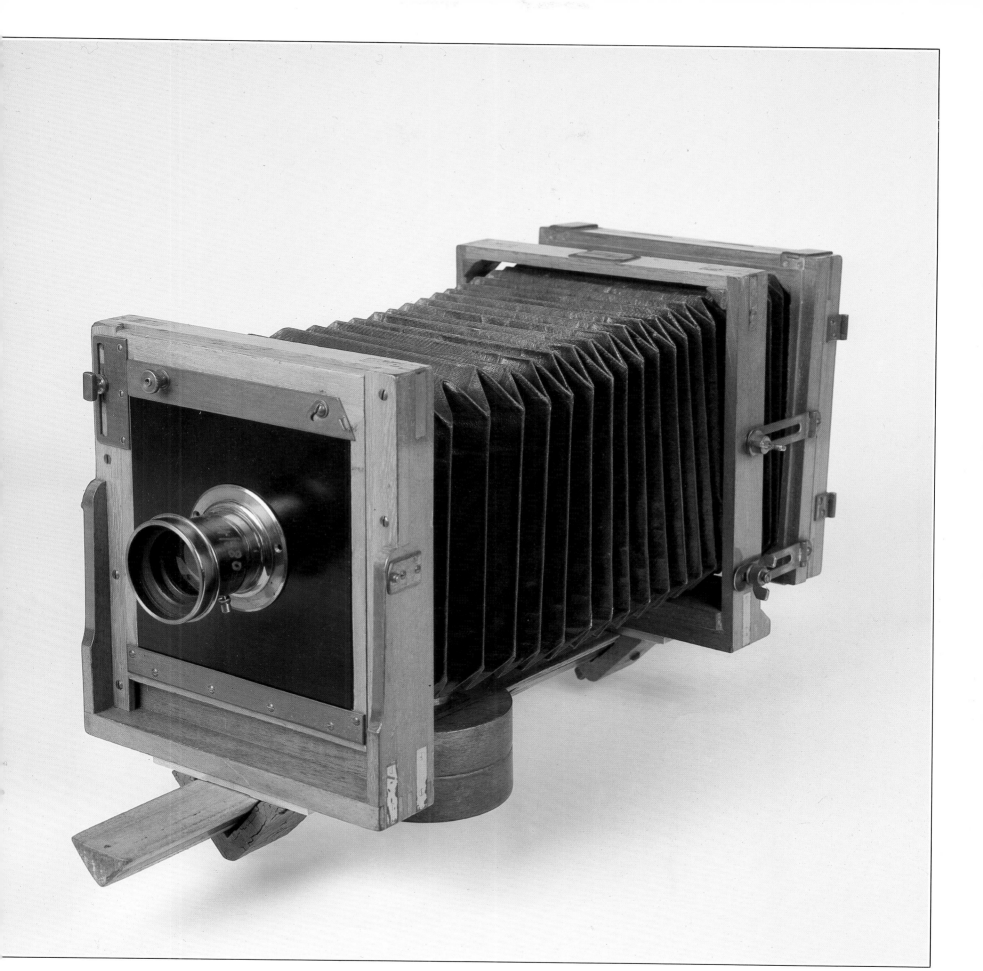

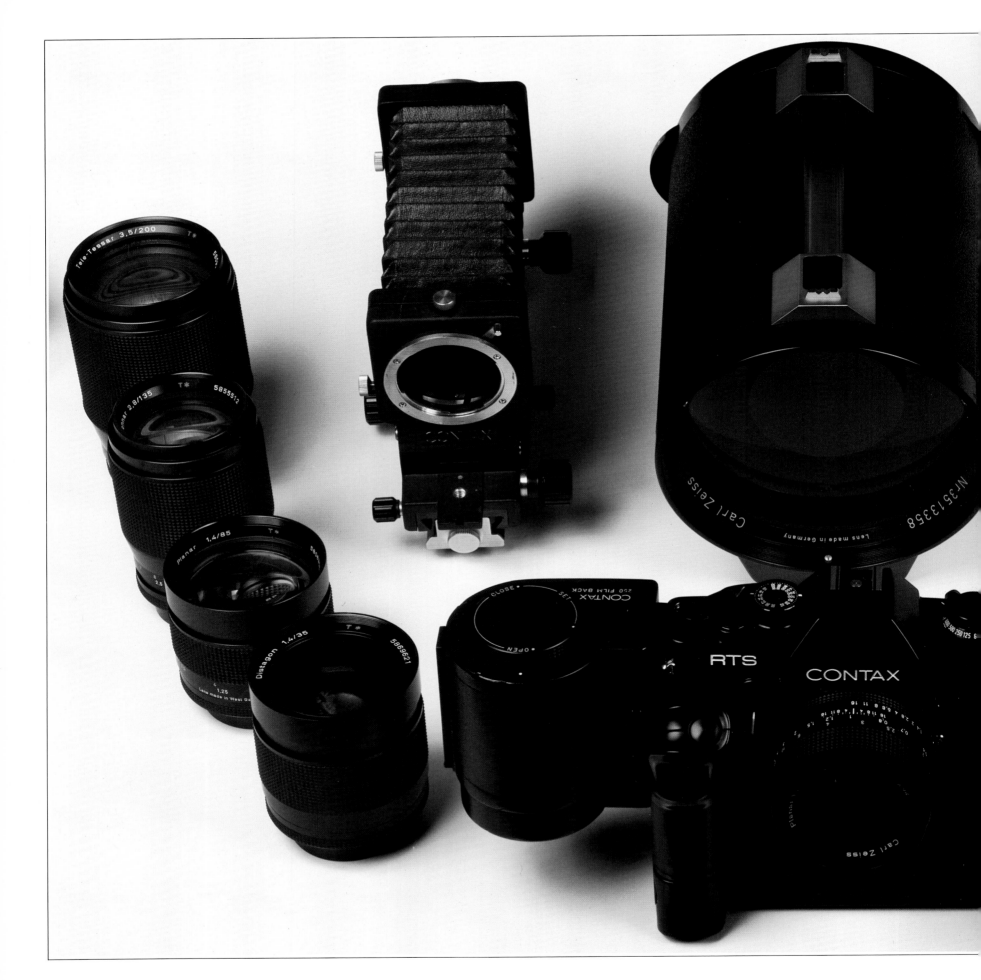

A challenge from Japan. It has been a long time from the days when the impression was that mainly imitations came from the Land of the Rising Sun. The Japanese pioneered through-the-lens-metering, they intensified the use of electronics in camera construction and perfected the multi-coating of lenses. Amateur photography owes decisive impulses to Japanese ingenuity in precision engineering—and also the largest choice of system cameras. A top model: Contax RTS—a camera built by Yashica and fitted with Carl Zeiss lenses. The venerable name now stands for ultra-modern electronics, superb lenses and design by Porsche.

Contax RTS
Single lens reflex camera; shutter electronically operated for diaphragm preference. Accessories: lenses from 15 mm fisheye to 1000 mm tele; winder; motor drive; bellows extension device; magazine for 250 frames; infrared release; data back etc.

The One-Minute Photograph. The beginnings of instantaneous photography are marked by two patents and the persistence of a little girl. The patents were granted to André Rott (Gevaert) and Dr. Edith Weyde (Agfa) for their silver salt diffusion method in 1940/41. The question "When can I see my picture?" was put to Edwin H. Land by his young daughter. A year later, the father could provide the answer: "In one minute." His Polaroid process is based on the same method as Rott and Weyde had developed for office copying purposes. It was contingent on the principle that the unexposed and underdeveloped silver halides spread from the negative onto the positive.

Polaroid Model 95 of 1948
Edwin H. Land built his own cameras for his instant photography
method. For his most recent model, the SX 70, he took out 144 patents
and built five factories. The color process "Polacolor" was introduced in
1963.
(Agfa-Gevaert Foto-Historama)

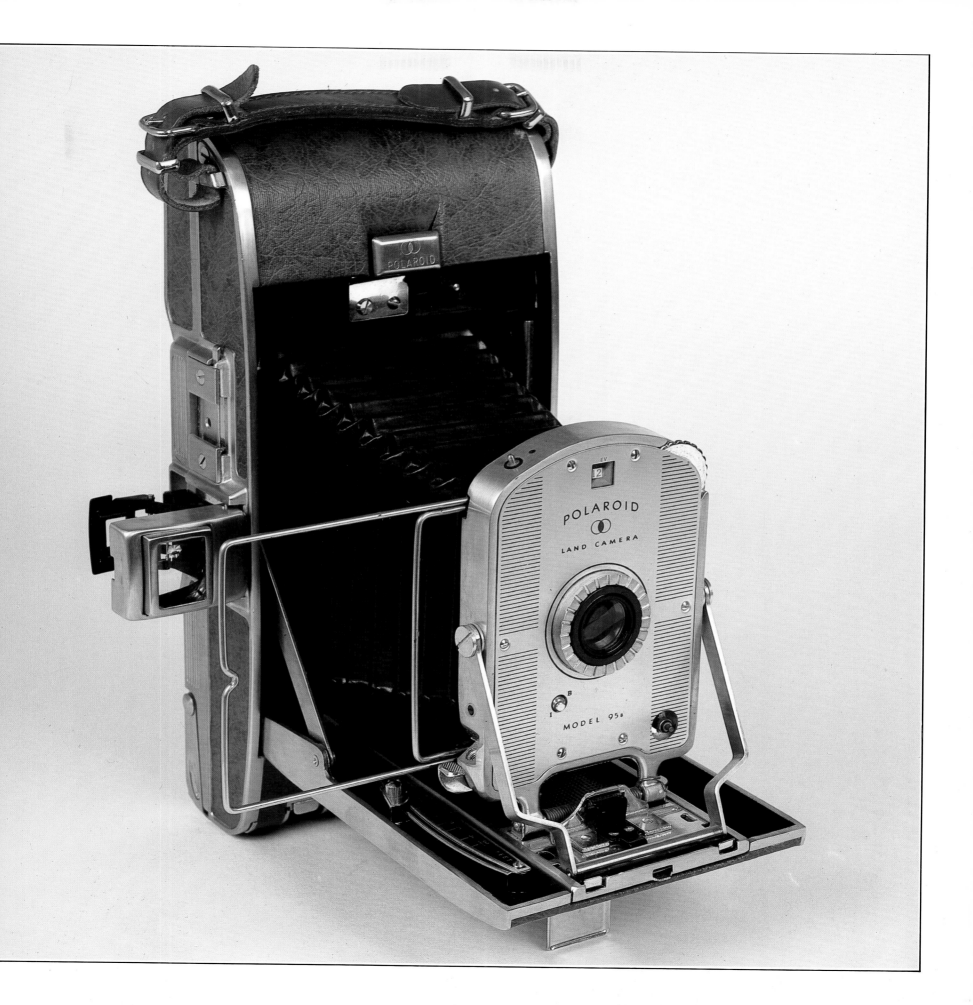

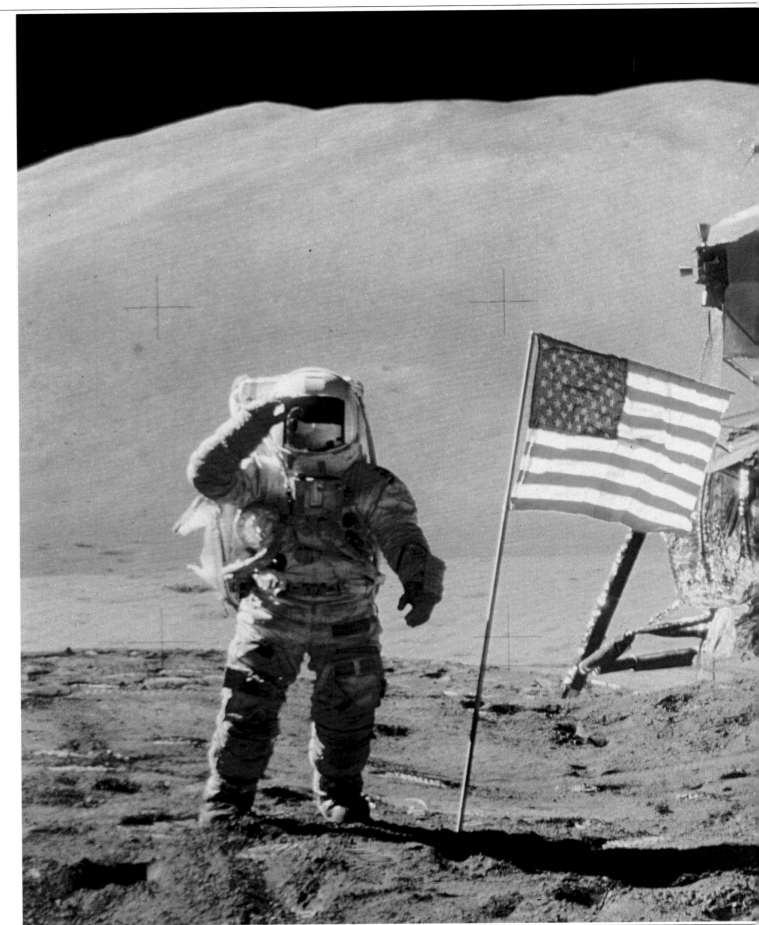

The Most Expensive Photograph of the World
The Apollo 15 space mission cost approximately $ 450 million (July 26 to August 7, 1971). Astronauts David R. Scott, Alfred M. Warden, and James B. Erwin returned from their excursion to the moon with this photograph. It was made with a Hasselblad camera.

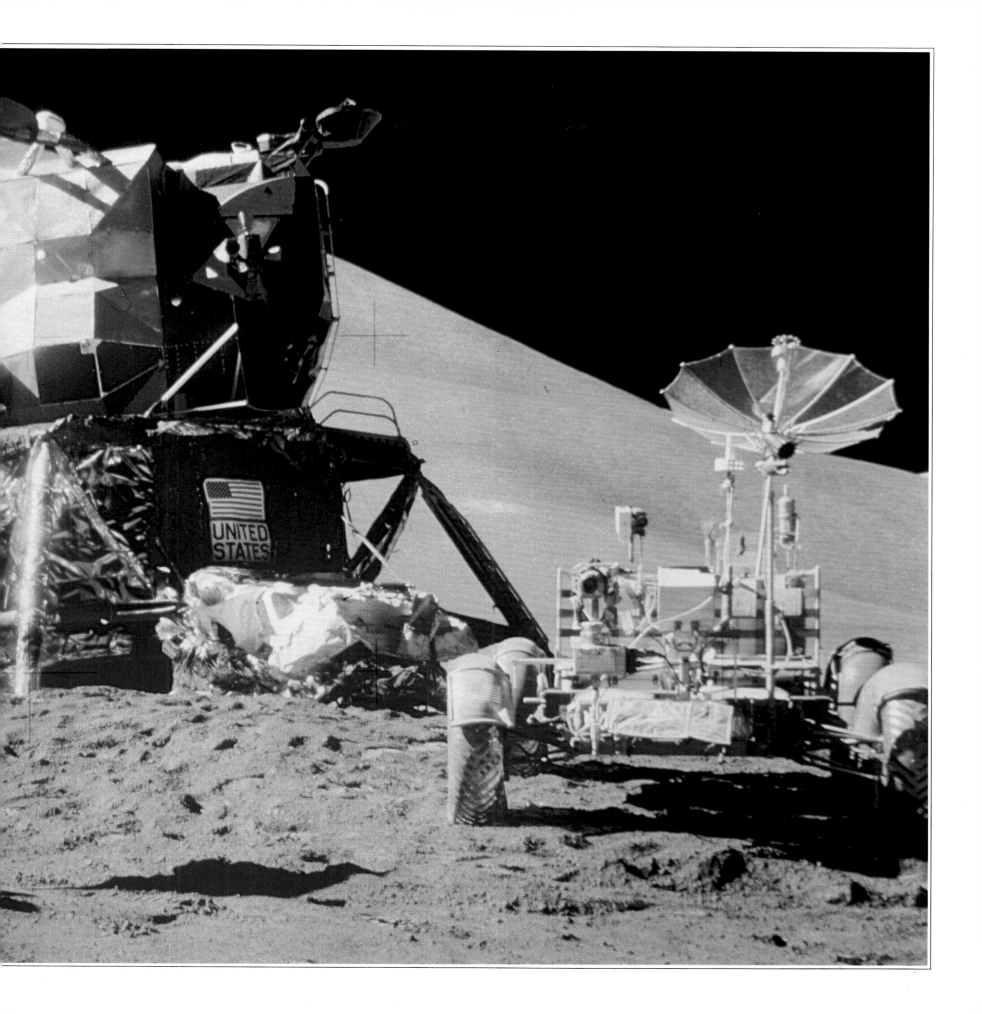

Every era has its masters—be it in painting, music, or literature. Photography, too, had its masters, with a particular talent for observing and perceiving. Despite technical obstacles, pictures were created whos serene expression and harmony, as yet untouched by the disturbing pace of our time, fascinate us with their power. Pictures that reflect man's age-old desire to capture time in a single moment.

On the following pages, 14 pioneers of photography demonstrate the beauty and the possibilities of this new medium with a respective example from their treasure-trove of photographs.

David Octavius Hill, 1802–1870, and Robert Adamson, 1821–1848, produced the first masterpieces in the history of photography: remarkably impressive portraits of prominent contemporaries.

The Scotsman Hill had been known as a landscape painter when, in May 1843 in Edinburgh, he witnessed the dramatic departure of 155 ministers from the Presbyterian Church and the foundation of the Free Church of Scotland immediately thereafter. This scene so impressed the painter that he felt inspired to record the founding ceremony on a gigantic painting. The ministers, however, could not pose for the artist and left Edinburgh to return to their respective communities. Hill resolutely clung to his idea, but found no way to realize his project—until the physicist Sir David Brewster suggested that he produce individual Calotypes (the paper negatives later called "Talbotypes") of each pastor and use them as models for his painting. (The number of the rebellious clergymen had grown to 386 in the meantime.) Since Hill lacked the necessary knowledge of photography, Brewster introduced him to the 22-year-old Robert Adamson, who had given up his career as an engineer and had turned his attention to photography and the production of Calotypes.

The two men joined forces and set out to transform the terrace of Hill's house in Edinburgh into a studio, complete with furniture, draperies, etc. Here most of their photographs were taken. Their portraits of the pastors won such acclaim that soon the majority of the Scottish society requested to be portrayed. The artistic conception of the two partners, their perfect sense of form, their instinct for daring and simple composition, and their emphasis of individual characterization, received unlimited praise. With Hill arranging the details in front of the camera, and Adamson functioning as technical expert behind it, the team produced pictures that, in contrast to quick snapshots, were well-arranged and harmonized portraits.

Between portrait sessions, Hill and Adamson took photographs of landscapes, rural scenes, views of Edinburgh, and the life of seamen in the fishing village of Newhaven. Some of the seamen were portrayed in a way that recaptured the flavor of Nelson's crew.

When Adamson, who had long been in poor health, died in 1848, Hill abandoned photography and took up painting again. In 1866, he finished his monumental painting of the 386 fathers of the church, which included immortalizing himself and Adamson with the camera as well as a number of his friends.

Miss Binny and Miss Monro, 1843–1848

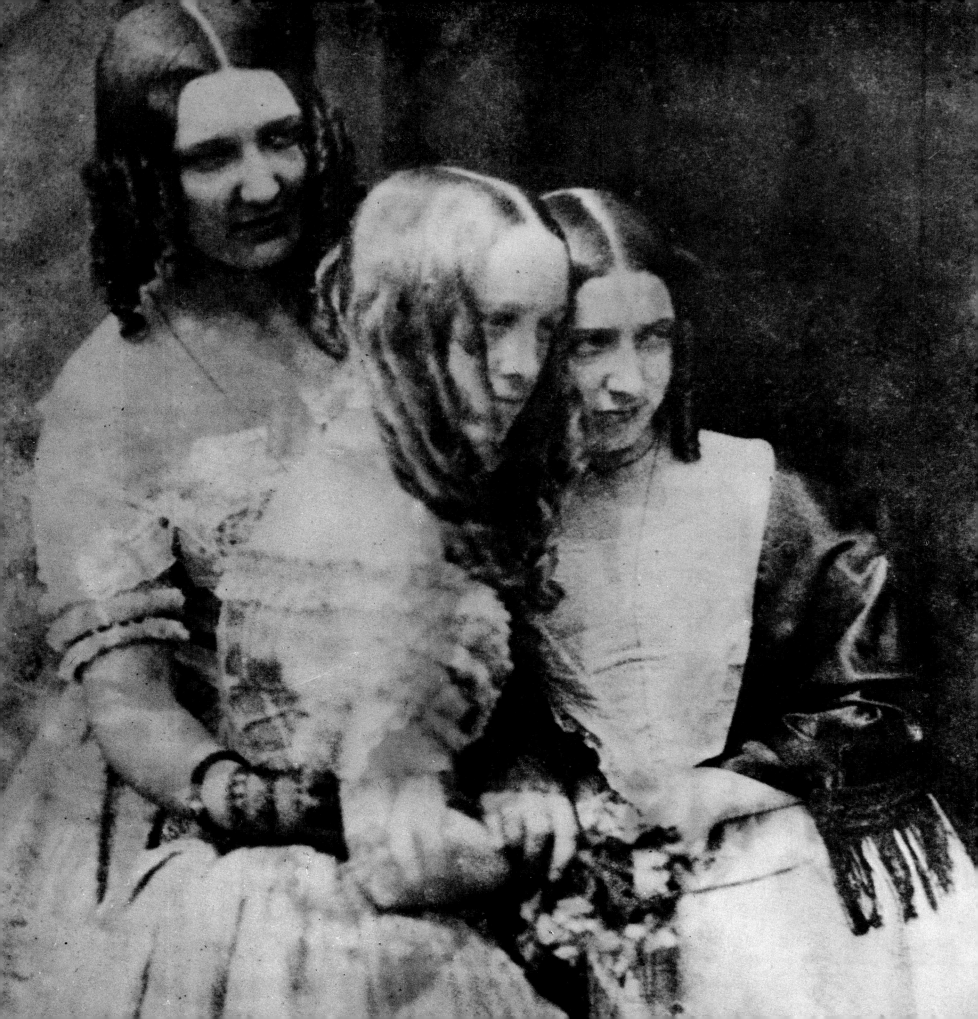

Roger Fenton, 1819–1869, was the first war photographer. Ever since the "eye" of the camera had become a scrupulously objective observer on the battlefield, war assumed a new dimension; everyone could now *see* the cruelty of killing and being killed.

Fenton was the son of a member of parliament. After completing a law degree in London, he moved to Paris, where he became a student of the well-known painter Paul Delaroche. Two years earlier, Delaroche had received the news of the Daguerreotype with this statement: "As of today, the art of painting is dead."

Back in England, Fenton, along with eleven others of similar interest, founded a club for photographers. In 1853, the recently established Photographic Society in London elected him its secretary. A year later, Fenton became a professional photographer. His specialty were photographs of ancient cathedrals and historical ruins, which were characterized by astonishing effects of light and shadow. Queen Victoria made Fenton the first court photographer. His pictures of the royal family, particularly those of the princesses, were admired at court with great reverence for the new medium.

After the outbreak of the Crimean War and the death of British photographers on board a troup carrier in a violent storm near Balaklava, Fenton moved to the war front in 1855. During a lull of action of several months during the siege of Sevastopol, he portrayed the life in the encampments of the communications unit and the improvements of formerly inadequate conditions with respect to clothing, food, and sanitary facilities. He made 360 pictures in the field, but hardly any of them conveyed the ferocity and destruction of war. The idea of blood and violence offended the delicate sensibilities of the Victorian era. Thus, all Fenton reflected of the war were views of naval bases, generals assuming proud poses, the camps of the communications unit, as well as soldiers of all ranks in their quarters, on horseback or sipping champagne—interspersed with glimpses of a few destroyed positions, which,

however, in no way portended the horrors of war.

After the war, Fenton resumed his former occupation of photographing English architecture and landscapes. At an annual exhibition of the British Photographic Society, he displayed two pictures entitled "Nubian Water Carrier" and "Female Egyptian Dancer," which stirred consternation and earned him the reprimand of misguided taste. But he was soon forgiven, for at subsequent exhibitions he again presented timely photographs of still life showing flowers, fruit, and game.

At the peak of his photographic creation in 1862, Fenton suddenly and unexpectedly abandoned his photographic pursuits and, without ever revealing his motives, returned to his solicitor's chambers.

Fenton was one of the most prolific and versatile photographers of England.

L'Entente Cordiale, 1855

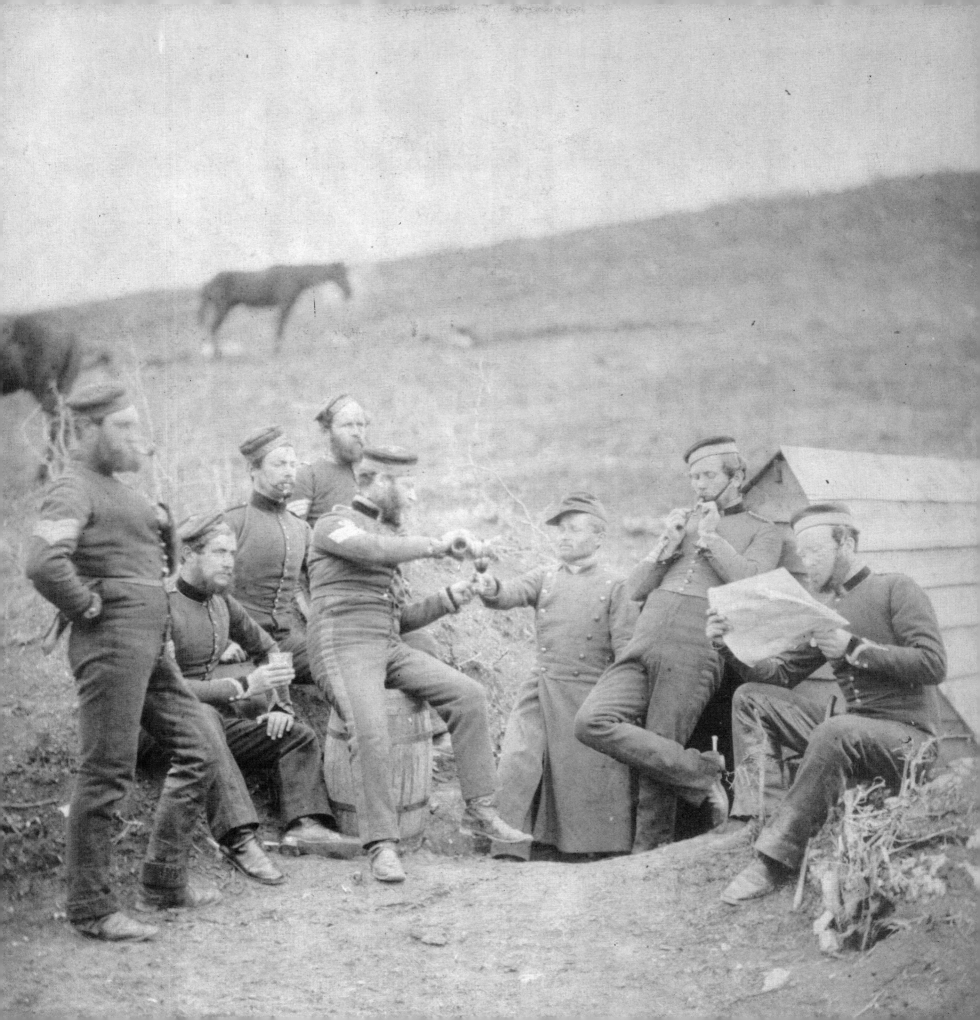

<u>Nadar</u>, 1820–1910, was the leading portrait photographer of France. He was also the first to take photographs underground and from the air.

Born in Paris as Gaspard Félix Tournachon, Nadar studied medicine in Lyon. After the revolution of 1848, in which he fought on the Republican side, he became interested in photography.

At that time, he had already made a name for himself as a scathing caricaturist, that is, the nickname "Tourne à dard" (Barbed Wire). He shortened this sobriquet to "Nadard" (later "Nadar") and adopted it as his nom de plume.

In 1853, he opened a studio together with his brother Adrien on the Rue St. Lazare. In 1859, he moved into a studio of his own on Boulevard des Capucines, which soon became a meeting place of the Paris intelligentsia. His first portfolios contain a wealth of fantastic pictures of eccentric characters: "ladies of the camellias" in reflected ballroom scenes, Dickensian pickpockets in affected poses, bizarre outdoor picnic scenes. The erstwhile caricaturist was also fond of portraying washerwomen, Spanish dancers, or boxers.

Whenever possible, Nadar made his portraits in full sunlight, which illuminated his models from the side—a method admired as a foreign novelty in Paris at that time. His photographs were masterpieces in their heretofore unknown sharp definition of detail. He allowed his models to choose their own poses and expressions, but very seldom were they permitted to show their hands on half-length portraits. He deliberately avoided artificial backgrounds. No one in the Paris of the Second and Third Republics who counted himself among the prominent elite failed to patronize Nadar's salon —Victor Hugo, Balzac, Berlioz, Daumier, Delacroix, Gustave Doré, Dumas, Théophile Gautier, Liszt, and Rossini were all habitués of the famous circle. George Sand and the young Sarah Bernhardt were flattered to be portrayed by Nadar, for it was his usual custom to strictly refuse to photograph women.

In his studio, too, he gave the Impressionists a chance to mount their first exhibition, which Monet akknowledged gratefully: "Nadar, the great Nadar, who is as essential to existence as the daily bread, gave us this room."

In 1855, Nadar began to experiment systematically with artificial light, on which subject he held lectures at the French Society of Photography three years later.

Concurrently, he conceived of the idea to take photographs from a balloon for the purposes of topographical survey and the production of maps, and had his method patented. In 1858, he took the first aerial photograph from a balloon. During the insurrection of the Commune in 1870/71, he was in command of a balloon corps. Always a staunch Republican, he rejected Emperor Napoleon III's request to make available his aerial photographs to the French army.

At the same time, he managed to make astonishing underground pictures; using an arc lamp, he photographed the catacombs and subterranean canals of Paris.

The Painter J.-F. Millet, circa 1858

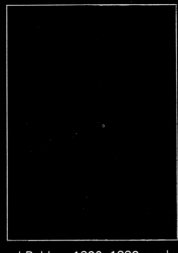

<u>Edouard Baldus,</u> 1820–1882, ranks among the foremost photographers of architecture of the nineteenth century. Born in Westphalia, Germany, and a naturalized Frenchman, he was a painter by trade. Beginning 1851, he worked for the Comité des Monuments Historiques.

Baldus was probably the first photographer to have attained his leading role in a professional contest. In 1853, the French government solicited bids for a contract to photograph all major national monuments. Of the various applicants it selected the five best ones and, with an allowance of 3,000 francs, sent them on location to take test pictures. Baldus won the competition and soon after set out for Nîmes, Avignon, Orange, Valence . . . Contemporary critics of photography praised his work: "Mr. Baldus is a master of the grand perspective and the wide horizon; his lens spans dimensions which the human eye can scarcely perceive." (Ernest Lacan, 1856)

The professor of photography, H. W. Vogel, of Berlin, reported from the World Fair in London in 1862: "In the field of architecture, it is definitely Baldus who furnished the best work that the Fair offers in this respect. Two prints, in particular, deserve special attention as exemplary specimens: one, a view of the Louvre, another, of the Arc de Triomphe, in Paris, both 31″ × 23″. The photograph of the Arc de Triomphe shows a sharpness and clarity of detail which bring out the minutest ornament and, at the same time, a purity, subtlety, and successful distribution of the gray tones which render the picture extraordinarily alive." In 1854/55—again in the service of the government—Baldus photographed the new wing of the Louvre. He made 1,500 individual photographs, each of which were one-tenth the size of the exposed original.

Along with two colleagues, Baldus subsequently photographed the sculptures of the Louvre and of Versailles. He used a method then which was to become prevalent only decades later: to light objects of art in their entirety as well as in each detail.

In addition, Baldus was an expert in the reproduction of paintings. Less known, however no less significant, are his collections of photographs of the architecture and landscape along the route of Calais to Paris (taken on the occasion of the state visit of Queen Victoria) and the section between Paris and Marseilles (taken at the inauguration of the railway line by Emperor Napoleon III).

Arc de Triomphe du Carrousel, Paris circa 1860

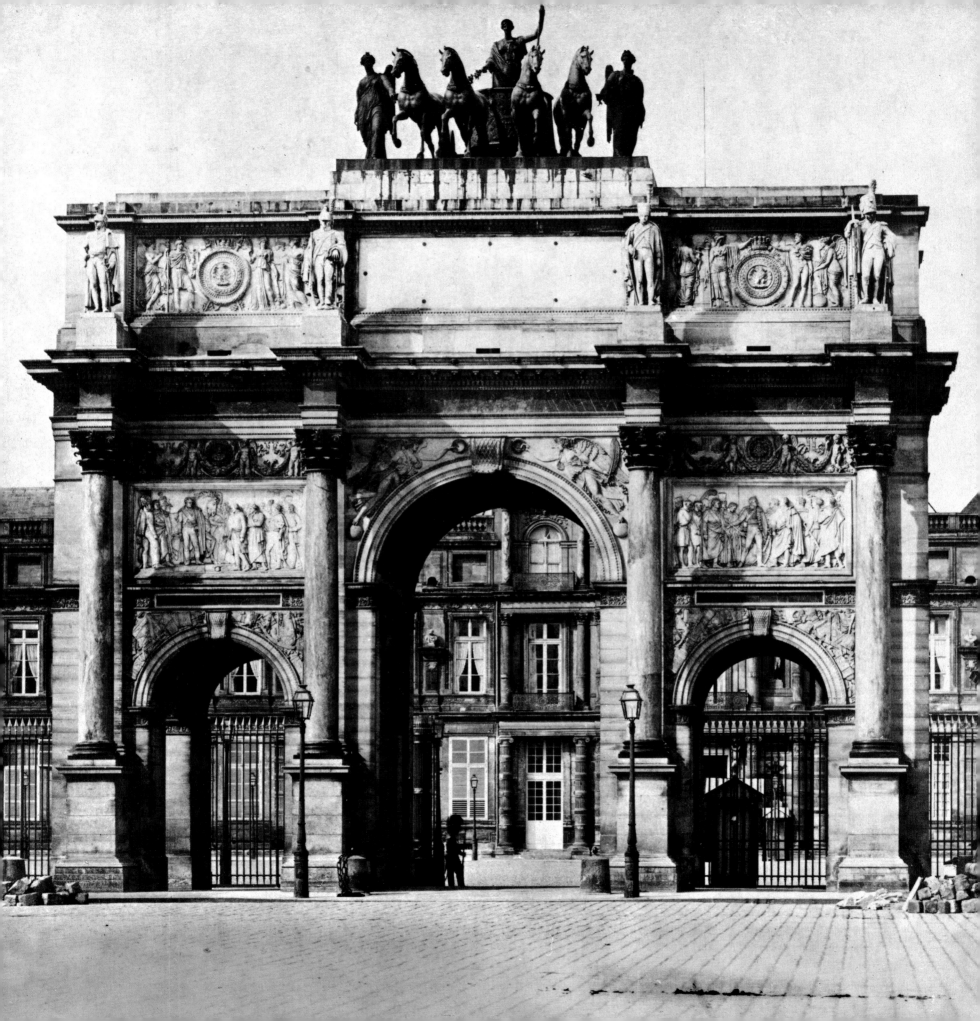

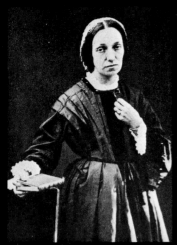

Julia Margaret Cameron,
1815–1879, was one of the most
strong-willed and fascinating
figures among the notables in the
history of photography. Her studies
of people are marked by
psychological forcefulness and
penetration. Of her 3,000
photographs, approximately 60 rank
among the most distinguished
works of photographic art.

Born in Calcutta as the daughter of a
high-ranking British civil servant,
Julia Margaret Cameron became in-
volved in photography at the ad-
vanced age of 49, after her daughter
and son-in-law had presented her
with a camera. The well-situated
Camerons had made their home on
the Isle of Wight, moving in illustri-
ous company, including the painter
Watts and the poet Alfred Tennyson.

After three years of practice, the
self-taught student of photography
(her husband had acquired his
knowledge of law and philosophy by
autodidactic training as well) trusted
her mastery of her new vocation
sufficiently to ask Lord Tennyson to
sit for her.

An entire series of prominent per-
sonalities of Victorian England fol-
lowed the example set by the poet.
Julia Cameron's impressive gallery of
portraits became an excellent reflec-
tion of the great and notable person-
ages of this glorious era. Many of
her photographs read like psychical
landscapes of life.

"Julia Margaret Cameron's por-
traits," said her biographer Helmut
Gernsheim, paying tribute to her tal-
ent, "revealed to the subjects more
about themselves than the mirror."

In 1874, she began to take photo-
graphs for the illustration of Tenny-
son's work "The Idylls of the King,"
although the poet and prototype of
the Victorian era, a master of form
and proponent of lofty moral ideals,
was not a partisan of photography.
As it were, he considered the pho-
tographic sittings an ordeal. The
photographer exposed 245 plates in
order to obtain 12 successful illus-
trations. Her style of these pictures,
as that of most of her work, recalls
the approach of the Pre-Raphaelite
paintings, which are today largely
thought to be affected.

During the 1920's, the writer Virginia
Woolf awakened renewed interest in

Julia Margaret Cameron, who was
her great-aunt, by dedicating her
comedy "Freshwater" to the photo-
grapher and her circle of friends on
the Isle of Wight.

Today, the honest, unpretentious,
and genuinely felt portraits of Julia
Margaret Cameron are considered to
be truly classical, while her unnatural
and self-conscious allegories have
been justly forgotten.

Sir John Herschel, 1867

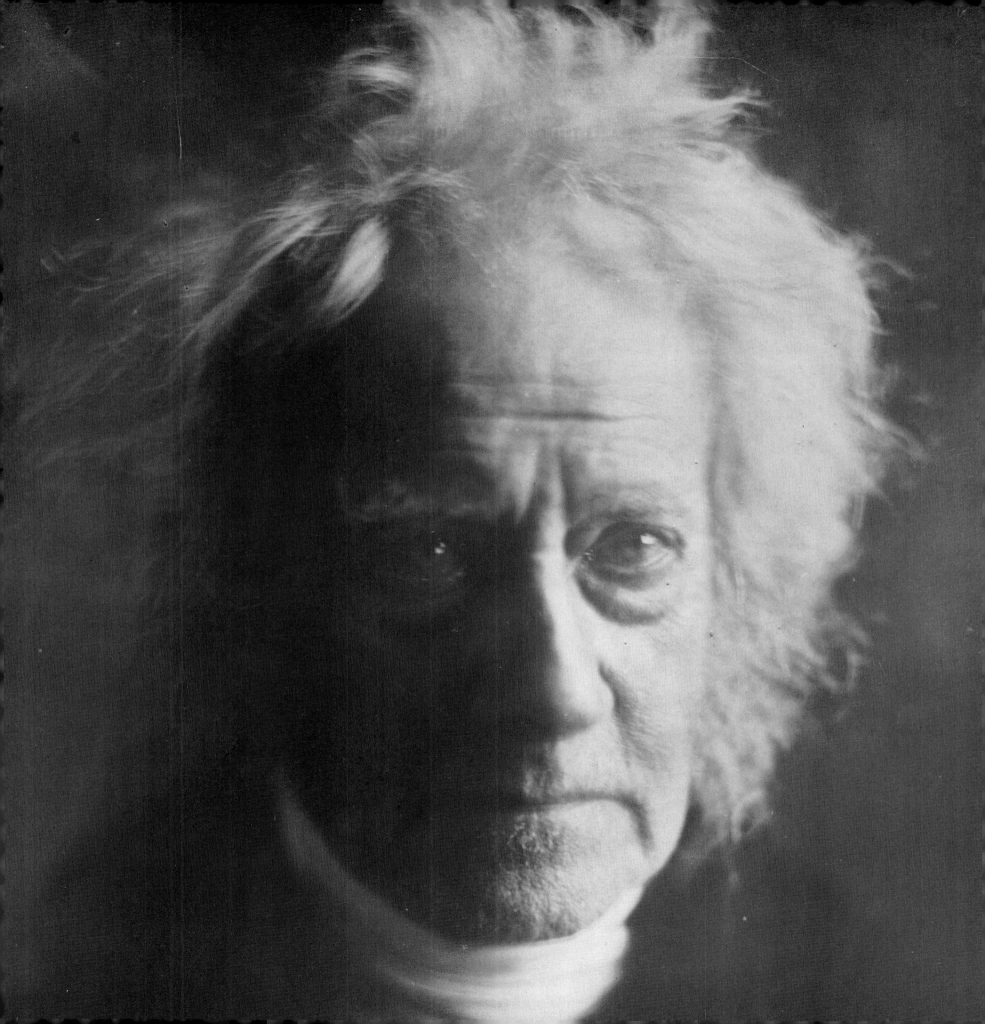

Ottomar Anschütz, 1846–1907, perfected the series picture, a succession of instantaneous photographs of a movement. Among the important photographers in history, this son of a painter from Leszno (the former Lissa), in the Polish province of Poznan, was one of the great tinkerers and dalliers in amateur construction.

After a thorough photographic training in Berlin, with Franz Hanfstaengl in Munich, and finally in Vienna, Anschütz returned to his native Leszno in 1868, where he converted a 33-feet-long furniture van into a mobile studio that would enable him to traverse the countryside.

His specialty became the series picture. While taking photographs of marching soldiers in 1880 and of military maneuvres a year later, the idea occurred to him to mount the focal-plane shutter (which was already known in England, but not yet utilized to full advantage) in front of the photographic plate rather than in front of the lens. It permitted exposure times that were considered sensationally short at the time: hundredths or even thousandths of a second. Anschütz managed to improve the photographic technique to such an extent that "instantaneous" pictures turned out sharp and rich in detail.

A protégé of the imperial family, Anschütz became internationally known and respected in 1883 through his photographic sequences of trotting, galloping, and jumping horses, his pictures documenting the Homburg imperial maneuvres, and the inauguration of the Niederwald monument. That year, the *Leipziger Illustrierte Zeitung* had juxtaposed these photographs and drawings of the same subjects.

A year later, Anschütz published his now famous pictures of storks. He had succeeded in overcoming the skittishness of a pair of storks and in photographing the different phases of its particular behavior in its native habitat. For his later animal photographs he incurred enormous expenses which, when compared to present times, even illustrated magazines can no longer afford. Since the cages of wild animals in the Breslau Zoo did not provide sufficient room or light, he had a large enclosure built and engaged the services of caretakers and assistants to lead each beast into the construction; in addition, he painted huge pictures showing the native environment of the beasts and had them mounted as backgrounds.

In 1887, Anschütz gave a demonstration of the "swift viewer" or Tachyscope—first in the small town of Leszno, then at the Ministry of Culture in Berlin—and created a worldwide sensation. Separate exposures of a walking man and of a trotting horse were arranged on a wheel and turned so swiftly that the observer received the impression of continuing movement. Only a year later, he introduced in Germany and America the Electrical Tachyscope —the progenitor of modern cinematography. At the World Fair in Chicago in 1893, Anschütz's viewing apparatus were still the center of attention—Edison's Kinetoscope being completed only months later.

Anschütz, however, did not pursue the possibilities of the motion picture as he mistrusted the film material then available in Germany. Instead, he perfected his method of producing hair-sharp, fine-grain series pictures and sequences of moving images of human beings and animals. He wrote a text book for beginners in three volumes and designed innumerable accessories for the photo amateur.

Series Pictures of Storks, 1884

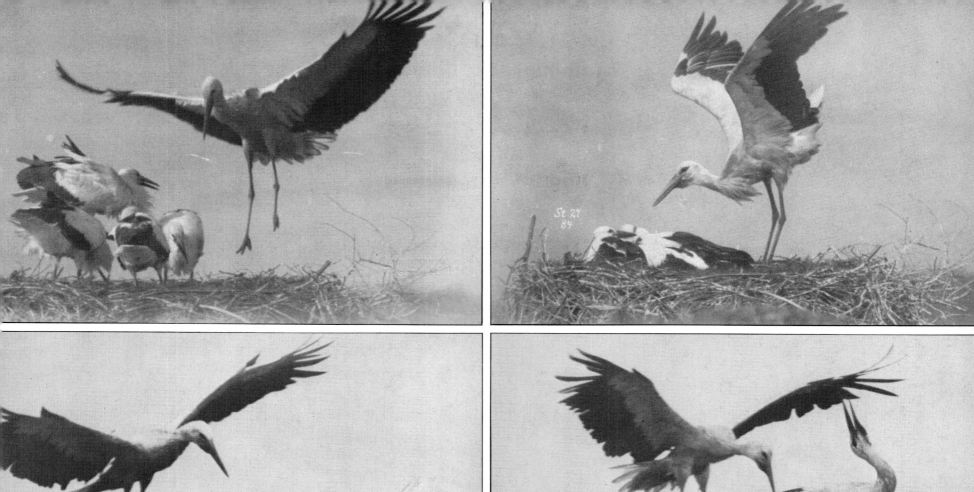

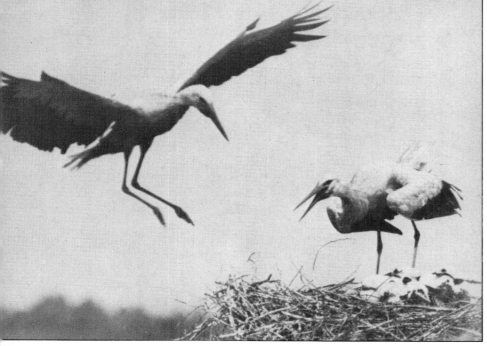

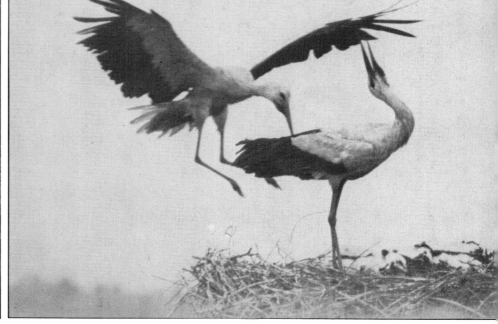

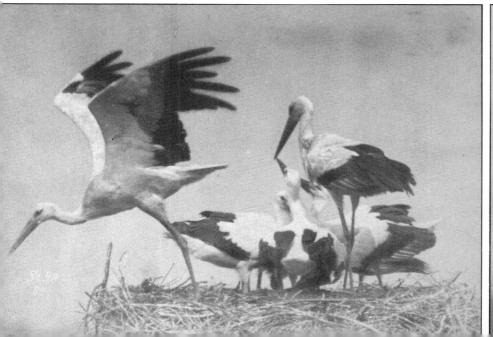

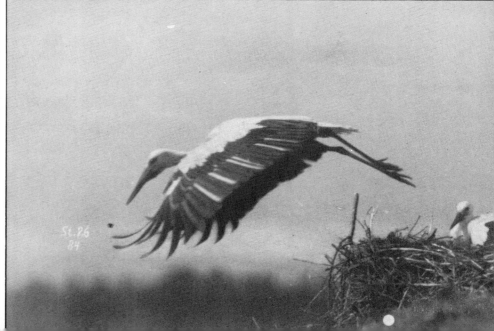

Lewis W. Hine, 1874–1940, elevated the photograph to the level of a "manifesto." Second only to Jacob A. Riis, he was the most consequential social reformer with the camera.

An unskilled worker from Oshkosh near Chicago, Hine attracted the attention of one of his teachers with his enthusiastic interest in art, which prompted the teacher to encourage him in further education and, finally, in university attendance. At the age of 27, Hine began to take courses in sociology at Columbia University in New York, spending his free time as an amateur photographer.

His first series of photographs was concerned with the impoverished immigrants in the quarantine station on Ellis Island. Increasingly, he used the camera as a tool with which to call attention to social misery, with particular emphasis on the oppressive conditions of the underprivileged in the big cities at the onset of industrialization.

By the time Hine was 37, his pictures had generated such strong public response that he relinquished his position as instructor of sociology at a private school and became a full-time professional photographer. The magazine *Charity and the Commons* commissioned him for photographic assignments to cover the squalid and inhuman conditions of the miners in Pittsburgh, the negroes in Washington, D.C., the slum dwellers, the undernourished, children afflicted with tuberculosis.

His photographs of children who were forced to work a 12-hour day on the cotton plantations in the South shocked the nation. Throughout the states of the nation, his pictures carried his moral entreaty: "Let children enjoy their childhood."

A photo series on child labor published in *Survey* earned him a position as photographer of the National Child Labor Committee. With Hine's photographs, the Committee documented the devastating consequences of child labor in pamphlets, magazines, films, and on posters. His pictures aroused such public indignation that the Government was finally compelled to pass a child labor protection law. Hine had shown once again that "photography has the power to act as a weapon with which to change the world" (Cartier-Bresson). During World War I the Red Cross sent him to Europe, from where he reported on the work of the Organization on the battlefields and documented the devastation wrought by the war in the Balkan states.

Upon his return to New York, Hine devoted himself to another major social issue: to focus attention, through his pictures, on the dignity of work. In his book entitled "Men at Work" he bears impassioned witness to human torture during the construction of the Empire State Building. In 1936, he was engaged as chief photographer by a Government research organization for employees questions.

Throughout his professional career, Hine faithfully adhered to his self-imposed mission. In his own words: "I wanted to show things that had to change; I also wanted to show things that deserved recognition."

Washerwomen in New York

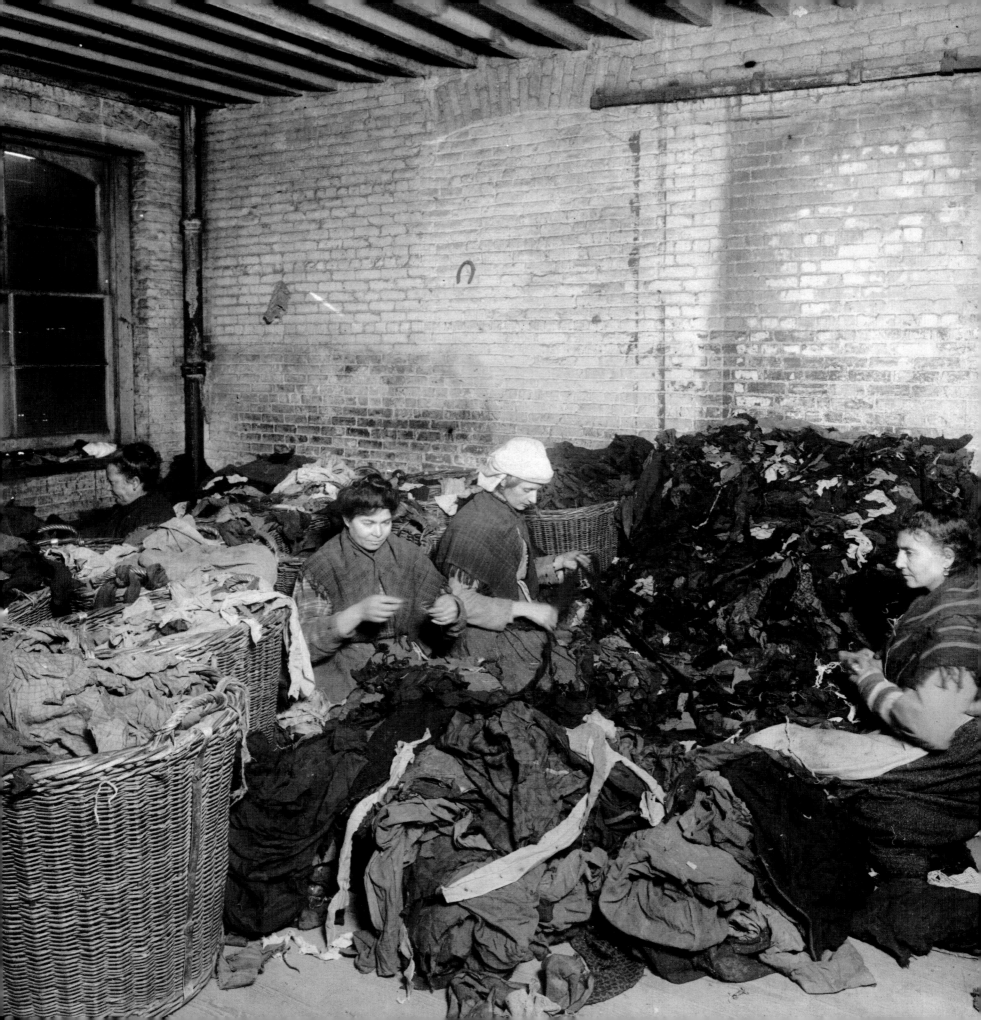

Alfred Stieglitz, 1864–1946, was the most powerful force in the struggle of photography at the turn of the century to be recognized as an independent creative medium. He laid the groundwork for the New Vision in America.

Born in Hoboken, N.J., of German parents, Stieglitz was sent abroad to receive his education and professional training in Germany. While studying engineering at the Royal Institute of Technology in Berlin, his interest in photography was stimulated by the fascinating figure and powerful influence of Hermann Wilhelm Vogel, an autodidactic scientist, who had founded the Photographic Society of Berlin and the publication entitled *Photographic News*. Under Vogel's tutelage, Stieglitz first studied photographic chemistry and the technological problems of photography. Soon, the well-to-do, intelligent, and artistically gifted student—inspired by the opportunities of the evergrowing metropolis of Berlin—also became interested in the creative aspects of photography.

After his return from a visit to Italy in 1886, he achieved his first successes, at a time of rigid poses, with his amateurishly realistic presentations. In the Holiday Work contest of the most important photographic journal at the time, the London *Amateur Photographer*, he won the much-coveted first prize.

In 1890, Stieglitz had to return to America and, as though from spite, devoted himself entirely to photography. He taught his contemporaries the esthetic possibilities and limitations of photography. He worked with a light, hand-held camera, then coming into fashion, which permitted greater creative freedom than any camera necessitating a tripod.

As editor of *American Amateur Photography, Camera Notes*, and particularly *Camera Work* (1903–1917), as co-founder of Photo-Secession, a group of daring innovators, as promoter of a new generation of photographers and of the modern art originating in Europe—Stieglitz, in his famous "291" Gallery on Fifth Avenue, vehemently and vociferously argued his message of purity—that only the genuine, the inherent in photography, was of consequence.

Countless young talents, from Edward Steichen to Ansel Adams, were artistically encouraged and materially supported by him. At the same time, he acquainted the American public with the paintings and sculptures of Cézanne, Renoir, Rousseau, Matisse, Brancusi, Picasso, and Braque. He also worked with the first surrealists, Marcel Duchamp and Francis Picabia, initiating their American debuts.

Despite his widespread activities, which were in part interrupted unexpectedly by World War I, Stieglitz produced a voluminous œuvre, consistently faithful to his insights and teachings. Most celebrated are his photographs of busy street scenes and cloud formations, as well as quiet studies for which his wife, the well-known painter Georgia O'Keefe, was an inexhaustible subject.

Today, the image of Stieglitz in enveloped by cult and legend, and he is honored not only as an eminent photographer but also as an educator, philosopher, and spiritual guide.

Early Morning, 1894

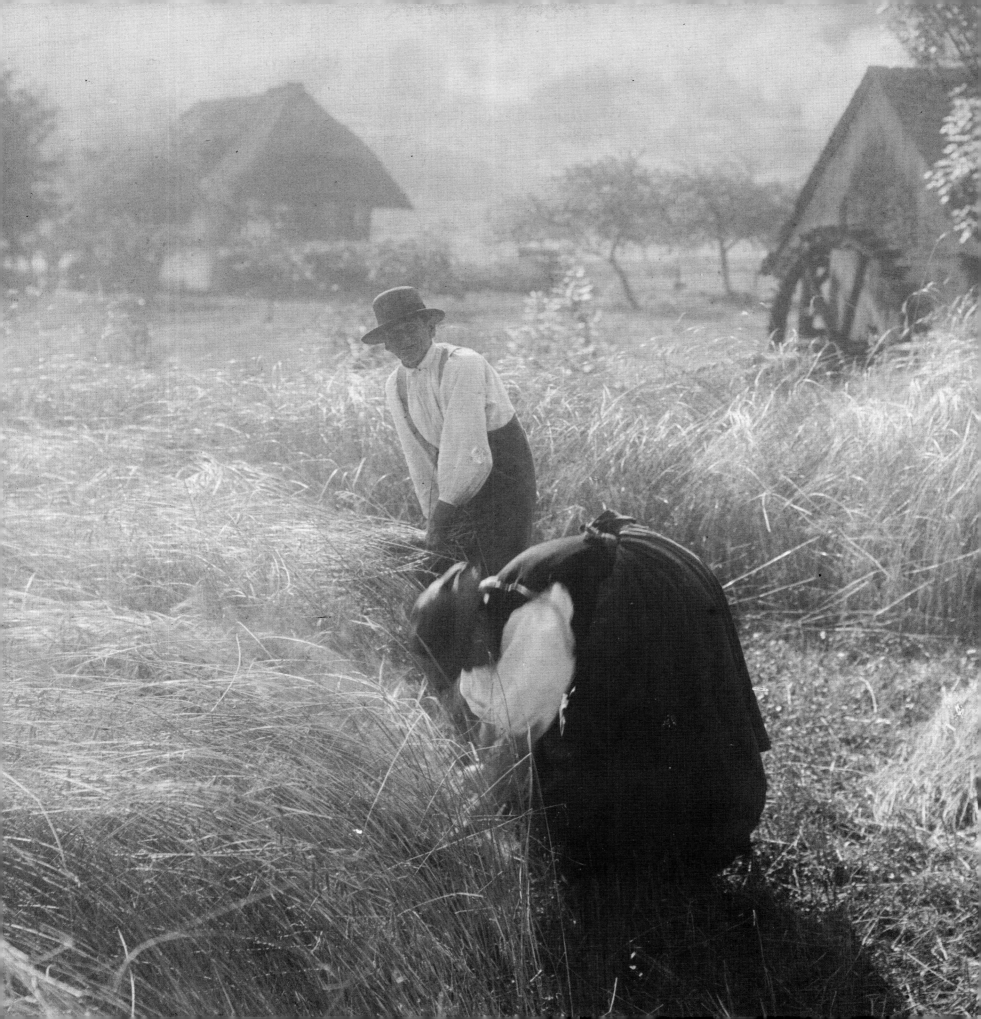

Eugène Atget, 1856–1927, was a classicist of documentary photography. He photographed the city of Paris where, since the turn of the century, he took pictures of the ordinary, the commonplace, every day for more than 20 years.

Atget was a native of Libourne, near Bordeaux. He had been a seaman, a painter, and an actor before turning to photography in 1899. Being penniless, he could only afford a heavy, unwieldy wooden camera and had to work with glass plates. Only Atget's own versatility as a former character actor—playing a père noble one day, a young scoundrel the next—can explain the great variety reflected in his 10,000 photographs of the city of Paris. The concierge in the courtyard and the dining room in the working-class apartment, the jobbing cobbler in the market place and the idlers in a café, the store selling corsets and the organ grinder, Versailles and the Luxembourg Gardens—he photographed them all. Sometimes he saw Paris with the eyes of a François Villon, sometimes with those of an Emile Zola. Nothing seemed forced, nothing posed or unnatural.

As many other colleagues of his time, he did not attempt to "paint" with his camera; for him, the encouraging reminder to "smile" did not exist. He wanted to document life and reality, and his accuracy and rigor were unshakable. His pictures had not only documentary value, however; they also radiated beauty, character, and poetry. Atget's photographs seem like the work of a man who has climbed the highest peaks, without fanfare, and therefore was never celebrated as a hero. Only much later did he begin to be recognized for being ahead of his time. His technique would almost have one believe that some of the optical/mechanical possibilities which were discovered only after him had already been available to him.

Atget's tall, slightly stooped appearance—for everyone who knew him, forever attached to his three-legged photographic instrument—eventually became part of the Paris scene. Quietly and methodically, he photographed the narrow streets of Montmartre and the Quartier Latin, the displays in the shopwindows, building façades, little walk-ups, ornaments—everything that attracted his perceptive eye. His only customers were house owners, a few artists like Utrillo, and the public-record office. His contemporaries were indifferent to him; at best, they saw him as an eccentric. His true worth went totally unrecognized during his lifetime. The photographic chronicler died a poor and forgotten man.

Four illustrated books represent his prodigious work, which was exhibited at the Museum of Modern Art.

As if through a window beautifully framed by the genius of Atget, we can today catch a glimpse of the Paris between 1900 and 1925.

Street Scene in Paris

MAISON DE L'ANNONCIATION

COMPAGNIE BEAUJOLAISE 89

VEN
MEME MAISON
RUE St DENIS 119

F. de LAITONS & BARRETTES
POUR MODES
Mme G. LETHUILLIER
Maurice GREILSAMER Succr

VINS
A
EMPORTER

Livraisons
à
Domicile

DÉGUSTATION
VINS ROUGES

DÉGUSTATION
10,15 & 20
APÉRITIFS DE 1er CHOIX

DÉGUSTATION
DE
VINS
Apéritifs

VINS DE TABLE
ROUGE 30 BLANC 35

BORDEAUX VIEUX 30

LIVRAISONS A DOMICILE

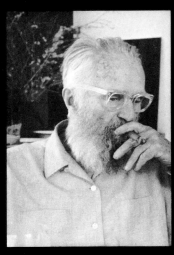

Edward Jean Steichen, 1879–1973, is a representative of impressionistic-pictorial photography as well as of the New Realism. During the 1920's and 1930's, he was among the leading exponents of fashion and portrait photographers of America. His pictures had a decisive influence on European photography.

Steichen's family had come to the USA from Luxembourg in 1881. After high school, he became a trainee in a lithography company in Milwaukee. His ambition was to become a painter, however, when his father gave him a camera as a present, he committed himself to photography. He photographed "Life in the Country" and earned his livelihood by selling pictures of suckling pigs for the production of posters.

At the turn of the century, Steichen as well as so many other photographers at the time came under the influence of Alfred Stieglitz, who proselytized the esthetic possibilities of photography as a member and co-founder of the group called "Photo-Secession" in New York. In order to encourage the gifted youth from the country, Stieglitz bought three of his photographs at $5 each.

Steichen, who was also talented as a painter, moved to Paris, where he befriended Rodin and started to make photographs following the lines of nineteenth-century pictorialism. He was highly motivated by his friendship with Rodin and, at that time, made some of his best pictures. The best-known are his portrait of Rodin and the "Ladies at the Horse Races" in Longchamps. When he returned to New York—and again under the aegis of Stieglitz—he made his very impressionistic photographs of the Brooklyn Bridge.

After the sinking of the Lusitania in 1915, Steichen was drawn by the sea. He soon rose to the post of advisor on aerial reconnaissance photography of the U.S. military forces in France. After the war, he remained in France, trying to develop his own photographic style. In an improvised studio, he undertook intensive measurements for the optimal photographic reproduction of an apple, exposed thousands of negatives showing a white cup and a

sauceboat—until he had discovered the merits of objective, essential reproduction.

After considerable success, and displaying a keen sense for business, he turned to society and fashion photography. Many of the notables of the world sat for him, and within a few years he was considered to be the absolute master of this genre of photography. He was also the highest-paid photographer. *Vanity Fair* and *Vogue* magazines, for whom he worked under contract, made his pictures internationally known.

In the thirties, Steichen took up the even more lucrative business of advertising photography. Just as his earlier portraits, his naturalistic renditions of commercial still life now became milestones in the history of photography. In 1938, being sufficiently affluent, he went into retirement. Four years later, however, the U.S. Navy recalled him to active duty to take command of its photography department.

In 1947, Steichen was again summoned from his retirement, this time by the Museum of Modern Art. He became director of the Museum's department of photography and, in that capacity, organized the magnificent exhibition called "The Family of Man." It was the best-visited photographic show of all time; 10 million people in 69 countries went to see it.

Steichen had finally attained legendary fame.

New York

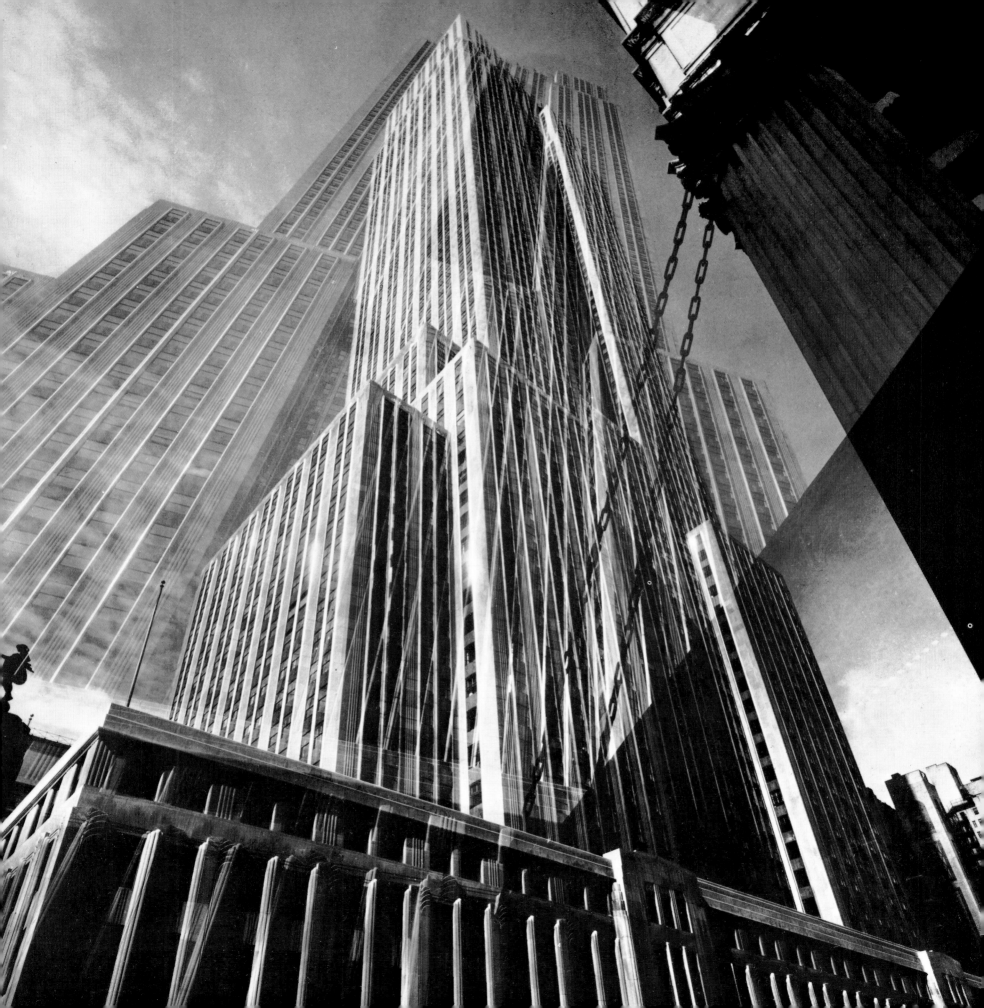

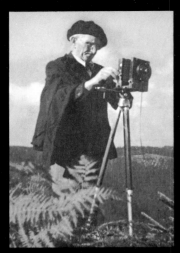

August Sander, 1876–1964, produced a photographic record of monumental proportions: the German "People of the Twentieth Century," which is only now receiving full recognition.

A miner by trade, Sander had his first encounter with the art of photography at the age of 16, when he was asked one day to help out a landscape photographer. From then on, he devoted all his free time to photography, until he was called for military service. He collaborated with a photographer from Trier whom he had met in the service and, in 1899, started his own business. In 1910, he opened a studio in Cologne.

Besides his work in the studio, Sander photographed people in their familiar environment and their characteristic, inherent countenance: the nun, the street sweeper, the local clerk, the butcher, or the candlemaker. In unadorned, archaic fashion, in profound sincerity, Sander put his subjects in front of the camera, standing or sitting.

In 1929, his work entitled "Face of the Times" was published, which prompted Thomas Mann to remark: "This collection of photographs, as finely delineated as they are unpretentious, is a treasure-trove for the student and lover of physiognomy and provides an excellent opportunity to explore the occupational and class-structural imprints on humanity."

Sander took photographs of blind children and men without work, cretins and cripples, with an unparalleled kindness and a deeply felt sympathy—the way Diane Arbus did later, whose work he influenced as much as that of innumerable other young photographers.

August Sander's pictures evince a thematical wholeness and consequence of execution which can scarcely be surpassed. Even the most prominent photographers, such as Edward Steichen, stood in awe before the straightforward simplicity and artless candor of Sander's photographs.

Today, Sander's pictures seem to restore to life the last individualists of a world buried under the rubble of two world wars. Individualists who, in Sander's world, were still firmly tied to their different social strata, which have now been largely equalized.

Alfred Döblin, the German physician and writer, saw in Sander a critic who "writes sociology without actually writing it." Sander's sociological studies of the "People of the Twentieth Century" were based on the portrayal of simple farmers whose miens and bearing reflected the archetypal, the intrinsic quality of man, in its purest form.

The exhibition entitled "The Family of Man" brought Sander's work well-deserved worldwide recognition.

Young Farmers on their Way to the Village Dance (Westerwald Mountains, Germany,) 1914

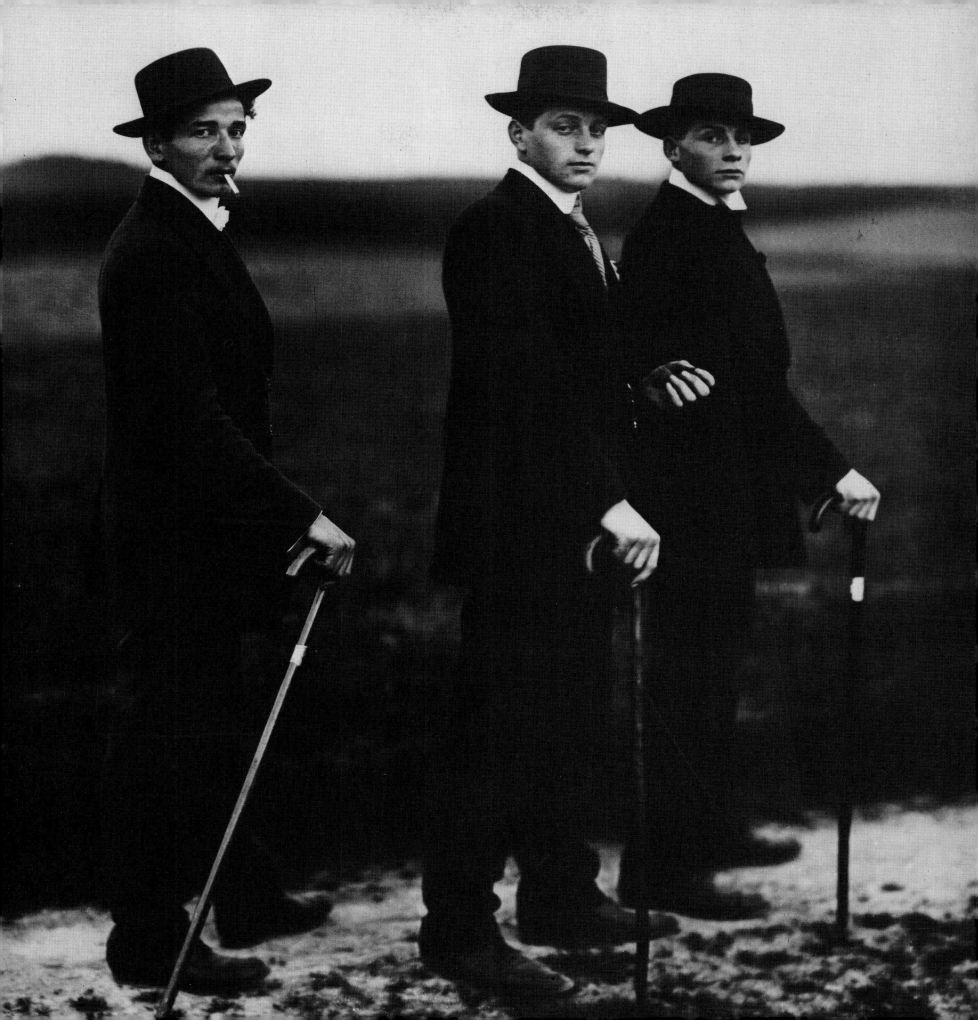

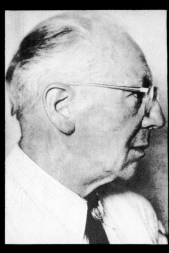

Hugo Erfurth, 1874–1948, counts among the most significant personalities in whose work the traditions of painted portraiture lingered on into the age of photography. In the portrayal of man he towered above all other photographers in Germany.

Hugo Erfurth was born in Halle, East Germany. At age 18, he began his apprenticeship with the court photographer Höffert in Dresden. After graduating to "master" of the craft and a few semesters in painting at the Academy of Arts at Dresden, he took over the studio of court photographer Schröder in 1896. When, in 1906, he acquired the palace of Count Lüttichau and enhanced it with a substantial collection of modern graphic art, his new studio became a popular gathering place of the Dresden cultural elite.

Initially still under the influence of Art Nouveau, he developed a Spartan composition of his pictures after the turn of the century, recalling the austerity of Holbein, in which he purposely employed even front lighting in order to achieve soft tonal values. Through the deliberate lack of depth and reduction of the range of grays, he strove to accomplish the "soft-focus pictorial, boldly simplified form."

Erfurth's portraits inspired the painter Hans Thoma to address the artist in full praise: "I am truly astonished to see that photography can be imbued with such spiritual depth. I have never before seen anything like it and must assume that you are unique in creating this effect."

In Erfurth's portraits, the elements of photography blend with those of painting, in part, because Erfurth had still been a master of the now extinct technique of oleography. This technique softened the "painful hard edges" resulting from the photographic process and elevated these "noble prints" to represent uniquely crafted originals.

When the Dresden National Socialists stigmatized him as a supporter of "decadent art," and therefore a political enemy, Erfurth moved to Cologne in 1934, establishing a new studio opposite the cathedral. There, all his records and the negatives of his work spanning four decades, portraying the notables of the intellectual and artistic world, were destroyed in a single night of bombing in 1943. Only 320 prints that had been deposited in a safe survived—a series of distinguished figures of this century such as Klee and Kandinsky (who were close friends throughout his life), Hauptmann and Hindemith, Haeckel and Harnack, Käthe Kollwitz and Renée Sintenis.

Lovis Corinth, the painter, congratulated the photographer after studying his comprehensive collection of portraits: "If photography can achieve such masterful results, I am compelled to revise my opinion on the subject."

Gerhart Hauptmann, 1933

<u>Dr. Erich Salomon,</u> 1884–1944, was one of the most significant pioneers of modern photojournalism.

Salomon was the son of a Berlin banker. After his participation in World War I, he planned to become a journalist, however followed up an opportunity to join the publicity department of the Ullstein publishing house. There, again by coincidence, he became involved in photography. —After a violent thunderstorm, which had devastated the streets of Berlin, Salomon commissioned a cameraman to photograph the resulting chaos and then offered the pictures for sale. He asked for 10 Marks as agent's commission.

Salomon studied the aspects of the new medium intensively and soon realized that conventional photography was far from having exploited all possibilities. In his opinion, most photographs had a static, unnatural quality; they appeared affected and boring. It seemed to be a question of technique. Indoors, photographs could only be taken with the aid of a flash unit. The preparations were so elaborate and time-consuming that when the shutter was finally released, the subjects had lost all naturalness and stiffened with self-consciousness.

Salomon acquired an Ermanox camera, equipped with a fast lens, and loaded it with special high-sensitivity glass plates (1³/₄″ × 2¹/₃″). It enabled him to take photographs in dimly lit rooms, without the use of a flash gun, that is to say, unnoticed and quickly.

He soon had a chance to prove his talents. During the hearings of a murder trial of a policeman in Coburg, he took photographs in the courtroom through a hole in his hat. It assured him the No. 1 position among photojournalists at Ullstein.

It was not the sensational aspect of his photos, however, that brought Salomon fame, but his portrayal of "Famous Contemporaries in Off-Guard Moments" (as he called his first book), which was often carried

out in a spectacular manner. Wherever prominent personalities, during the late 1920's and early 1930's, conferred, conducted concerts, dined—Salomon was ever-present. No police barricades, secret service, or locked doors stopped him. Eventually, Salomon always managed to come within reach of his victim. He was a master of disguise—whatever the occasion called for, he would be either the impeccably clad refined gentleman or the workman in stained uniform.

Salomon had a preference for politicians at conferences. His lens followed the members of the conference tenaciously until any late-night or early-morning hour. The French Foreign Minister, Aristide Briand, nicknamed Salomon the "King of the Indiscreet;" rather than a reproof, it was meant to be a compliment.

Indeed, Salomon was not particularly interested in the private affairs of the famous. He wanted to be regarded as a chronicler, an "historian," who attempted to portray the involvement and work of the men who were shaping the fate of history. No stylized portrayals, but informal glimpses of men in the midst of thinking, acting, talking.

Salomon, who later traded in his Ermanox for a Leica, was blessed with an unerring instinct for the essence of a person or a scene. His pictures are spontaneous, natural, alive with atmosphere—as though taken by a candid camera.

In 1931, Salomon was able to catch yet another revealing glimpse: the malicious sneer on the face of Josef Goebbels in the Reichstag.

In 1933, Salomon escaped to Holland. In 1944, he was killed at Auschwitz.

For two generations, Salomon's pictures have remained models for the world's foremost photojournalists.

William Randolph Hearst, circa 1930

Albert Renger-Patzsch, 1897–1966, was the leader of the New Realism, a trend-setting movement within modern German photographic circles. Being the son of an enthusiastic amateur photographer, he displayed a true passion for the camera at a very early age.

After graduating from the "gymnasium" and completing military service, Renger-Patzsch studied chemistry in Dresden and later, in Rumania, struggled through the chaos of the inflation as a bookseller, merchant, and bookkeeper. In 1925, he opened a photographic studio in Bad Harzburg. Four years later, he was offered the directorship of the department of photography at the Folkwang School in Essen. The physical change from the idyllic nature of the Harz Mountains to the industrial center of the nation paralleled his artistic metamorphosis from nature-loving idealism to strict adherence to fact and reality.

In 1928, Renger-Patzsch published his illustrated book entitled "The World is Beautiful," a collection of objects and articles of daily life. The photographs created a sensation. They formed the basis for the photographic trend of the New Realism and triggered an optical revolution: the straight-forward, honest representation, the establishment of close contact with the object—whether a simple little object or the vast expanse of a landscape.

The guiding principle of his voluminous as well as significant work was expressed by Renger-Patzsch in these words: "Photography, regardless of its manifold and bewildering complexity, constitutes a graphic process of a special kind. It is neither high art nor a craft. Its value is determined in esthetic as well as technical terms and, given its mechanical nature, it appears to be more suited to do justice to an object than to express artistic individuality."

During World War II, Renger-Patzsch was drafted to serve as a war correspondent and could therefore pursue his photographic documentations only intermittently. In 1944, his studio in Essen, including 18,000 negative prints, was destroyed by bombs. Homeless, he moved to

Westphalia, where he lived until the end of his life.

The German Society of Photography paid tribute to him in 1960 by conferring upon him its highest distinction: the culture prize. The Cologne photographic museum Photo-Kina organized an exhibition in his honor.

All his works of the New Realism period, appearing in his timeless picture books, some of which are mentioned below, are distinguished by exemplary artistic unity, perfect discipline, and incomparable objectivity:

– "Lübeck" (1928)
– "Baked-Brick Cathedrals in Northern Germany" (1930)
– "The Essen Cathedral" (1930)
– "Iron and Steel" (1930)
– "The Land of the Upper Rhine" (1944)
– "The Unchanging World" (1947)
– "In the Forest" (1965)
In 1962 and 1966, the excellent privately produced volumes entitled "Trees" and "Stone" were published, both with a preface by Ernst Jünger.

Railway Tracks

Camera Typology

This general classification of camera designs from 1839 to 1975 is arranged by the following categories:

Box Cameras
Field Cameras
Large Format
Reflex Cameras
Magazine Cameras
Photo Jumelles and Special Types
Box Form
Strut Cameras
Folding Cameras
Small Format and 35 mm
Miniature Cameras
Detective Cameras
Specialized Equipment

From each group, typical constructions are shown; improvements or modifications are disregarded. The classification illustrates, in concise form, the major steps in the technical development.

The cameras are from the following museums and collections:
Agfa-Gevaert Foto-Historama, Leverkusen (FH)
George Eastman House, Rochester (GEH)
Provinziaal Museum Het Sterckshof, Antwerp (STH)
Deutsches Museum, Munich (DM)
Wendel Collection, Düsseldorf
Preus Collection, Norway
Kummer Collection, Munich
Science Museum, London
Sinar, Schaffhausen
Linhof, Munich

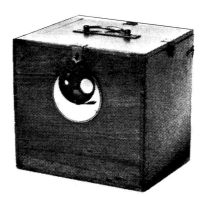

1 BOX CAMERA
Nonretractable
Daguerreotype Camera by Gaudin, 1841
Manufacturer: Lèrebours, Paris
Format: 7 cm (2³/₄") diameter
Presumably first camera with interchangeable diaphragm openings by means of a rotating disc pierced with different-sized holes. (GEH)

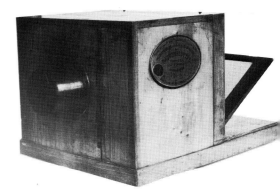

2 BOX CAMERA
Retractable
Daguerreotype Camera by Daguerre, 1839
Manufacturer: Giroux, Paris
Format: 16.5 × 21.5 cm (6¹/₂" × 8¹/₂")
First mass-produced camera. Focusing by sliding inner bo
(DM)

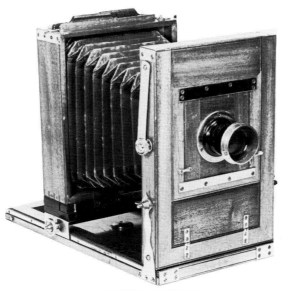

6 FIELD CAMERA
With back housing
Circa 1890
Manufacturer: unknown
Format: 18 × 24 cm (7" × 9¹/₂")
(FH)

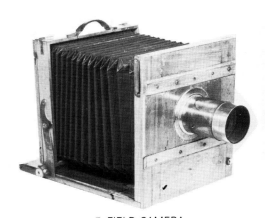

7 FIELD CAMERA
With square bellows
Circa 1900
Manufacturer: unknown
Format: 24 × 30 cm (9¹/₂" × 11⁷/₈")
(FH)

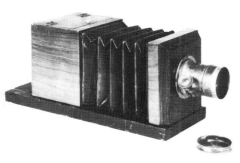

3 BOX CAMERA
Retractable, with bellows and box
Daguerreotype Camera, 1851
Manufacturer: W. & W. H. Lewis
Format: 8 × 10.5 cm (3¹/₆″ × 4¹/₈″)
First camera with bellows between lens-board and sliding back. (GEH)

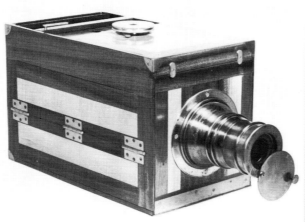

4 FOLDING BOX CAMERA
Daguerreotype Camera, 1840
Manufacturer: Charles Chevalier, Paris
Format: 18.5 × 21.5 cm (7¹/₃″ × 8¹/₂″)
Camera can be folded flat after unscrewing and removing lens. (FH, Replica)

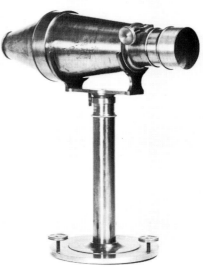

5 BOX CAMERA
Special Type
Designer: Voigtländer, 1841
Manufacturer: Voigtländer, Vienna
Format: 9 cm (3¹/₂″) diameter
First all-metal camera; for Daguerreotype plates. (FH, Replica)

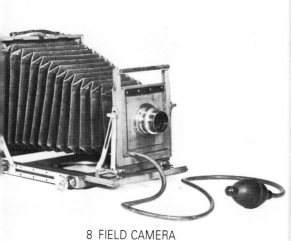

8 FIELD CAMERA
With tapered bellows
Circa 1900
Manufacturer: presumably Thornton Pickard, London
Format: 24 × 30 cm (9¹/₂″ × 11⁷/₈″)
Model with double-extension base. (FH)

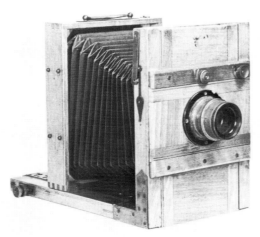

9 FIELD CAMERA
With rectangular housing
Circa 1880
Manufacturer: presumably German
Format: 18 × 24 cm (7″ × 9¹/₂″)
Model for wet and dry plates. (FH)

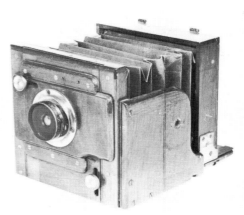

10 FILD CAMERA
Circa 1910
Manufacturer: C. Hare, London
Format: 13 × 18 cm (5¹/₈″ × 7″)
Based on design of English Tourist Camera. (FH)

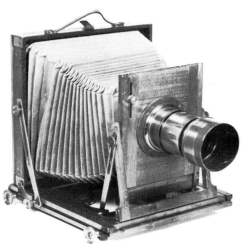

11 FIELD CAMERA
Circa 1890
Manufacturer: R. A. Goldmann, Vienna
Format: 24 × 30 cm (9½″ × 11⅞″)
Based on design of English Field Camera. (FH)

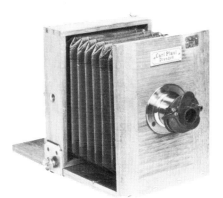

12 FIELD CAMERA
Circa 1910
Manufacturer: Carl Plaul, Dresden
Format: 9 × 12 cm (3½″ × 4¾″)
Simplest type of field camera. Also called "student" or "beginner's camera." (FH)

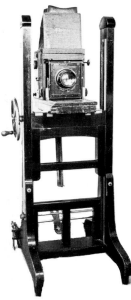

13 STUDIO CAMERA
With bipod
Mentor Studio Reflex, 1920
Manufacturer: Goltz & Breutmann, Dresden
Format: 13 × 18 cm (5⅛″ × 7″)
Two-legged stand in almost unaltered form still in use t
day. Advantage: Continuous height adjustment. (FH)

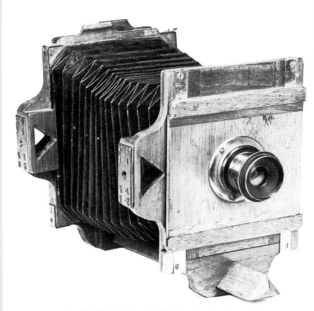

17 MONORAIL CAMERA (Optical Bench)
Research Camera by David-Watzek, 1895
Manufacturer: H. Mattschek, Vienna
Format: 13 × 18 cm (5⅛″ × 7″)
The Kühn-Stegemann research camera, designed by Heinrich Kühn in 1916 and a forerunner of the modern studio camera, resembled the above model. (FH)

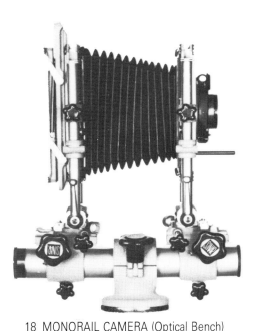

18 MONORAIL CAMERA (Optical Bench)
Sinar Professional Camera, 1948
Manufacturer: Carl Koch, Schaffhausen
Format: 9 × 12 cm (3½″ × 4¾″)
First professional camera of modern design consisting of separate components mounted on a monorail. (Sinar)

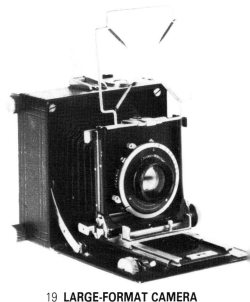

19 LARGE-FORMAT CAMERA
With sliding baseboard
Linhof Technika, 1934
Manufacturer: Linhof Camera Works, Munich
Format: 6 × 9 cm (2⅜″ × 3½″)
With rotating back for vertical and horizontal format. (Lin

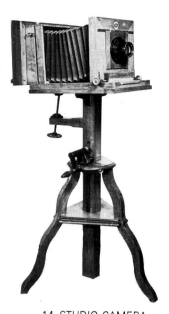
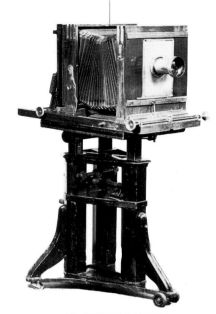
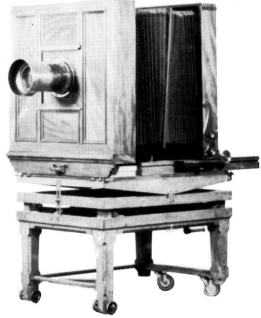

14 STUDIO CAMERA
With center-column tripod
Circa 1910
Manufacturer: Herlango, Vienna
Format: 18 × 24 cm (7″ × 9½″)
Camera with double-extension base; generally in use by small studios. (FH)

15 STUDIO CAMERA
With triple-column stand
Circa 1885
Manufacturer: presumably Voigtländer, Brunswick
Format: 24 × 30 cm (9½″ × 11⅞″)
Camera and tripod type for large studios. (FH)

16 COPY CAMERA
On table stand
Circa 1885
Manufacturer: Curt Bentzin, Görlitz
Format: 60 × 70 cm (23⅝″ × 27½″)
(FH)

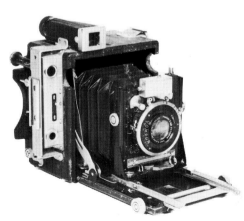
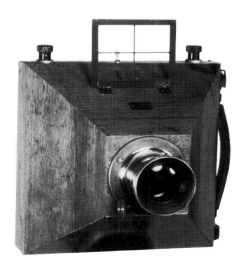
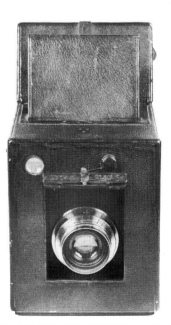

20 LARGE-FORMAT CAMERA
With sliding camera bed
Graflex Speed Graphic, 1955
Manufacturer: Folmer Graflex Corp., Rochester
Format: 6 × 9 cm (2½″ × 3½″)
Press camera with focal-plane and between-the-lens shutter. (FH)

21 PRESS CAMERA
Wooden Camera by Ottomar Anschütz, circa 1888
Manufacturer: C. P. Goerz, Berlin
Format: 9 × 12 cm (3½″ × 4¾″)
This first large-format press camera made the focal-plane shutter popular. (FH)

22 SINGLE-LENS REFLEX CAMERA
For plates, box form, nonretractable
Vannek Reflex Camera, circa 1890
Manufacturer: Watson & Sons, London
Format: 8 × 10.5 cm (3⅙″ × 4⅛″)
One of the earliest reflex cameras; with interchangeable magazine for 12 plates. (STH)

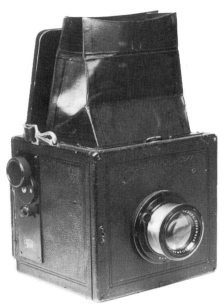

23 SINGLE-LENS REFLEX CAMERA
For plates, box form, nonretractable
Simplex-Ernoflex, 1925
Manufacturer: Ernemann, Dresden
Format: 6.5 × 9 cm (2¹/₂″ × 3¹/₂″)
(FH)

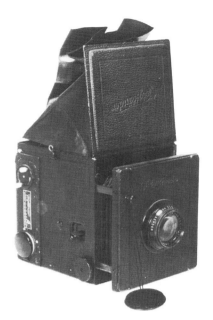

24 SINGLE-LENS REFLEX CAMERA
For plates, retractable, with gear rack
Vida Reflex Camera, circa 1915
Manufacturer: Voigtländer, Brunswick
Format: 9 × 12 cm (3¹/₂″ × 4³/₄″)
(FH)

25 SINGLE-LENS REFLEX CAMERA
For roll film, foldable, with sliding baseboard
Graflex No. 1A circa 1920
Manufacturer: Folmer & Schwing Co., Rochester
Format: 6.5 × 11 cm (2¹/₂″ × 4¹/₃″)
(FH)

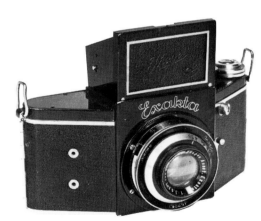

29 SINGLE-LENS REFLEX CAMERA
For roll film, rigid type
Exakta, 1933
Manufacturer: Ihagee Works, Steenbergen & Co., Dresden
Format: 4 × 6.5 cm (1¹/₂″ × 2¹/₂″)
First small-format single-lens reflex camera for roll film. (FH)

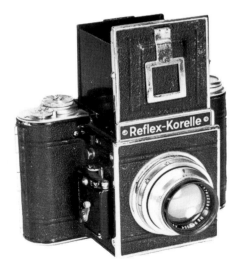

30 SINGLE-LENS REFLEX CAMERA
For roll film
Reflex-Korelle, 1936
Manufacturer: R. Kochmann, Dresden
Format: 6 × 6 cm (2¹/₄″ × 2¹/₄″)
First single-lens reflex camera of 2¹/₄″ × 2¹/₄″ format.
Focal-plane shutter speed up to ¹/₁₀₀₀ sec. (FH)

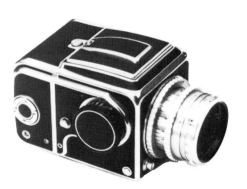

31 SINGLE-LENS REFLEX CAMERA
For roll film
Hasselblad 1600 F, 1948
Manufacturer: Viktor Hasselblad, Stockholm
Format: 6 × 6 cm (2¹/₄″ × 2¹/₄″)
First model of camera with which all photographs we
taken on the moon. Focal-plane shutter speed up to ¹/
sec. (Hasselblad)

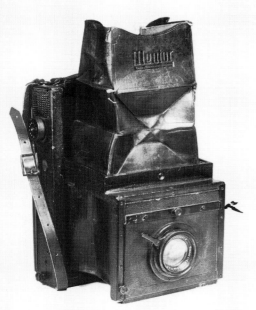

26 SINGLE-LENS REFLEX CAMERA
For roll film
Mentor "Klapp" (Strut) Reflex, since 1914
Manufacturer: Goltz & Breutmann, Dresden
Format: 9 × 12 cm (3¹/₂" × 4³/₄")
Focal-plane shutter speed up to ¹/₁₀₀₀ sec.
(FH)

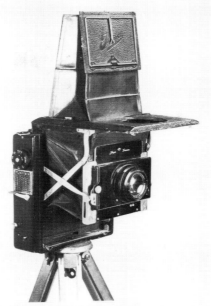

27 SINGLE-LENS REFLEX CAMERA
For roll film, foldable, without baseboard
Ihagee Patent "Klapp" (Strut) Reflex, 1925
Manufacturer: Ihagee Works, Steenbergen & Co., Dresden
Format: 6.5 × 9 cm (2¹/₂" × 3¹/₂")
Focal-plane shutter speed up to ¹/₁₀₀₀ sec.
(FH)

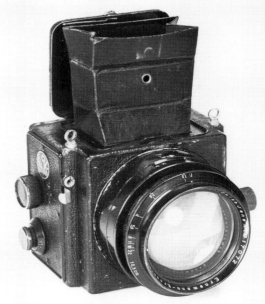

28 SINGLE-LENS REFLEX CAMERA
For plates, with lens-mount
Ermanox Reflex, 1927
Lens: Ernostar 1.8/105 mm
Manufacturer: Ernemann, Dresden
Format: 4.5 × 6 cm (1³/₄" × 2³/₈")
First single-lens reflex camera with extra-fast lens. (FH)

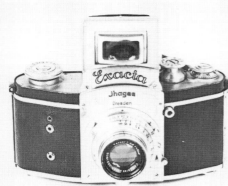

32 SINGLE-LENS REFLEX CAMERA
For 35 mm roll film
Kine Exakta, 1936
Manufacturer: Ihagee Camera Works, Steenbergen & Co.,
Dresden
Format: 24 × 36 mm (35 mm film)
First 35 mm reflex camera. Focal-plane shutter speed up to
¹/₁₀₀₀ sec. (STH)

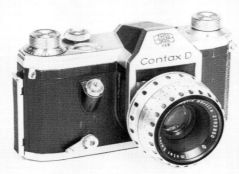

33 SINGLE-LENS REFLEX CAMERA
For 35 mm roll film
Contax D, circa 1953
Manufacturer: VEB Zeiss Ikon, Dresden
Format: 24 × 36 mm (35 mm film)
Mass-produced model of pre-World War II design. First 35
mm reflex camera with built-in prism finder. (FH)

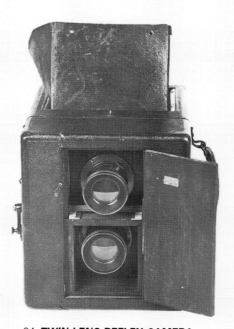

34 TWIN-LENS REFLEX CAMERA
For plates, box form
Le Cosmopolite, 1887
Manufacturer: I. Français, Paris
Format: 9 × 12 cm (3¹/₂" × 4³/₄")
Ranks among earliest twin-lens reflex cameras. (STH)

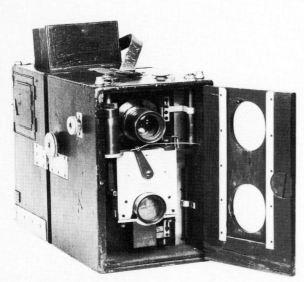

35 TWIN-LENS REFLEX CAMERA
For plates
Photo-Detective, 1889
Manufacturer: A. Le Docte, Brussels
Format: 8.3 × 10.8 cm (3¼″ × 4¼″)
(FH)

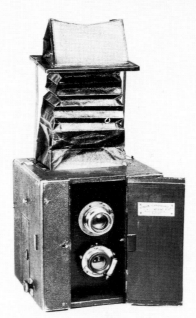

36 TWIN-LENS REFLEX CAMERA
For roll film, rigid type
London Stereoscopic Camera, circa 1910
Manufacturer: London Stereoscopic Co.
Format: 9.5 × 12.5 cm (3¾″ × 5″)
One of the earliest twin-lens reflex cameras for roll film.
(FH)

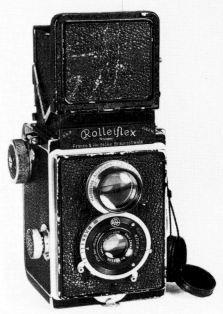

37 TWIN-LENS REFLEX CAMERA
For roll film
Rolleiflex, 1929
Manufacturer: Franke & Heidecke, Brunswick
Format: 6 × 6 cm (2¼″ × 2¼″)
First model of new camera type. Between-the-lens shu
speed up to ¹/₃₀₀ sec. (FH)

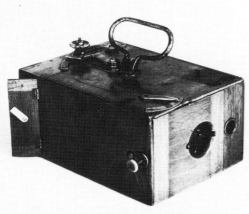

41 MAGAZINE CAMERA
Nonretractable
Schmid's Patent Detective Camera, 1884
Manufacturer: E. & H. T. Anthony, New York
Format: 3½″ × 4½″
This camera introduced the idea of the ''detective camera.''
(FH)

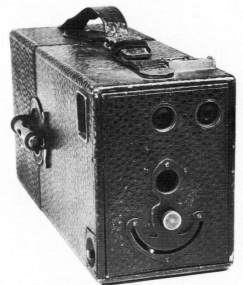

42 MAGAZINE CAMERA
Nonretractable
Frena, circa 1900
Manufacturer: Beck, London
Format: 9 × 12 cm (3½″ × 4½″) (designed for 40 exposures on sheet film) (FH)

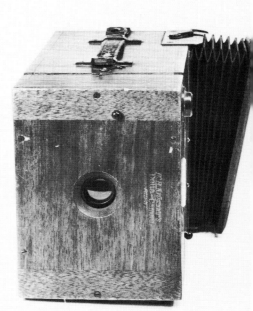

43 MAGAZINE CAMERA
Nonretractable
Delta Camera, 1892
Manufacturer: Dr. Krügener, Frankfurt
Format: 9 × 12 cm (3½″ × 4¾″) (12 plates)
Plate exchange through movement of bellows; substitu
by a sliding lever in a later model. (FH)

38 TWIN-LENS REFLEX CAMERA
For roll film
Welta Superfekta, 1934
Manufacturer: Welta Camera Works, Freital
Format: 6 × 9 cm (2³/₈'' × 3¹/₂'')
With rotating back for vertical and horizontal format. (FH)

39 TWIN-LENS REFLEX CAMERA
For 35 mm
Contaflex, 1935
Manufacturer: Zeiss Ikon, Dresden
Format: 24 × 36 mm (35 mm film)
First camera with built-in photoelectric exposure meter.
Metal focal-plane shutter. Speed up to ¹/₁₀₀₀ sec. (FH)

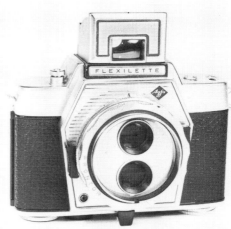

40 TWIN-LENS REFLEX CAMERA
For 35 mm
Flexilette, 1960
Manufacturer: Agfa Camera Works, Munich
Format: 24 × 36 mm (35 mm film)
(FH)

44 MAGAZINE CAMERA
Nonretractable
Facile, 1887
Manufacturer: Fallowsfield, London
Format: 9 × 12 cm (3¹/₂'' × 4¹/₂'') (12 plates)
Turning-knob on side activates plate exchange. (FH)

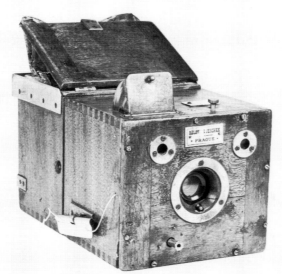

45 MAGAZINE CAMERA
Retractable
Edison, 1894
Manufacturer: Ernemann, Dresden
Format: 9 × 12 cm (3¹/₂'' × 4³/₄'') (12 plates)
Plate exchange by turning-knob on side or leather bag. (FH)

46 MAGAZINE CAMERA
Retractable
Suter Camera, 1893
Manufacturer: Suter, Basel
Format: 9 × 12 cm (3¹/₂'' × 4³/₄'') (20 plates)
Plate exchange by sliding lever. (FH)

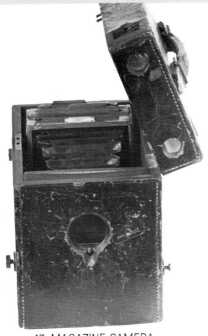

47 MAGAZINE CAMERA
With bellows
Detective Camera, circa 1890
Manufacturer: Watson & Sons, London
Format: 8 × 10.5 cm (3¹/₆″ × 4¹/₈″) (for separate exposures)
No genuine magazine camera, but a typical detective camera. (STH)

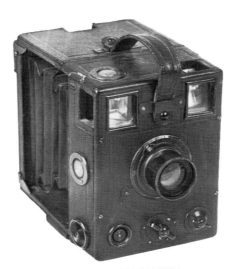

48 MAGAZINE CAMERA
With bellows
France, circa 1905
Manufacturer: unknown
Format: 9 × 12 cm (3¹/₂″ × 4³/₄″)
The camera could be folded; the plate magazine was attached to the back. (STH)

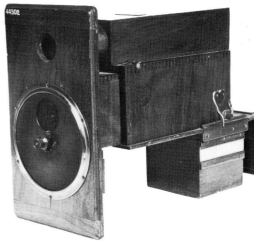

49 MAGAZINE CAMERA
With movable plate magazine
Academy Camera, 1884
Manufacturer: Ed. Liesegang, Elberfeld
Format: 3 × 3 cm (1¹/₆″ × 1¹/₆″)
Licensed construction of Academy Camera by Marion & Co., London. Principle: Twin-lens reflex. (DM)

53 SPECIAL TYPE
Chambre automatique, 1861
Manufacturer: Adolphe Bertsch, Paris
Format: 6.6 × 6.6 cm (2¹/₂″ × 2¹/₂″)
Foxed focus; thereby "automatic." Focus from 10 m (33 feet) to infinity. (FH, Replica)

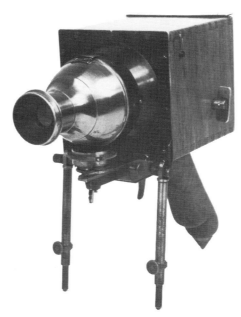

54 SPECIAL TYPE
Escopette, 1889
Manufacturer: F. Boissonas, Geneva
Format: 6.8 × 7.2 cm (2³/₄″ × 2⁷/₈″) (110 exposures on roll film)
The first European camera using Eastman roll film. (FH)

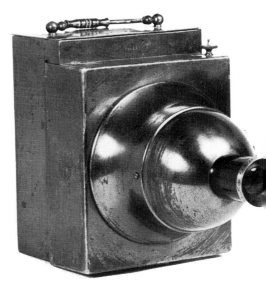

55 SPECIAL TYPE
Photosphere, 1888
Manufacturer: Société Française de Photographie, Paris
Format: 9 × 12 cm (3¹/₂″ × 4³/₄″)
All-metal construction; made for the tropics. (FH)

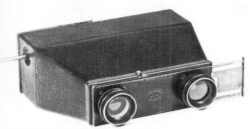

50 PHOTO JUMELLES AND SPECIAL TYPES
Photo Jumelle, 1892
Manufacturer: J. Carpentier, Paris
Format: 4 × 6.5 cm (1½″) × 2½″) (12 plates)
Design derived from binocular; one lens was used as view
finder, the other for picture taking. (FH)

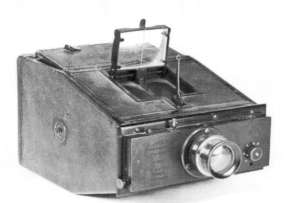

51 PHOTO JUMELLE
Steno Jumelle, 1894
Manufacturer: L. Joux, Paris
Format: 9 × 12 cm (3½″ × 4¾″) (12 plates)
Plate exchange through vertical movement of camera top.
(FH)

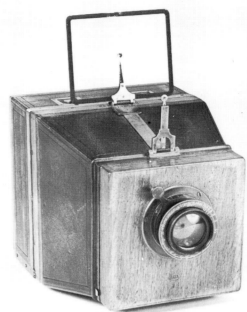

52 PHOTO JUMELLE
Jumelle Sigriste, 1898
Manufacturer: S.O.L. (Guido Sigriste), Paris
Focal-plane shutter speed up to ¹/₁₀,₀₀₀ sec.
(FH)

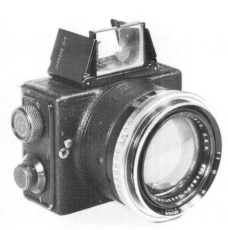

56 SPECIAL TYPE
Ermanox, 1924
Manufacturer: Ernemann, Dresden
Format: 4.5 × 6 cm (1¾″ × 2³/₈″)
camera with fastest lens of its time; largest lens opening:
1:2.0. (FH)

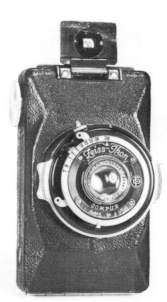

57 SPECIAL TYPE
Colibri, 1930
Manufacturer: Zeiss Ikon, Dresden
Format: 3 × 4 cm (1¹/₆″ × 1½″) on roll film
(FH)

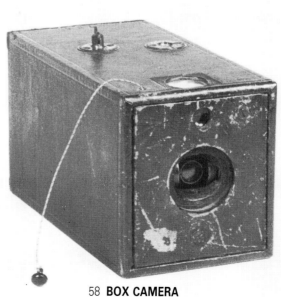

58 BOX CAMERA
The Kodak, 1888
Manufacturer: Eastman Dry Plate & Film Co., Rochester
Format: 65 mm (2⁵/₈″) diameter (110 exposures on roll film)
First roll film camera in the world. (FH)

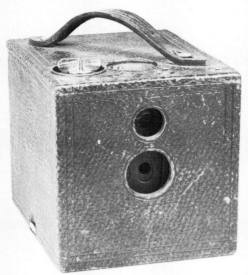

59 BOX CAMERA
Bull's Eye No. 2, 1897
Manufacturer: Eastman Kodak Co., Rochester
Format: 3½'' × 3½'' (roll film)
(FH)

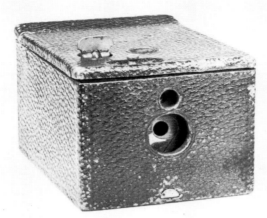

60 BOX CAMERA
Pocket Kodak, 1895
Manufacturer: Eastman Kodak Co., Rochester
Format: 4 × 5 cm (1½'' × 2'') (roll film)
First camera designed to use present-day roll film. (FH)

61 BOX CAMERA
Luzo von H. J. Redding, 1891
Manufacturer: J. Robinson & Sons, London
Format: 2⅜'' diameter (roll film)
(FH)

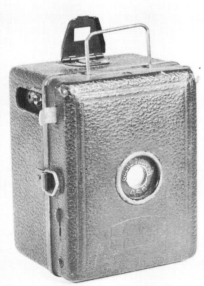

65 BOX CAMERA
Baby Box, 1935
Manufacturer: Zeiss Ikon, Dresden
Format: 3 × 4 cm (1⅙'' × 1½'') (roll film)
(FH)

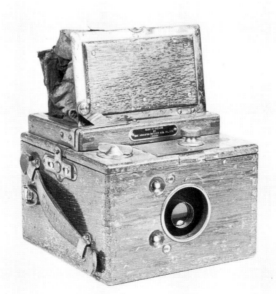

66 BOX CAMERA
Ensign Reflex Box, circa 1925
Manufacturer: Houghtons-Butcher Co., London
Format: 6 × 9 cm (2½'' × 3½'') (roll film)
Suitable for the tropics. (FH)

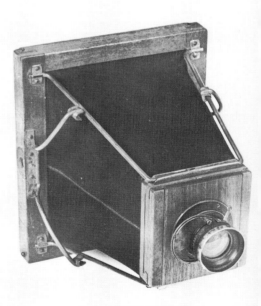

67 STRUT CAMERA
Without baseboard, with metal struts
Plücker Stéréographe de poche, 1871
Manufacturer: unknown
Format: 13 × 18 cm (5⅛'' × 6'') (plates)
(STH)

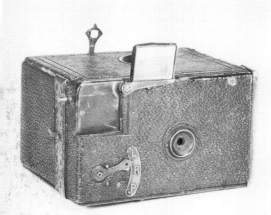

62 BOX CAMERA
Le Pascal, 1898
Manufacturer: Japy Frères, Paris
Format: 4 × 5.5 cm (1¹/₂″ × 2¹/₆″)
(12 exposures on roll film)
First roll film camera with spring mechanism for film advance and cocking of shutter. (FH)

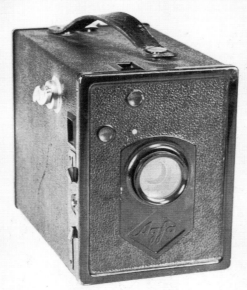

63 BOX CAMERA
Agfa Box, 1930
Manufacturer: Agfa Camera Works, Munich
Format: 6 × 9 cm (2³/₈″ × 3¹/₂″) (120 roll film)
The camera was sold for 4 Reichsmark ($0.95) in 1932. (FH)

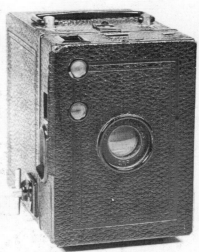

64 BOX CAMERA
Box Tengor, circa 1930
Manufacturers: Zeiss Ikon, Dresden
Format: 6 × 9 cm (2³/₈″ × 3¹/₂″) (roll film)
(FH)

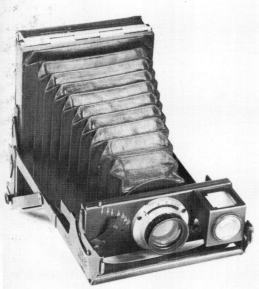

68 STRUT CAMERA
Without baseboard, with metal struts
Nydia, 1900
Manufacturer: Newman & Guardia, London
Format: 9 × 12 cm (3¹/₂″ × 4¹/₂″)
...e to special strut construction, extremely flat-folding. (FH)

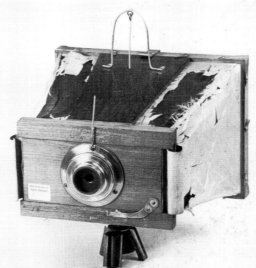

69 STRUT CAMERA
Without baseboard, with wooden struts
Scénographe by Dr. Candèze, 1875
Manufacturer: E. Deyrolle Fils, Paris
Format: 10 × 15 cm (4″ × 6″)
One of the oldest folding cameras. (FH)

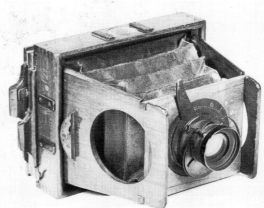

70 STRUT CAMERA
Without baseboard, with wooden struts
Eclipse, 1890
Manufacturer: J. F. Shew & Co., London
Format: 9 × 12 cm (3¹/₂″ × 4¹/₂″)
(FH)

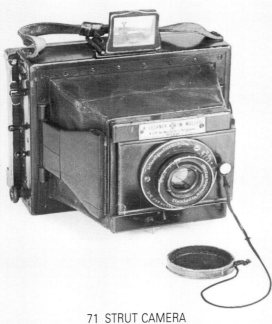

71 STRUT CAMERA
Without baseboard, with wooden struts
Lechner's Pocket Camera, circa 1900
Manufacturer: R. Lechner (W. Müller), Vienna
Format: 9 × 12 cm (3½″ × 4¾″)
Focal-plane shutter
(FH)

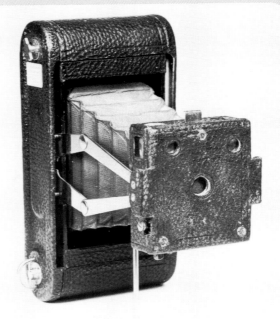

72 STRUT CAMERA
Without baseboard, with knee-jointed struts
Folding Pocket Kodak, 1898
Manufacturer: Eastman Kodak Co.; Rochester
Format: 6 × 9 cm (2½″ × 3½″) (roll film)
Possibly the first strut camera for roll film. (FH)

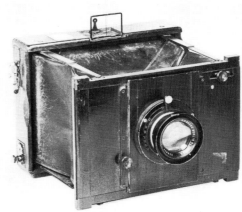

73 STRUT CAMERA
Without baseboard, with knee-jointed struts
Anschütz Strut Camera, circa 1900
Manufacturer: C. P. Goerz, Berlin
Format: 13 × 18 cm (5⅛″ × 6″) (plates)
The design of the Anschütz Strut Camera with focal-plane
shutter was the prototype for numerous press cameras be-
tween 1900 and 1930. (FH)

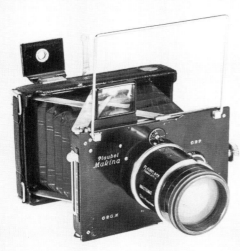

77 STRUT CAMERA
Without camera bed, with lazy tongs
Plaubel Makina, 1926
Manufacturer: Plaubel & Co., Frankfurt
Format: 6.5 × 9 cm (2½″ × 3½″) (plates)
(FH)

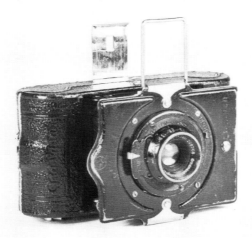

78 FOLDING CAMERA
With bellows and supporting struts
Bobette I, 1925
Manufacturer: Ernemann, Dresden
Format: 22 × 33 mm (⅞″ × 1⅓″) (roll film 4 cm [1½″] in
width) (FH)

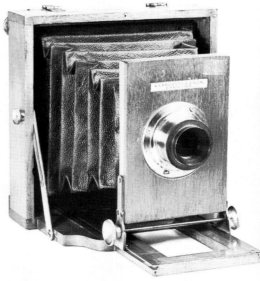

79 FOLDING CAMERA
Merveilleux, circa 1890
Manufacturer: J. Lancaster & Son, Birmingham
Format: 9 × 12 cm (3½″ × 4½″) (plate)
Variant of English View Camera with fold-in base. (FH)

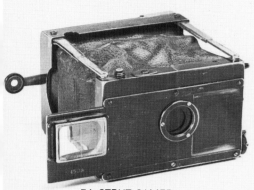

74 STRUT CAMERA
Without baseboard, with knee-jointed struts
Block Notes, 1904
Manufacturer: L. Gaumont & Cie., Paris
Format: 4.5 × 6 cm (1³/₄″ × 2³/₈″)
This camera type was also called "vest pocket camera."
(FH)

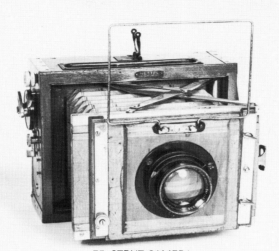

75 STRUT CAMERA
Without camera bed, with lazy tongs
Nettel "Deckrollo" (Roller Blind), circa 1910
Manufacturer: Nettel Camera Works, Sontheim/Neckar
Format: 9 × 12 cm (3¹/₂″ × 4³/₄″)
Made for the tropics. (FH)

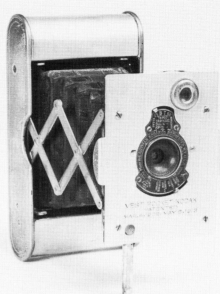

76 STRUT CAMERA
Without camera bed, with lazy tongs
Vest Pocket Kodak, 1913
Manufacturer: Eastman Kodak Co., Rochester
Format: 4.5 × 6 cm (1³/₄″ × 2³/₈″) (roll film)
(FH)

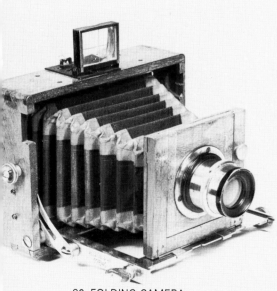

80 FOLDING CAMERA
Portable camera with wooden housing, circa 1890
Manufacturer: unknown
Format: 9 × 12 cm (3¹/₂″ × 4³/₄″) (plate)
Special type with aluminum base. (FH)

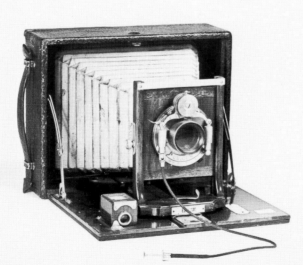

81 FOLDING CAMERA
Essem Camera, circa 1900
Manufacturer: unknown
Format: 13 × 18 cm (5¹/₈″ × 6″) (plate)
(FH)

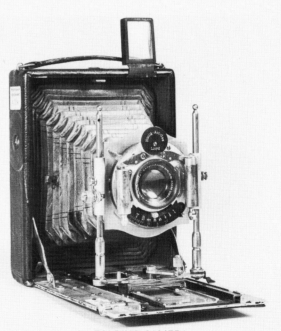

82 FOLDING CAMERA
Hüttig Lloyd, 1905
Manufacturer: R. Hüttig, Dresden
Format: 9 × 12 cm (3¹/₂″ × 4³/₄″) (plate)
(FH)

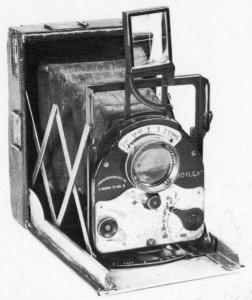

83 FOLDING CAMERA
Roylex, circa 1915
Manufacturer: London Stereoscopic Co.
Format: 6 × 9 cm (2¹/₂″ × 3¹/₂″) (plate)
Same model as "Sybil" by Newman & Guardia, London.
(FH)

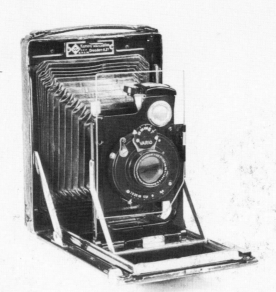

84 FOLDING CAMERA
Patent-Etui, 1924
Manufacturer: Kamera-Werkstätten, Dresden
Format: 6 × 9 cm (2³/₈″ × 3¹/₂″) (plate)
Flat-folding due to special strut construction. (FH)

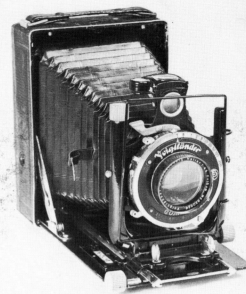

85 FOLDING CAMERA
Voigtländer Bergheil, circa 1930
Manufacturer: Voigtländer AG, Brunswick
Format: 9 × 12 cm (3¹/₂″ × 4³/₄″) (plate)
De luxe model in green leather. (FH)

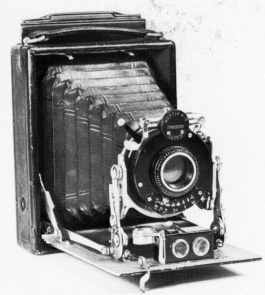

89 FOLDING CAMERA
With self-erecting lens
Hüttig Cupido, circa 1910
Manufacturer: R. Hüttig, Dresden
Format: 9 × 12 cm (3¹/₂″ × 4³/₄″) (plate)
One of the first cameras equipped with self-erecting lens;
also called "Fixed-Focus Camera." (FH)

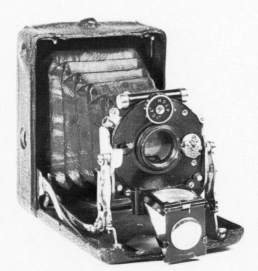

90 FOLDING CAMERA
With self-erecting lens
Ica Atom, 1913
Manufacturer: Ica, Dresden
Format: 4.5 × 6 cm (1³/₄″ × 2¹/₃″) (plate)
Upon opening the camera, the view finder swings into
place. (FH)

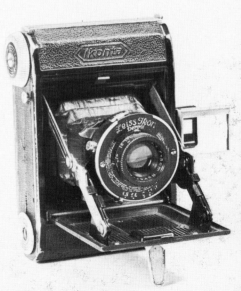

91 FOLDING CAMERA
With self-erecting lens
Zeiss Ikon Ikonta, circa 1930
Manufacturer: Zeiss Ikon, Dresden
Format: 3 × 4 cm (1¹/₆″ × 1¹/₂″) (roll film)
(FH)

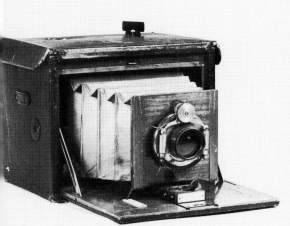

86 FOLDING CAMERA
For roll film
Folding Kodak No. 4, 1894
Manufacturer: Eastman Kodak Co., Rochester
Format: 13 × 18 cm (5¹⁄₈″ × 6″)
Early large-format roll film camera. (FH)

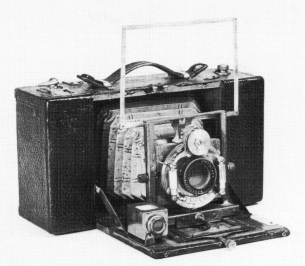

87 FOLDING CAMERA
For roll film
Delta-Patronen-Flachkamera (Delta Cartridge Flat-Bodied
Camera), 1903
Manufacturer: Dr. Krügener, Frankfurt
Format: 9 × 12 cm (3¹⁄₂″ × 4³⁄₄″)
Designed for plates and roll film. (FH)

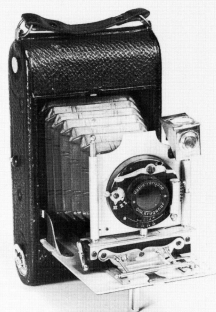

88 FOLDING CAMERA
For roll film
Roll Film Camera, 1902
Manufacturer: Dr. Krügener, Frankfurt
Format: 8 × 10.5 cm (3¹⁄₆″ × 4¹⁄₆″)
(FH)

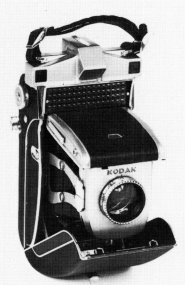

92 FOLDING CAMERA
With self-erecting lens
Super Kodak Six 20, 1938
Manufacturer: Eastman Kodak Co., Rochester
Format: 6 × 9 cm (2³⁄₈″ × 3¹⁄₂″) (roll film)
First camera with built-in exposure meter. (STH)

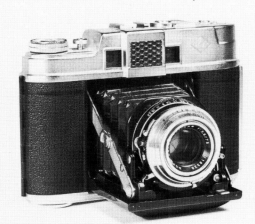

93 FOLDING CAMERA
With self-erecting lens
Agfa Automatic 66, 1956
Manufacturer: Agfa Camera Works, Munich
Format: 6 × 6 cm (2¹⁄₄″ × 2¹⁄₄″) (roll film)
First camera with automatic diaphragm. (FH)

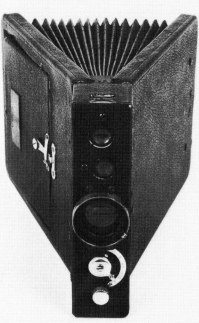

94 FOLDING CAMERA
Accordion-pleated special type
Vega, 1900
Manufacturer: Vega S.A., Geneva
Format: 9 × 12 cm (3¹⁄₂″ × 4³⁄₄″)
(FH)

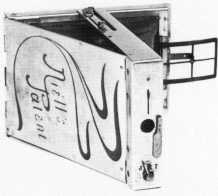

95 FOLDING CAMERA
Accordion-shaped special type
Lopa, 1902
Manufacturer: Niéll & Simons, Brussels
Format: 6.5 × 9 cm (2¹/₂″ × 3¹/₂″) (plate)
Camera can be folded flat to vest-pocket size. (FH)

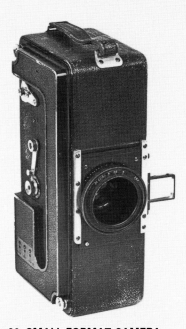

96 SMALL-FORMAT CAMERA
Tourist Multiple, 1913
Manufacturer: Herbert & Huesgen, New York
Format: 18 × 24 mm (35 mm film)
Earliest forerunner of 35 mm small-format camera. (STH)

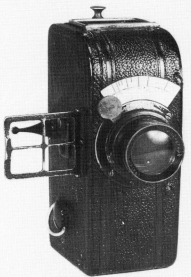

97 SMALL-FORMAT CAMERA
Minigraph, 1915
Manufacturer: Levy-Roth, Berlin
Format: 18 × 24 mm (35 mm film)
(FH)

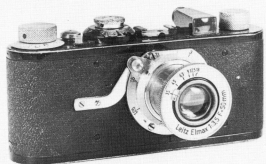

101 35 mm CAMERA
With retractable lens
Leica A, 1925
Manufacturer: Ernst Leitz, Wetzlar
Format: 24 × 36 mm (35 mm film)
Since 1926: Leica B with Compur Shutter
Since 1930: Leica C with interchangeable lens. (FH)

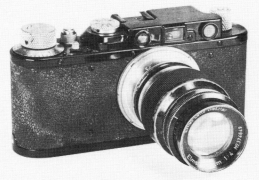

102 35 mm CAMERA
With retractable lens
Leica II, 1932
Manufacturer: Ernst Leitz, Wetzlar
Format: 24 × 36 mm (35 mm film)
First Leica with range-coupled view finder.
Since 1933: Leica III with long-exposure provision (1 to ¹/₁₅ sec.). (FH)

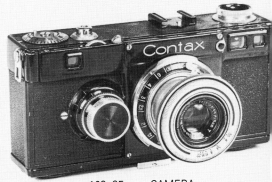

103 35 mm CAMERA
With retractable lens
Contax I, 1932
Manufacturer: Zeiss Ikon, Dresden
Format: 24 × 36 mm (35 mm film)
With metal focal-plane shutter. (FH)

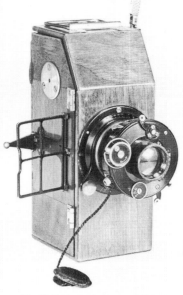

98 SMALL-FORMAT CAMERA
Sico, 1922
Manufacturer: Wolfgang Simons, Berne
Format: 30 × 40 mm (unperforated 35 mm film)
(FH)

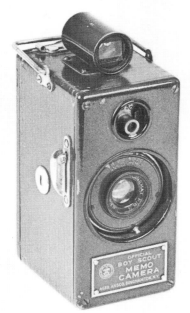

99 SMALL-FORMAT CAMERA
Ansco Memo, 1927
Manufacturer: Ansco Inc., Binghampton, N.Y.
Format: 18 × 23 mm (35 mm film)
(STH)

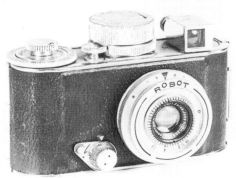

100 SMALL-FORMAT CAMERA
Robot, 1934
Manufacturer: Otto Berning & Co., Düsseldorf
Format: 24 × 24 mm (35 mm film)
Automatic cocking of shutter and film advance by means of
spring mechanism. (FH)

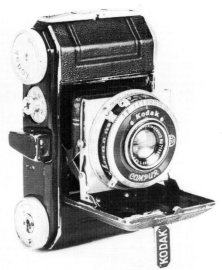

104 35 mm CAMERA
With bellows
Retina I, 1934
Manufacturer: Kodak, Stuttgart
Format: 24 × 36 mm (35 mm film)
(FH)

105 35 mm CAMERA
With bellows and lazy tongs
Agfa Karat, 1937
Manufacturer: Agfa Camera Works, Munich
Format: 24 × 36 mm (35 mm film)
The Rapid Cassette introduced in 1963 evolved from the
Karat Cartridge specially designed for this camera. (FH)

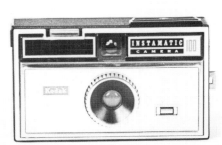

106 SMALL-FORMAT CAMERA
Instamatic 100, 1963
Manufacturer: Eastman Kodak Co., Rochester
Format: 28 × 28 mm (1″ × 1″)
First camera for 126-film cassettes. (Kodak)

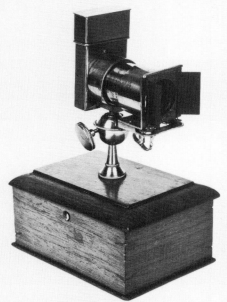

107 MINIATURE CAMERA
Pistolgraph, 1858
Manufacturer: Thomas Skaife, London
Format: 1¹/₈'' diameter (plate)
(GEH)

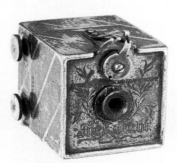

108 MINIATURE CAMERA
Kombi, 1893
Manufacturer: Alfred C. Kemper, Chicago
Format: 27 mm (1'') diameter (roll film, 33 mm in width)
Upon removal of the roll film magazine, the camera could
be used as a viewer. (FH)

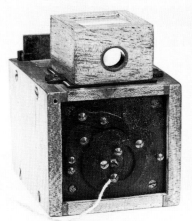

109 MINIATURE CAMERA
Colibri, 1893
Manufacturer: Heinemann & Dressler, Munich
Format: 3.5 × 4 cm (1¹/₃'' × 1¹/₂'') (plate)
The same camera was produced under the name "Mino
(FH)

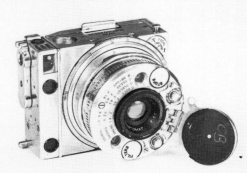

113 MINIATURE CAMERA
Compass, 1937
Manufacturer: Le Coultre & Cie., Le Sentier (Switzerland)
Format: 24 × 36 mm (1'' × 1¹/₂'') (plates or special roll
film)
Universal miniature camera with an array of sophisticated
provisions. (FH)

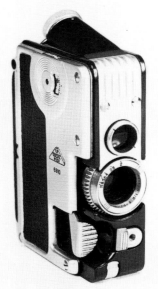

114 MINIATURE CAMERA
Minicord, 1951
Manufacturer: C. P. Goerz, Vienna
Format: 10 × 10 mm (16 mm roll film)
One of the rarest twin-lens reflex miniature cameras. (FH)

115 MINIATURE CAMERA
Pocket Instamatic 100, 1972
Manufacturer: Eastman Kodak Co., Rochester
Format: 11 × 17 mm (¹/₂'' × ²/₃'')
First camera for 110-film cassettes. (Kodak)

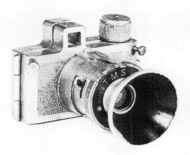

110 MINIATURE CAMERA
L'Aiglon, 1934
Manufacturer: unknown
Format: 12 × 14 mm (¹/₂″ × ¹/₂″) (special roll film)
(FH)

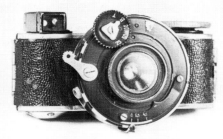

111 MINIATURE CAMERA
Mini-Fex, 1932
Manufacturer: Fritz Kaftanski, Berlin
Format: 14 × 18 mm (¹/₂″ × ³/₄″) (roll film)
(FH)

112 MINIATURE CAMERA
Minox, 1937
Manufacturer: VET Works, Riga
Format: 8 × 11 mm (¹/₃″ × ¹/₂″) (roll film in special cartridges)
First model of the famous miniature camera designed by Walter Zapp. (FH)

116 DETECTIVE CAMERA
Photo Revolver, 1862
Manufacturer: A. Briois, Paris
Format: 23 mm (1″) diameter (7.5 cm [3″] plate)
(GEH)

117 DETECTIVE CAMERA
Photo Cravate, 1890
Manufacturer: E. Bloch, Paris
Format: 2.5 × 2.5 cm (1″ × 1″) (plate)
(Wendel)

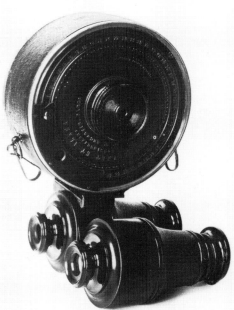

118 DETECTIVE CAMERA
Jumelle de Nicour, 1867
Manufacturer: Geymet & Alker, Paris
Format: 4 × 4 cm (1¹/₂″ × 1¹/₂″) (plate)
First field-glass camera. (GEH)

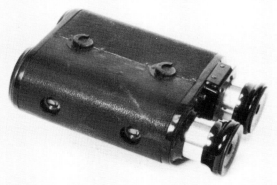

119 DETECTIVE CAMERA
Stéréo-Physiographe, 1896
Manufacturer: Leon Bloch, Paris
Format: 45 × 107 mm (1³/₄″ × 4¹/₄″) (plate)
This camera could take photographs around the corner. (FH)

120 DETECTIVE CAMERA
Ben Akiba, 1903
Manufacturer: A. Lehmann, Berlin
Format: 16 × 20 mm (²/₃″ × ³/₄″) (roll film)
Camera camouflaged as handle was screwed onto a walk-ing stick. (FH)

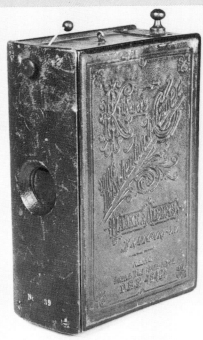

121 DETECTIVE CAMERA
Note Book Camera, Dr. Krügener, 1888
Manufacturer: Haake & Albers, Frankfurt
Format: 4 × 4 cm (1¹/₂″ × 1¹/₂″) (plate)
With built-in magazine for 24 plates. (FH)

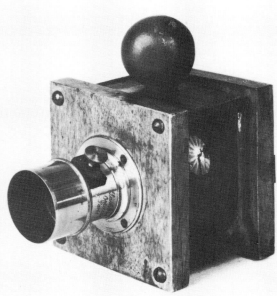

125 RAPID-DEVELOPMENT CAMERA
Dubroni No. 1, 1864
Manufacturer: Maison Dubroni, Paris
Format: 4 cm (1¹/₂″) diameter (plate)
First camera with built-in developing provision. (GEH)

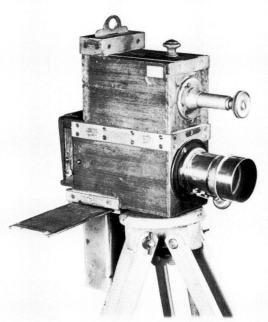

126 RAPID-DEVELOPMENT CAMERA
Faller Ferrotype Camera, circa 1900
Manufacturer: Eugen Faller, Paris
Format: 3 × 5 cm (1¹/₆″ × 2″)
The plates were developed in a tank underneath the camera immediately upon exposure. (FH)

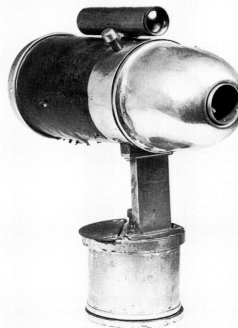

127 RAPID-DEVELOPMENT CAMERA
FASA Ferrotype Camera, circa 1915
Manufacturer: unknown (possibly U.S.)
Format: 25 mm (1″) diameter (100 plates)
This camera made "instant" portraits for medallions. (FH)

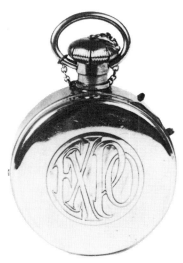

122 DETECTIVE CAMERA
Expo Watch Camera, 1904
Manufacturer: Expo Camera Corp., New York
Format: 15 × 22 mm (½″ × ⅞″)
(STH)

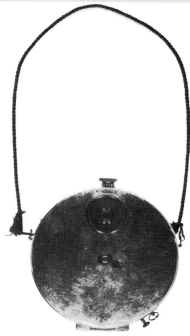

123 DETECTIVE CAMERA
Steineck's ABC Camera, 1949
Manufacturer: Dr. Steineck
Format: 3 × 4 mm (⅛″ × ⅙″) (circular sheet film)
(FH)

124 DETECTIVE CAMERA
Buttonhole Camera
Stirn's Detective Camera, 1886
Manufacturer: R. Stirn, Berlin
Format: 40 mm (1½″) diameter (plate)
(FH)

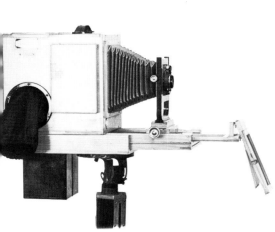

128 RAPID-DEVELOPMENT CAMERA
Velophot Camera, circa 1920
Manufacturer: Herlango, Vienna
Format: 9 × 12 cm (3½″ × 4¾″)
With development provision for paper negatives, which
re copied with the same camera. The positive could also
e developed immediately in the camera. Typical camera
used by street photographers. (FH)

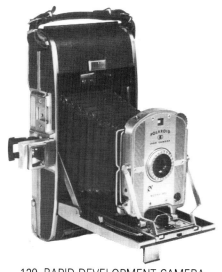

129 RAPID-DEVELOPMENT CAMERA
Polaroid Land Camera 95, 1948
Manufacturer: Polaroid Corp., Cambridge, Mass.
Format: 8.5 × 11.5 cm (3⅓″ × 4½″)
First camera for instant photography by Dr. Land. (FH)

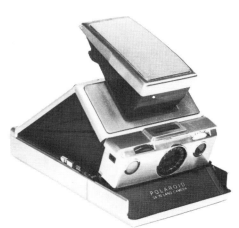

130 RAPID-DEVELOPMENT CAMERA
Polaroid Land SX 70, 1973
Manufacturer: Polaroid Corp., Cambridge, Mass.
Format: 7.8 × 7.8 cm (3″ × 3″)

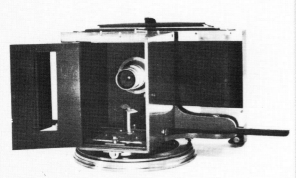

131 PANORAMIC CAMERA
Rotating
Pantascopic Camera, 1862
Manufacturer: Johnson & Harrison, London
Format: 19 × 31 cm (7¹/₂″ × 12¹/₄″)
Angle of view: 110 degrees
By means of a spring mechanism, the camera was turned on its axis. (Science Museum)

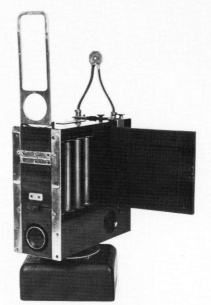

132 PANORAMIC CAMERA
Rotating
Cyclographe à foyer fixe, 1894
Manufacturer: M. Damoizeau, Paris
Format: 9 × 80 cm (3¹/₂″ × 31¹/₂″)
Angle of view: 360 degrees
Through a spring mechanism, the camera was turned on its axis and the film being pulled through it. (GEH)

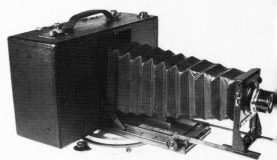

133 PANORAMIC CAMERA
Rotating
Cirkut Camera No. 6, circa 1895
Manufacturer: Folmer Graflex Corp., Rochester
Format: different-sized, depending on angle of view
Angle of view: up to 360 degrees
Camera is rotated through a spring mechanism and the f[] being pulled past a slot. (Kummer)

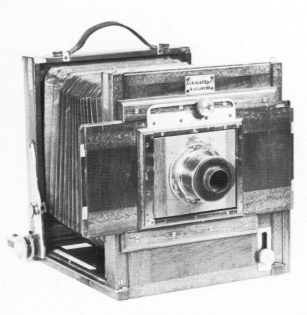

137 STEREO CAMERA
Retractable, with bellows
Field camera with sliding lens, circa 1890
Manufacturer: unknown
Format: 18 × 24 cm (7″ × 9¹/₂″)
For stereo photographs, the lens-board was alternately moved right and left. (FH)

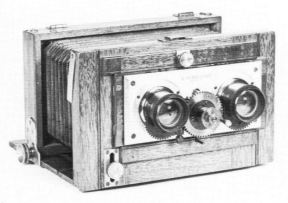

138 STEREO CAMERA
Retractable, with bellows
Field camera with two lenses, circa 1890
Manufacturer: unknown, possibly Mackenstein, Paris
Format: 8 × 17 cm (3¹/₆″ × 6³/₄″) (plate)
(FH)

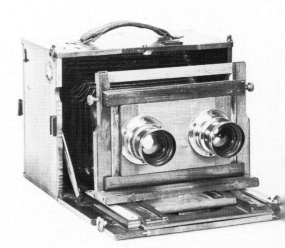

139 STEREO CAMERA
Retractable, with bellows
Box-type camera with two lenses, circa 1880
Manufacturer: presumably Baalbreck & Fils, Paris
Format: 12 × 17 cm (4³/₄″ × 6³/₄″) (plate)
(FH)

134 PANORAMIC CAMERA
With pivoting lens
Cylindrographe by Moëssard, 1889
Manufacturer: unknown
Format: 12 × 42 cm (4³/₄″ × 16¹/₂″)
Angle of view: 170 degrees
During exposure, the lens was moved by hand. (Preus)

135 PANORAMIC CAMERA
With pivoting lens
Le Périphote, 1901
Manufacturer: Lumière, Lyon
Format: 7 × 38 cm (2³/₄″ × 15″)
Angle of view: 360 degrees
During exposure, the lens rotates around the entire camera.
(GEH)

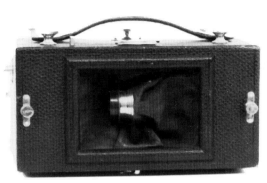

136 PANORAMIC CAMERA
With pivoting lens
Al Vista, circa 1900
Manufacturer: Multiscope & Film Co., Burlington
Format: 5″ × 16″ (roll film)
Angle of view: almost 180 degrees
A spring mechanism swings the lens. Through variable
openings of the leaf diaphragm, different exposure times
were made possible. (FH)

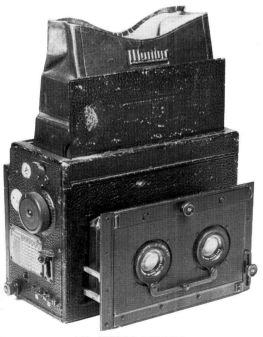

140 STEREO CAMERA
Reflex version
Mentor Stereo Reflex, circa 1920
Manufacturer: Goltz & Breutmann, Dresden
Format: 10 × 17 cm (4″ × 6³/₄″) (plate)
(FH)

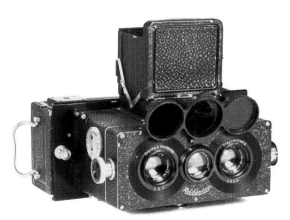

141 STEREO CAMERA
Reflex version
Heidoscop, 1925
Manufacturer: Franke & Heidecke, Brunswick
Format: 6 × 13 cm (2¹/₃″ × 5¹/₈″) (plate)
The central lens serves the reflex finder. (FH)

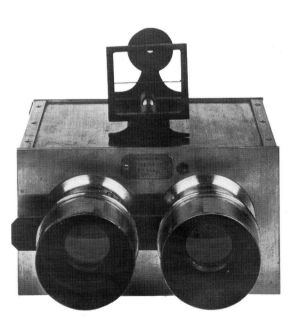

142 STEREO CAMERA
Box form
Chambre automatique, 1860
Manufacturer: Adolphe Bertsch, Paris
Format: 6.6 × 14 cm (2¹/₂″ × 5¹/₂″) (plate)
(GEH)

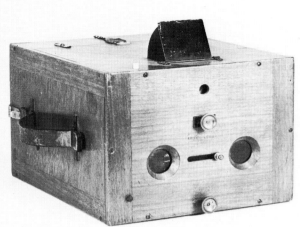

143 STEREO CAMERA
Box type, with magazine for plates
Stereo Delta, circa 1895
Manufacturer: Dr. Krügener, Frankfurt
Format: 9 × 18 cm (3¹/₂'' × 7'')
Stereo version of Delta Magazine Camera. (FH)

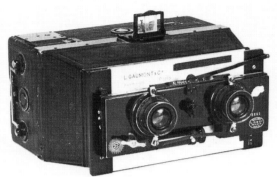

144 STEREO CAMERA
Jumelle type
Stéréo-Spido, circa 1900
Manufacturer: L. Gaumont & Cie., Paris
Format: 9 × 18 cm (3¹/₂'' × 7'') (plate)
(FH)

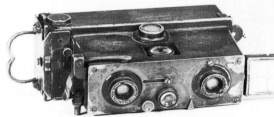

145 STEREO CAMERA
Jumelle type
Vérascope, circa 1900
Manufacturer: J. Richard, Paris
Format: 45 × 107 mm (1³/₄'' × 4¹/₄'') (plate)
(FH)

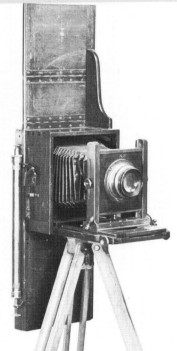

149 **SPECIAL-PURPOSE CAMERA**
For color photographs
Color Camera by A. Miethe, 1904
Manufacturer: W. Bermpohl, Berlin
Format: 9 × 12 cm (3¹/₂'' × 4³/₄'')
The three color impressions were exposed successively;
the plate exchange rack was activated pneumatically. (FH)

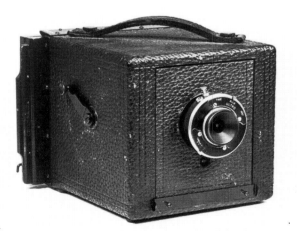

150 SPECIAL-PURPOSE CAMERA
For color photographs
Ives Hicro Camera, 1915
Manufacturer: Ives, Rochester
Format: 10 × 10.5 cm (4'' × 4¹/₆'')
The plates were exposed separately through a semi-
transparent mirror, whereby an orange filter was introduced
for a second exposure. (FH)

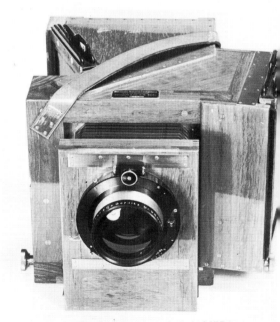

151 SPECIAL-PURPOSE CAMERA
For color photographs
Bermpohl Natural-Color Camera, 1934
Manufacturer: Bermpohl & Co., Berlin
Format: 13 × 18 cm (5¹/₈'' × 7'')
Through a system of partially transparent mirrors, three
separate color impressions could be obtained simulta-
neously. (FH)

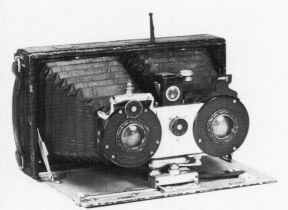

146 STEREO CAMERA
Folding type
Stereo-Ideal, 1906
Manufacturer: R. Hüttig, Dresden
Format: 6 × 13 cm (2¹/₃'' × 5¹/₈'') (plate)
(FH)

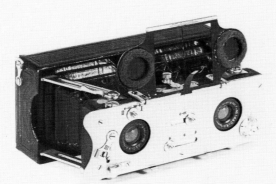

147 STEREO CAMERA
Strut type
Plastoscop, circa 1900
Manufacturer: Dr. Krügener, Frankfurt
Format: 45 × 107 mm (1³/₄'' × 4¹/₄'') (plate)
(FH)

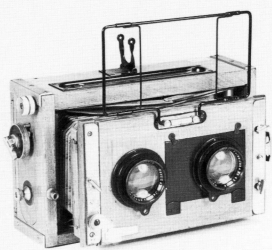

148 STEREO CAMERA
Strut type
Contessa-Nettel-Stereo, circa 1920
Manufacturer: Contessa-Nettel Works, Heilbronn-Sontheim
Format: 6 × 13 cm (2¹/₃'' × 5¹/₈'')
(FH)

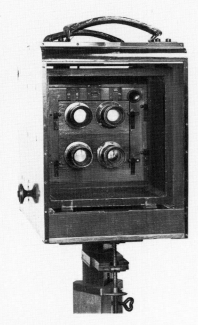

152 SPECIAL-PURPOSE CAMERA
For multiple exposures
Carte de visite Camera, circa 1880
Manufacturer: Curt Bentzin, Görlitz
Format: 4 exposures on 18 × 24 cm (7'' × 9¹/₂'') (plate)
(FH)

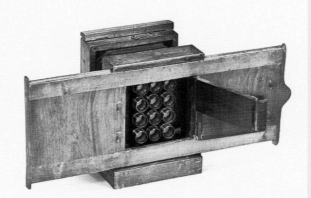

153 SPECIAL-PURPOSE CAMERA
For multiple exposures
Wooden camera with 12 lenses, circa 1870
Manufacturer: unknown
Format: 12 exposures on 9 × 12 cm (3¹/₂'' × 4³/₄'') (plate)
This type of camera was used to take photographs for me-
dallions. (FH)

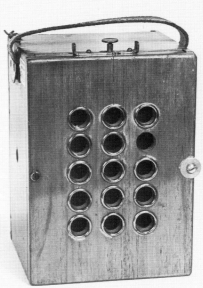

154 SPECIAL-PURPOSE CAMERA
For multiple exposures
Royal Mail Copying Camera, 1907
Manufacturer: W. Butcher & Sons, London
Format: 15 exposures on 9 × 12 cm (3¹/₂'' × 4¹/₂'') (plate)
This camera copied normal-size portraits, reducing them to
the size of a postage stamp. (FH)

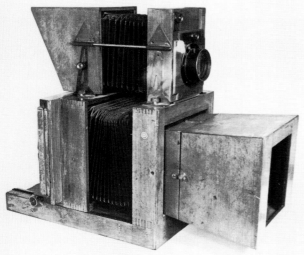

155 SPECIAL-PURPOSE CAMERA
For law enforcement applications
Berthillon Camera, 1904
Manufacturer: Neue Görlitzer Kamerawerke, Görlitz
Format: 18 × 24 cm (6″ × 9¹/₂″)
Camera for identification photographs (mug shots), after
Prof. Berthillon, Paris. (FH)

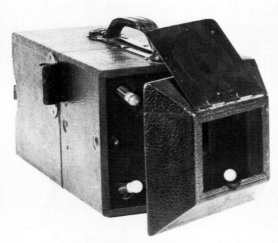

156 SPECIAL-PURPOSE CAMERA
For law enforcement applications
Fingerprint Camera, circa 1940
Manufacturer: Folmer Graflex Corp., Rochester
Format: 6.5 × 9 cm (2¹/₂″ × 3¹/₂″)
Special camera used for fingerprints. (FH)

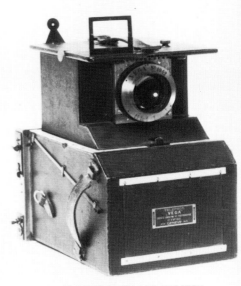

157 SPECIAL-PURPOSE CAMERA
For telephotography
Téléphote Vega, 1901
Manufacturer: Vega S.A., Geneva
Format: 13 × 18 cm (5¹/₈″ × 7″)
Focal length: 120 cm (47″)
Compact construction due to mirror system. (FH)

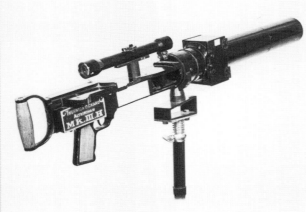

158 SPECIAL-PURPOSE CAMERA
For telephotography
Photographic Rifle, circa 1915
Manufacturer: Thornton Pickard, London
Format: 4.5 × 6 cm (1³/₄″ × 2¹/₃″) (roll film)
The camera was installed in airplanes for target practice.
(FH)

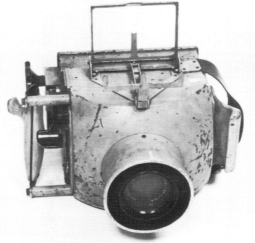

159 SPECIAL-PURPOSE CAMERA
For aerial photography
Aerial Photography Camera, circa 1920
Manufacturer: presumably Zeiss Ikon, Dresden
Format: 13 × 18 cm (5¹/₈″ × 7″)
Camera built for military purposes. (FH)

160 SPECIAL-PURPOSE CAMERA
For underwater photography
Calypso, circa 1960
Manufacturer: Spirotechnique, Paris
Format: 24 × 36 mm (35 mm film)
First waterproof camera. (STH)